PUBLIC ART
IN VANCOUVER

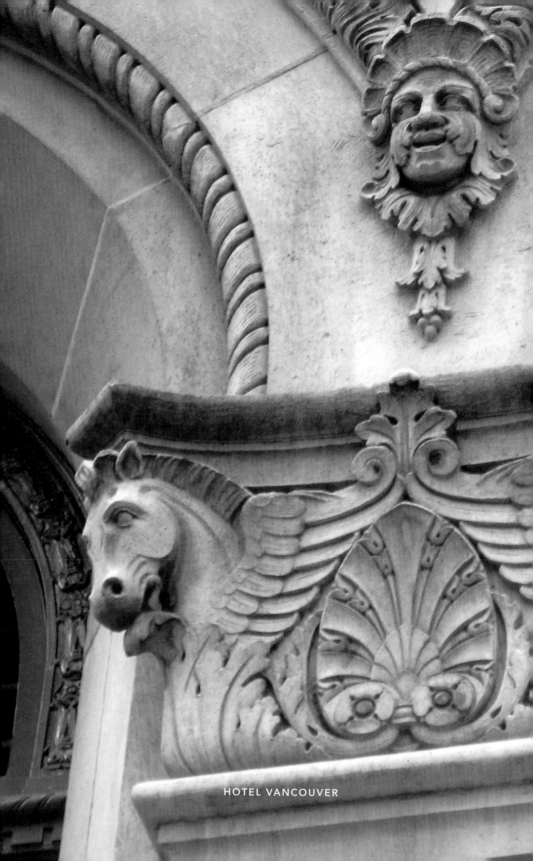

HOTEL VANCOUVER

PUBLIC ART
IN VANCOUVER

ANGELS AMONG LIONS

JOHN STEIL +
AILEEN STALKER

TouchWood
Editions

VICTORIA | VANCOUVER | CALGARY

TouchWood Editions

108 – 17665 66A Avenue	PO Box 468
Surrey, BC V3S 2A7	Custer, WA
www.touchwoodeditions.com	98240-0468

LIBRARY AND ARCHIVES CANADA CATALOGUING IN PUBLICATION

Steil, John, 1949–
Public art in Vancouver : angels among lions / John Steil and Aileen Stalker.
Includes bibliographical references. ISBN 978-1-894898-79-9
1. Public art—British Columbia—Vancouver—Guidebooks. 2. Vancouver (B.C.)—Guidebooks.
I. Stalker, Aileen, 1944– II. Title.
N8846.C2S72 2009 709.711'33 C2009-900756-8

LIBRARY OF CONGRESS CONTROL NUMBER: 2009920168

Edited by Marlyn Horsdal
Proofread by Holland Gidney
Cover design by Clint Hutzulak + Jacqui Thomas
Interior design by Jacqui Thomas
All photographs by John Steil except for the top photo and bottom photo
on page 169, both of which are courtesy of the Vancouver Biennale
Maps by John Steil
Author photos by Robert Spencer

Printed in Canada

TouchWood Editions acknowledges the financial support for its publishing program from the Government of Canada through the Book Publishing Industry Development Program (BPIDP), Canada Council for the Arts, and the province of British Columbia through the British Columbia Arts Council and the Book Publishing Tax Credit.

contents

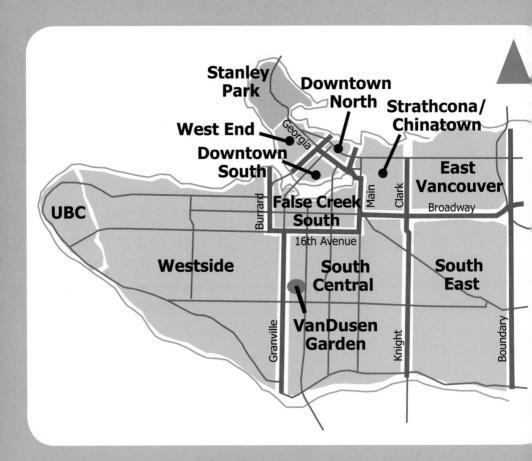

Stanley Park

Downtown North

Strathcona/ Chinatown

West End

Georgia

Downtown South

East Vancouver

Burrard

False Creek South

Main

Clark

Broadway

UBC

Westside

16th Avenue

South Central

South East

Granville

VanDusen Garden

Knight

Boundary

> THE OVERALL PICTURE—AN INTRODUCTION TO PUBLIC ART

The character of a city is revealed by its public art—what it collectively places on its streets and walls and in its public spaces.

Vancouver is a relatively young city, but during the last few decades public art has expanded dramatically throughout the city with hundreds of pieces in all sizes, materials and styles added to its original statues, busts and memorials. This is largely due to significant government initiatives, the participation of developers and the enthusiasm of Vancouver's highly creative artists.

> A HISTORICAL PERSPECTIVE ON PUBLIC ART

The history of public art reflects both society and artistic style. While many art historians would suggest that public art, as a significant artistic force, "began" in the 1960s, it has existed since the earliest petroglyphs. Early emphasis on statues in honour of gods and goddesses shifted to statues recognizing military heroes and sculptural additions to buildings.

Some believe that when Picasso's cubist sculpture was placed in a Chicago civic square in 1967, a new era for public art began. Reviled at first, over time it became a signature piece for the city.

In the following decades, the range of materials, subject matter and forms of sculptures, murals and multimedia installations responded to the possibilities of public spaces. Ways of seeing and identifying public art shifted as it became available to citizens who did not frequent galleries and museums.

During the 1980s, public art added a sense of time and place, and an understanding of past history, to expanding urban centres. More recently, it has assumed an additional integrative role: linking art, space, culture and democratic expression. The very focus and form of public art address issues of change and choice that often cause discomfort or dissent among portions of the viewing public. Selection of subject matter, media,

site and funding of public art remains an engaging topic. The question of what constitutes "public" and "art," and who is the audience, continues to, and probably always will, provoke debate.

> THE SCOPE OF PUBLIC ART

The Vancouver artists who create public art and the city's art consultants, educators, and administrators of public art programs define public art within a broad perspective. They suggest that public art consists of works that are created as a conversation with their sites and interact with the people encounter them. By having the art address the aesthetic, economic and regulatory conditions of public places and life, the dynamics and cultures of shared spaces become visible.

The artworks can be permanent or static, and they can also include performance art, discussions and presentations about the work with the artist, and use of art in a virtual Internet environment. Artists who work with the community consider the process of development and execution of the piece by those who will be its eventual audience as a key aspect of public art. In community art projects, diverse individuals are brought together in a way that educates and shifts perspectives about art, life and cultures.

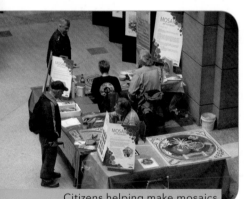
Citizens helping make mosaics

The City of Vancouver divides its official registry of public art into three categories related to who funded and/or completed the project: civic, private and community public art. The artworks include monuments, paintings, murals, tapestries, figures, First Nations art, relics, busts, fountains, gateways, mosaics, sculptures and reliefs.

Our guidebook has an inclusive approach. It celebrates pieces that are conventional as well as art on the edge. It raises questions. Is an angel on a tombstone public art? Where is the distinction between art and promotion? When does a WW I tank shift from being a killing machine to a relic that pushes us to consider it as an artistic statement— one that might provoke a viewer to address a political question? Similarly, when does an abandoned corporate symbol express, artistically, our city's history?

How these questions are answered depends on a variety of perspectives, including the intentions of the artist and the donor and how the viewer responds in the public space.

Almost any medium—concrete, spray paint, granite, clay, wood, neon, glass, steel, rocks, bronze, electronics, steam—provides a limitless palette of materials and colours, and sometimes sounds, for creating public art. There are images; there are words. Some pieces are driven by wind, tides, steam or electricity. From abstraction to reality, from miniature to monumental—the range is impressive and it includes, of course, angels and lions.

While this book documents primarily "objects" created as public art, emerging styles include light, video, electronics, environmental, ephemeral and performance art. The integration of public art and landscape architecture provides additional opportunities for art in everyday life.

However, public art in Vancouver is more than just a collection of objects placed in the public realm. Central to the intent of public art is public experience. The viewer is encouraged to look, touch, think, remember, imagine—public art is intended to engage the viewer in many ways.

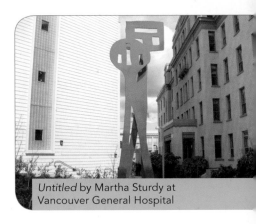

Untitled by Martha Sturdy at Vancouver General Hospital

Ideally, public art should have meaning for a broad and diverse public and address the overall context of social, ethnic, religious and cultural groups. Sometimes, the expression is subtle. Other times, it is more direct and easily accessible. An example is the *Millennium Story Stones*, where stories are shared by real people, engaging the reader and creating a mental picture that weaves together context, site and experience. Another example is the mural we have called *Red Crows*, close to Commercial Drive. It is a social record of time and place that informs visitors and amuses neighbourhood residents.

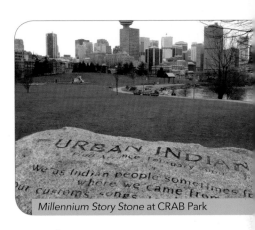

Millennium Story Stone at CRAB Park

> SELECTION OF PUBLIC ART

To make informed decisions about the selection of public art, discussions among the artists, architects, developers and policy-makers are encouraged. Increasingly, in an attempt to maintain green space within an urban environment, designers and artists are collaborating on site-specific, integrated public art.

But does this practice make the selected piece public art? Ideally, artists who are commissioned to create a public art installation will consider the urban space and context for the piece, the characteristics of the city and the history and future of the area where the artwork will be placed. However, some artworks are the result of the artist's own interest and the artistic possibilities found in certain materials, such as wood, metal or resin. Art pieces like the golden balls on the stacked marble on a downtown corner demonstrate that availability of outdoor spaces encourages large-scale projects, more contemporary forms and the use of different media. These installations have to be understood and appreciated for their own merit and story, the questions they create and their contribution to our urban fabric.

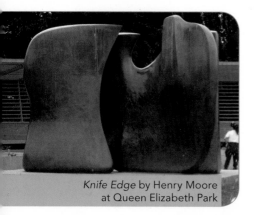

Knife Edge by Henry Moore
at Queen Elizabeth Park

The public art consultants who work with artists and developers, and the civic administrators who participate in the selection of City-sponsored art, strongly believe that public art should be created by artists (or in community-art projects coordinated by an artist leader) who have a depth and range of artistic practice. Their ability to engage the viewer with their work is the most important consideration when selecting artworks. However, opportunities to choose works by mature and emerging, international and local artists also need to be created.

> CHOOSING PUBLIC ART SITES

The distribution of public art in Vancouver is intriguing. The majority of public art, sponsored by both the civic and corporate sectors, is located in the city's central area. As a general observation, there tends to be less public art in higher income, low-density areas. Areas east of Main Street generally have an abundance of community art.

Community-based public art projects extend the reach of such art beyond traditional areas, which often are outside but close to museums and galleries. The inclusion of transient art such as banners, or theme parades for which statues, memorials, puppets and paper lanterns are developed and used for an event before fading into memories, has truly expanded access to public art to a wider audience. Events such as the Night for All Souls in Mountainview Cemetery invite citizens to explore their individual and collective identity in public spaces, albeit in a more ephemeral manner.

Environmental art is gaining interest as urban developments expand and green spaces decrease. The art respects the needs of the site and often restores the area to its natural state or integrates art in such a way that it is in harmony with the site.

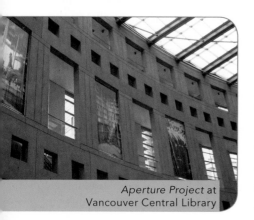

Aperture Project at
Vancouver Central Library

Public art does not have to be permanent. For some people, this factor makes it more acceptable. They can discuss, criticize or enjoy the piece, knowing it will move on, and so do not have to accept it as a permanent part of their daily urban life. The free-standing contemporary art selected by The Vancouver International Sculpture Biennale, for example, generally only provokes controversy when the community debates which pieces might stay at a specific site. Some installations, while site-specific, are deliberately transient, such as those in the *Aperture Project* at the Vancouver Central Library.

> FUNDING OF PUBLIC ART

Funding for public art has often been a source of angst in communities. Opinions range from "a misuse of our tax dollars" to "art is essential for the cultural integrity of the city and its citizens." Vancouver, like other major cities, has negotiated a "percentage for art" and the installation of public art as part of the approval process for large developments. Some municipal projects, such as the Ridgeway bike route, have included public art as part of their construction budgets.

A multi-stream source of funds is the most reliable, and corporate and philanthropic donors contribute to the purchase of public art in other cities. Although significant donations are made to the Vancouver Art Gallery and other initiatives, a specific program to encourage this type of contribution does not exist within the city-funded Public Art Program.

> EDUCATION AND PUBLIC ART

Increasingly, public art challenges previously held ideas about what constitutes art. Some think that public art will never be able to speak to all of its diverse audiences. However, when artists create powerful works, they can have great impact and lead the viewer to seek answers about the work.

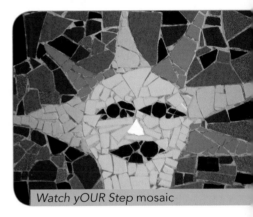

Watch yOUR Step mosaic

When public art becomes problematic, when the pieces are described as "trash, unsuitable, or inartistic," it is generally because the form or the subject was not made readily accessible, either emotionally or intellectually, to the viewer. To respond to the needs of the public, the intent of the artwork should be made clear through signage and community information programs that at least engage the public in a dialogue. Art programs and field trips for school children and the engagement of senior citizens in events to increase understanding about the intent of public art are also essential. Disenfranchised youth and citizens who participate in the creation of public art share their own perspectives and benefit from the opportunity to be involved in their community.

The education of civic politicians and the media about the meaning and purpose of public art leads to increased support and insightful reporting.

> USING THIS GUIDEBOOK

This guidebook focuses on Vancouver's public art with two goals in mind. First, to share the treasures of Vancouver's public art with a wide audience. Second, to reveal the personality of the city as illustrated by many public art pieces that say where we are from and who we are.

For each community area there is a map with the installations cross-referenced to the narrative. By combining the maps of adjacent communities, longer trips can be planned, or circle routes developed. Not all of the public art pieces in each community could be included—there are just too many! On your routes, you may discover new public art or "guerrilla art"—where individuals have installed art on their front lawns or in public places without official approval. Pieces also arrive or leave in response to demolition and redevelopment. There are also changing marketing schemes or shifts in political correctness. After complaints that the concrete seal that used to be at Second Beach in Stanley Park was being demeaned by having to balance a ball on its nose, the ball was removed and now sits on a pole above the Engtlish Bay concession stand. Few know all of the stories behind Vancouver's many pieces of public art, hence, this guidebook.

> ONE LAST PICTURE—
PUBLIC ART IN VANCOUVER NOW AND IN THE FUTURE

The majority of art pieces in Vancouver have been installed since 1991 when the civic public art program was formally organized. Does this art represent Vancouver? Is it art that befits the "world-class" status that Vancouver seeks? Does public art in Vancouver fulfill the ideas of what exciting, dynamic public art has come to embody in other cities in the last half-century?

To some extent, the jury is still out. While supporters of public art appreciate a wide range of contemporary and traditional art, and the city has a vibrant and very skilled artist community covering a wide range of practices, we may need to wait a bit longer for broadly based support for public art. Previously, much of the art focused on the youthfulness of the city and on its natural setting—at times bland and repetitive, its quality ranges from poor to exceptional. Artistic recognition of the early origins of the city as the home of a distinct, vibrant Coast Salish culture has only recently begun to emerge.

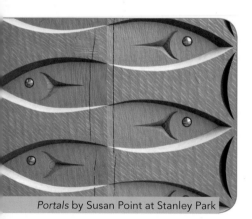

Portals by Susan Point at Stanley Park

Looking to the future, those in a position to choose art for Vancouver now seem somewhat more willing to take risks and to address these issues. Developers want to have art with "pizzazz" as part of their projects, the Biennale will include video and electronic art, and environmental and performance art are gaining acceptance. Public art no longer has to be a lasting object. Citizens are also becoming more informed and open to provocation or intrigue as contemporary art and more subtle or ephemeral artworks are gradually introduced.

Recent art installations show increased diversity and artists who lead community art projects are including communities in new, creative ways.

Artworks by both local artists who now have an international status and other world-recognized artists are being purchased. Focus on individual programs is beginning to be replaced by collaboration of those involved in the programming and acquisition of public art—the Vancouver Art Gallery is curating works for the plaza of the Shangri-La Hotel development and the Parks Board and civic programs are becoming more aligned. Additional opportunities exist to co-operate with the planning and placement of the Vancouver Biennale's temporary exhibitions.

Ephemeral artwork

A review of the city's public art program in 2008 resulted in numerous advances, with increased funding and artists actively encouraged to initiate more projects and suggest possible sites. Individuals with strong art backgrounds will participate in the selection and approval of artworks and the routine use of public art consultants and managers for developing public art projects will occur. Public lectures offered by Langara College will provide the opportunity for anyone to broaden their understanding of public art.

Vancouver has lots of space for the introduction of new works. However, within the city the totality of the art has not been considered, leading to a somewhat piecemeal pproach to placement. New transit stations, the north library plaza and new downtown apartment/office developments lend themselves to the creative use of their spaces. Southeast False Creek also provides an opportunity to both connect with downtown public art and to develop projects responsive to the specific site. There are areas in the city with few pieces of public art—Kerrisdale and Oakridge are two examples. On the east side of the city, the majority of public art is completed through smaller community projects despite new civic developments and large parks that could accommodate complex pieces that are larger in scale. Consideration of how the city wants to depict itself through its art needs to occur, and the selection of art that will allow future generations to reinterpret the works for the times in which they live.

What else does Vancouver need to have "world-class" public art? Suggestions have been varied and numerous: more opportunities for people to pause and reflect on the art without commerce or noise; interaction with the artworks and the sites—to touch, see, smell, hear; space to exhibit temporary works; creation of a "culture corridor" and a sculpture park; extension of art events such as Main Street's The Drift to the whole city, and emulation of the Nuit Blanche hosted by artists in Toronto. All of these are possibilities. Further opportunities include animation of public spaces—performance art, electronic and new media art; improved signage and educational publications about the art; and a more informed media. The idea of more guerrilla art was met with smiles and encouragement by the individuals who contributed to the review's introductory

chapter—assuming it met expectations for safety and respected cultural norms. A need for "more art that whispers" also seemed to strike a chord for many of the artists, supporters and administrators involved with public art. Development of a compassionate city for all citizens that will result in support and protection for artists—many of whom live and work in the same areas as Vancouver's disenfranchised citizens—is viewed as essential. The list goes on—creative people have creative solutions.

> ANGELS AMONG LIONS

Finally, why did we select the name *Angels Among Lions* for our subtitle? There are very few angels (the *Angel of Victory* at Waterfront Station—and the graffiti version on Central Avenue—an angel at Mountainview Cemetery and one on a school mural in south Vancouver) but there are countless lions throughout Vancouver.

Lions of all sizes and shapes are dear to the citizens of Vancouver and reflect the diversity of our cultural groups—the Shanghai Lions, the implacable lions at the south entrance of Lions Gate Bridge. There are at least 64 lions on Burrard Bridge, while innocuous buildings in Gastown may have a dozen. Lionsgate Entertainment makes award-winning films, the Lions peaks overlook Vancouver. The BC Lions play football and countless lions guard mansions and small homes.

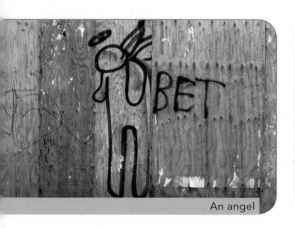

An angel

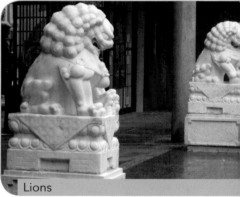

Lions

But that is merely a concrete interpretation of the subtitle. A more metaphorical perspective recognizes that public art has the potential to be an "angel" in our midst bringing energy, humour and inclusion and bridging divergent thinking about art that is available for everyone to experience. The subtle, evocative and sometimes surprising messages of public art are compelling. The impact of the unyielding "lions" of traditional art and conservative taste should continually be challenged. Public art needs ongoing energetic support as we continue to define and explain Vancouver. Listen, look and touch the angels. •

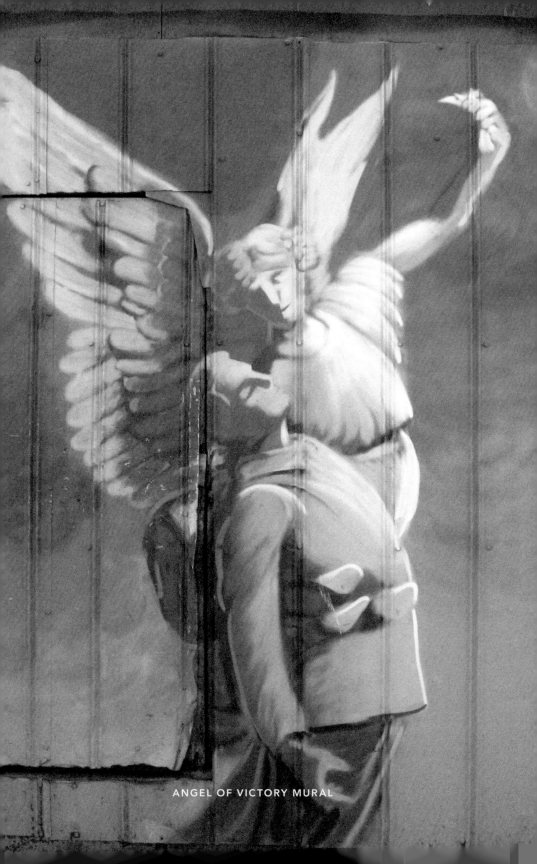

ANGEL OF VICTORY MURAL

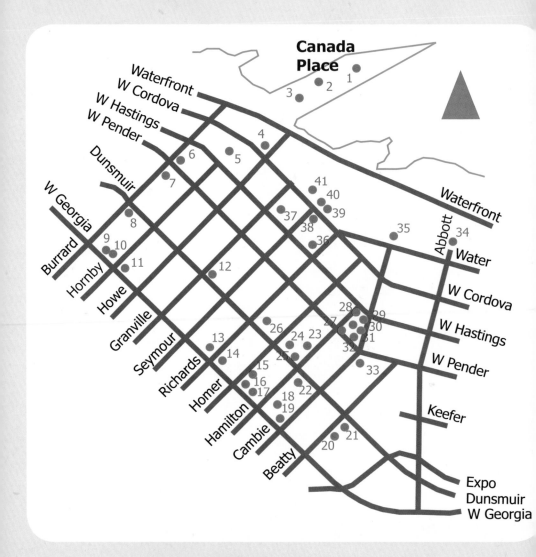

downtown north

1 SALUTE TO THE LIONS OF VANCOUVER 1991

> The Lions, a pair of peaks on Vancouver's North Shore, gave their name to the bridge over First Narrows, the BC Lions and Lionsgate Entertainment, and have become an icon for Vancouver. In this sculpture on the west terrace of the Canada Place pier, a pair of metal lions jumps through hoops toward the peaks. The designer, Gathie Falk, is a well-known Vancouver painter, sculptor and performance artist. Her subjects are often the result of "visions … that come out of the blue." •

>>>
999 CANADA PLACE WAY

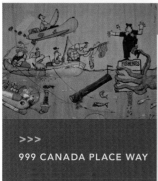

2 BC INDUSTRIES WALL HANGINGS 1986

> British Columbia industry was showcased at the BC Pavilion at Expo 86, with these wall hangings created to show the province's major resource industries in a humorous light. Images drawn by Adrian Raeside, a BC cartoonist, were enlarged and silkscreened onto canvas. Born in New Zealand, he has worked as the editorial cartoonist for the Victoria *Times Colonist* for 30 years. His editorial cartoons appear in newspapers and magazines worldwide. After Expo, the hangings were relocated here. •

>>>
999 CANADA PLACE WAY

3 SISAXO'LAS POLE AND GITXSAN POLES

> This installation, in the entrance lobby of the Vancouver Convention Exhibition Centre, consists of three poles. The oldest and tallest, the Sisaxo'las pole, was carved by Kwakwaka'wakw artist Charlie James. It was exhibited in Stanley Park for 65 years until it was moved inside to stop its decay. The two shorter poles, carved by Gitxsan artists, were commissioned for a Richmond industrial subdivision, then donated to the Vancouver Museum in 1988. •

>>>
999 CANADA PLACE WAY

4 UNTITLED (WATERFRONT) N.D.

> Just inside the southeast entrance to the Waterfront Hotel and retail concourse, you need to look up. A man and a woman are waving goodbye from the deck of a ship. It looks like the 1930s. The two figures, plus a couple of gulls, are monochromatic, but a series of metal streamers, hung on wire, add a splash of colour to the installation. •

>>>
WEST CORDOVA ST
+ HOWE ST

5 WORKING LANDSCAPE 1998

> In a small park between West Hastings Street and Canada Place, Daniel Laskarin installed four circular platforms complete with a bench and potted tree. Three of the platforms rotate at different speeds like turntables, to complete their revolutions in one hour, eight hours or 40 hours, each representing a unit of the typical work week. Unfortunately, technical difficulties mean they are not always functioning. Laskarin is a professor of Visual Arts at the University of Victoria. •

>>>
901 WEST HASTINGS ST

6 VANCOUVER VERTICAL 1981

> This fabric installation, a series of vertical woven strips, shows a downtown skyline reflected in Coal Harbour. It's by Joanna Staniszkis, who did large fabric pieces for several other Downtown office buildings from the early 1970s to the mid-1980s. This image is very similar to another installation —apparently made of WW II silk parachutes—*Reflections of Vancouver*, located in the lobby of the Convention and Exhibition Centre just a couple of blocks away. •

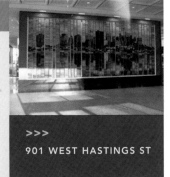

>>>
901 WEST HASTINGS ST

7 POINTS OF VIEW 2008

> This Liz Calvin mosaic combines views of two Vancouver landmarks. Harbour Centre, built in the mid-1970s, is Vancouver's Downtown lookout. Neil Armstrong, first man on the moon, rode one of the outdoor elevators in 1977 and left his famous footprints in concrete at the top. The other is the former General Post Office, finished in 1910, designed by David Ewert in a beaux arts style. This building was redeveloped as part of a complex in the mid-1980s by the federal government. •

>>>
BURRARD ST +
WEST PENDER ST

8 THE POD 1989

> Rick Switzer captured the majesty of two orcas (killer whales) leaping through the waves in this bronze sculpture. Orcas are highly social and swim in pods, usually led by an older female. They are not unique to the Pacific Northwest, being found from the Arctic to the Antarctic as well as in tropical waters. Close to Vancouver, there are both transient and resident pods around the San Juan Islands and southern Vancouver Island. •

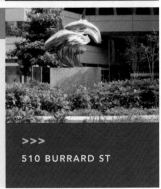

>>>
510 BURRARD ST

9 ART-I-TECTURE 2005

> Created for the Downtown Vancouver Business Improvement Area by Bruce Walther, this mosaic makes reference to downtown buildings. The central figure, a nurse by Joseph Francis Watson, is from the old Georgia Medical-Dental Building on this site, now replicated in fibreglass on the new building, Cathedral Place. Behind the nurse is a stained-glass image of the Marine Building. Other details include B.C. Binning's mosaics at the Electra Building and Lionel Thomas's work, formerly at the old library. •

>>>
925 WEST GEORGIA ST

10 NAVIGATION DEVICE: ORIGIN UNKNOWN 1991

> In addition to this work, designer and artist Robert Studer of Vancouver also fabricated a story to go along with it: this large glass-and-steel installation was "found" on Lyell Island, in the Queen Charlotte Islands, BC. Through light and sound sensors, it interprets movement in the lobby, causing lights to change and chimes to sound. Its mystery, fragmentation and inscriptions are meant to lead the viewer to question, first, its possible origins, and then the role of technology in the search for our own origins. Studer creates unique works for both corporations and individuals, and is constantly working towards discoveries of new properties of glass. •

>>>
925 WEST GEORGIA ST

11 PENDULUM 1987

> This installation, in the atrium of the HSBC building, is in two parts. A large aluminum pendulum, 27 m long and weighing 1,600 kg, swings from the atrium's glass roof. When it finishes its electric-motor-driven arc, it aligns with the slightly angled buttress to form one visual piece. It's by Alan Storey, who has created many public artworks in Vancouver and elsewhere in Canada and the US. Many of his works draw on mechanical processes and include movement. •

>>>
885 WEST GEORGIA ST

12 BC BEGINNING 1958

> B.C. (Bertram Charles) Binning was commissioned by the Imperial Bank of Canada to create this mural for its banking hall. Shoppers Drug Mart should be complimented for retaining the mosaic, during a recent renovation as a showpiece (contrast this with the renovation of the TD Bank down the street, where another mural was removed). This mural represents all the sectors of BC's provincial economy. The maquette, in oil, is in the collection of the Vancouver Art Gallery. •

>>>
586 GRANVILLE ST

13 RANDALL BUILDING MURAL 1991

> This 1929 building, now with a heritage designation, was designed by Richard Perry. It was renovated in 1991 by the owner, Toni Cavelti, who had a jewellery store here. The mural on the upper east exterior wall, based on a copper engraving from 1698 by German Christopher Weigel (1654–1725), shows a medieval master goldsmith instructing apprentices. The mural was completed by Kitty Mykka and Nicole Kozak-iewkz, and restored in 2005 by Mykka and Lance Belanger. •

>>>
555 WEST GEORGIA ST

14 ROYAL SWEET DIAMOND 2000

> Rural Saskatchewan has influenced Joe Fafard's work. Originally concentrating on ceramic sculpture, he turned to bronze in the early 1980s and established his own foundry to produce his work, which includes many life-sized animals, especially horses and cows. This life-size bull, *Royal Sweet Diamond*, gazes out from the plaza. Fafard's website lists FAQs, one being: "Why have you done so many cows?" Answer: "I don't know, but I have no regrets." He is an Officer of the Order of Canada. •

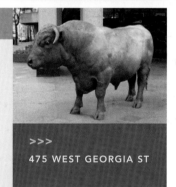

>>>
475 WEST GEORGIA ST

15 THE POSTMAN 1955

> Built in the mid-1950s, this post office is really a huge mail-processing plant. When it opened, it was the largest welded-steel structure in the world. The cornerstone was laid in 1955 by the Honourable Robert H. Winters, Canada's minister of public works. *The Postman*, cut into the red granite above the cornerstone, is by Paul Huda. It certainly hearkens back to a past era of more formal dress, rain capes and less ergonomically correct mailbags. •

>>>
349 WEST GEORGIA ST

>>>
349 HOMER ST

16 UNTITLED (POST OFFICE) 1957

> Along the bottom of this mural are the words "Sorting the royal mails by land, sea and air in British Columbia." The dominant figure is Mercury, winged messenger of Roman mythology. The mural shows the evolution of mail delivery, from stagecoaches to ships, from biplanes to helicopters (there is a landing pad on the roof!). Orville Fisher studied at the Vancouver School of Art, did a mural at the San Francisco World's Fair in 1938, and was a WW II artist. •

>>>
WEST GEORGIA ST
AT HOMER ST

17 CANADA COAT OF ARMS c.1932

> Two 6-m-high Canadian coats of arms are on the south wall of the post office. Included are a variety of symbols: English lion, Scottish lion, fleurs-de-lys, Irish harp and unicorn. As it was only adopted in 1994, the circular ribbon with the Order of Canada motto, *Desiderantes Meliorem Patriam* ("They desire a better country") is not included. Canada's motto *A Mari usque ad Mare* ("From sea to sea") is based on Psalm 72:8. •

>>>
WEST GEORGIA ST
+ HAMILTON ST

18 QUEEN ELIZABETH PLAZA FOUNTAIN 1971

> This bronze-and-steel fountain in the lacklustre plaza at the Queen Elizabeth Theatre was designed by Gerhard Class. Water spews from the inner sphere. It's reported that the fountain's original design of two granite figures representing immigrants was abandoned due to a shortage of funds. It was donated by the German-Canadian Centennial Committee of BC. •

>>>
CAMBIE ST +
WEST GEORGIA ST

19 RAINFOREST 1986

> This sculpture was a gift from "Pioneers who settled in British Columbia from Punjab, India." Gordon Ferguson completed it during the City Shapes Sculpture Symposium held to celebrate Vancouver's centennial. Blue steel poles on a tilted platform form a matrix holding a variety of objects connected to the lumber industry: chairs, ladders, framed houses and baseball bats. Also, there are the tools of the lumber trade, such as an axe and a saw blade. •

20 WRITING TO YOU 2007

> At the east end of St. Julien Square (named after the Battle of St. Julien at Ypres, 1915) is a vignette created by a bronze table with a letter from Major Lloyd Augustus: "I dream of white sheets, a warm room, hot bath and you beside me." Opposite is a bronze trunk with a letter written back by Mary Augustus: "I try not to think of you in action, or I make myself crazy." The artists were Ian Carr-Harris, a winner of a 2007 Governor General's award for visual and media arts, and Yvonne Lammerich. •

>>>
BEATTIE ST SOUTH
OF DUNSMUIR ST

21 TANKS, GUNS N.D.

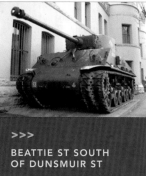

> Relics often take on new meanings. One tank, the RAM MK II, operated with a crew of five and a top speed of 40 km/hr during WW II. The other, *Boss*, a Sherman (32 tonnes, 48 km/hr), was commanded by "Lt.Col. Worthington in 1944 north of Falaise, France during a heroic 14-hour battle on Hill 140." The two 64 lb. guns, originally mounted in 1878 on Vancouver Island, were given to the first citizen militia unit in Vancouver. •

>>>
BEATTIE ST SOUTH
OF DUNSMUIR ST

22 FLORENTINE DOOR AND WALL #3 1967

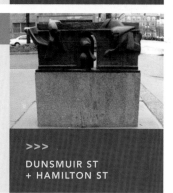

> Outside the Vancouver Playhouse is a subtle bronze piece by Frank Perry—a door opening in a wall. A Vancouver native, he joined the Royal Canadian Engineers at 16 and served overseas in WW II. Afterwards, he graduated from UBC and then attended art school at UBC and in London. He also spent time in Florence, Italy. He was noted for anthropomorphic bird forms, such as the large-beaked bird on the northeast corner of this piece. Door #2 is at UBC. •

>>>
DUNSMUIR ST
+ HAMILTON ST

23 UNLIMITED GROWTH INCREASES THE DIVIDE 1990

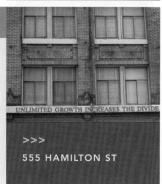

> The full text, in copper letters by Kathryn Walter, across the front of the Del-Mar Hotel, reads UNLIMITED GROWTH INCREASES THE DIVIDE. A political statement, for sure, and typical of one side in the polarization of Vancouver politics, but is it art? Not in the same tradition, surely, as PLACED UPON THE HORIZON (CASTING SHADOWS) on the Vancouver Art Gallery, which is clearly conceptual art. But many artists use their work to make political statements, sometimes using words rather than symbols. •

>>>
555 HAMILTON ST

> > >

333 DUNSMUIR ST

24 WATER WORK 1993

> This fountain was designed by Tokyo-born Tony Bloom. He worked with Durante Kreuk Landscape Architects and Jim Posey. A kinetic work, it was inspired by *shishi odoshi*, a traditional bamboo rod that fills with water and then drops with a bang, scaring deer from the garden. Here, the top blue steel piece gradually fills with water, then tilts, pouring water into the bottom piece and causing it to tilt and drain. •

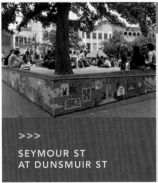

> > >

DUNSMUIR ST
+ HAMILTON ST

25 CELEBRATION 2008

> Given the importance of the Chinese community here, the large number of dragons in public art is not surprising. This mosaic, coordinated by Liz Calvin with assistance from Ann Wilson and Ruth Murray, is based on the Chinese New Year's celebration held the first Sunday of the Chinese (Lunar) New Year. The dragon dance symbolizes coming good luck and success. One notion is that the dance is to appease the "Dragon King" into releasing rain onto drought-stricken farmlands. •

> > >

SEYMOUR ST
AT DUNSMUIR ST

26 WATCH yOUR STEP 2005

> Watch yOUR Step, a mosaic project involving 15 youth, has four other sites downtown. This site at Cathedral Park is based on the theme of Outside/Inside. Seniors from the adjacent 411 Centre were involved in developing design ideas. The park is over a major BC Hydro station. In September 2008, BC Hydro started installing a third transformer, so the mural was to be removed carefully, stored safely and then reinstalled. The original artistic director was Leah Decter. •

> > >

WEST PENDER ST
+ HAMILTON ST

27 THE GREAT FIRE 2001

> On June 13, 1886, shortly after the city was incorporated, and less than an hour after the blaze started, Vancouver was destroyed. People ran for the Hastings Mill area as the flames blew north and east, fuelled by a strong wind and wooden houses. At the end of the fire, 3,000 people were homeless. Yet within months, the new city was rebuilt and, in July 1887, the first transcontinental train arrived in Vancouver, ensuring the city's success. •

28 VANCOUVER CORNER 2001

> This thoughtful soldier is duplicated on the top of a granite monument near the town of St. Julien in Belgium. In the second Battle of Ypres, 1915, when poison gas was first used, it was Canadian and French troops who initially defended a 12-km stretch at the front, with the Canadians continuing to defend the area for four days. Over 2,000 Canadian men, some of whom were from Vancouver, were killed and buried in the nearby fields. •

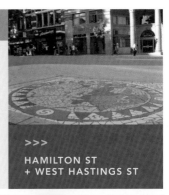

>>>
HAMILTON ST
+ WEST HASTINGS ST

29 CENOTAPH 1924

> This is the largest of Vancouver's many cenotaphs. The three-sided obelisk designed by Major G.L. Thornton Sharp (architect, town planner and park commissioner) is constructed of the same grey granite, from Nelson Island, as the lions at the Vancouver Art Gallery. The inscriptions read "Their name liveth for evermore," "Is it nothing to you," and "All ye that pass by." The ornamentation includes a sword and two wreaths—one of laurels, the other of poppies—both entwined with maple leaves. •

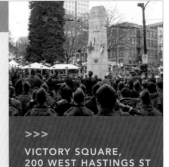

>>>
VICTORY SQUARE,
200 WEST HASTINGS ST

30 ANTIQUITY 2005

> Several themes run through the mosaic by the CETA Co-op located on a small concrete stage: there is the poppy; there are details from nearby buildings—Sun Tower caryatids, Dominion Building angels—and there is the lion. It's one of only a few pieces with both lions and angels. Names of surrounding streets are also included: Hamilton (the CPR land commissioner who named it after himself), Pender (the captain of HMS *Plumper*), Cambie (a CPR divisional engineer) and Hastings (a rear admiral). •

>>>
VICTORY SQUARE,
200 WEST HASTINGS ST

31 VICTORY SQUARE LIGHTING 2002

> Canada earned its international reputation and status through the sacrifices of its soldiers. This, the site of Vancouver's original courthouse—where recruits signed up for WW I —was renovated in 2004. One of the most exciting new elements was the introduction of lights evoking the helmets on the cenotaph, created by Pechet and Robb Studio. The park has also been the site of other civic activities, such as the 2002 Tent City protesting Downtown Eastside poverty. •

>>>
VICTORY SQUARE,
200 WEST HASTINGS ST

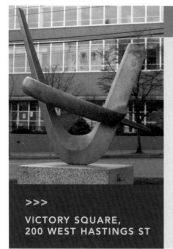

32 PROVINCE NEWSPAPER MEMORIAL 1967

> Gerhard Class created many public artworks in Vancouver from the late 1950s through the early 1970s. This aluminum form on a granite base, at the south end of Victory Square, was cast by the artist using styrofoam and sand. It was given by the *Daily Province* newspaper—which, for 67 years, had offices in the building across from the square at 198 West Hastings—to commemorate its donation to landscaping the square when the former courthouse on the site was demolished. •

>>>
VICTORY SQUARE,
200 WEST HASTINGS ST

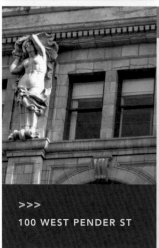

33 SUN TOWER CARYATIDS 1912

> When built for newspaper publisher Louis Taylor (eight-time mayor of Vancouver), this 17-storey beaux arts building was the tallest in the British Empire. A row of caryatids (female figures as supporting columns) is just below the cornice line. These bare-breasted terracotta maidens, designed by sculptor Charles Marega and made in England, caused some scandal when they were unveiled. In 1918, Harry Gardiner (a.k.a. the Human Fly) climbed the outside of the building. In 1920, Harry Houdini dangled from the top. •

>>>
100 WEST PENDER ST

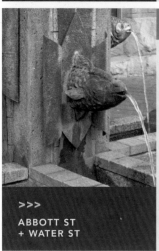

34 FISH FOUNTAIN 1987

> Just off the edge of Gastown's main street is a small commemorative fountain. It has four cast-bronze salmon heads spitting water into troughs of Quadra Island granite. The flowing metal work at the top, looking like fish tails, is the major clue that this work is by Sam Carter. It was commissioned in honour of Samuel Leshgold, a fishing enthusiast and Gastown supporter, by his family. •

>>>
ABBOTT ST
+ WATER ST

35 STEAM CLOCK 1977

> Crowds often wait patiently for this Victorian-style clock's performance. Along with the totems at Brockton Point, it's one of the most-photographed locations in Vancouver. Conceived of by a Vancouver city planner, the clock was built by horologist Raymond Saunders and was the world's first steam-powered clock. He has since created other steam clocks around the world, including a twin to the Gastown clock in Otaru, Japan. Electricity drives the pulleys that raise the weights but steam from the district's heating system sounds the Westminster Chimes on the quarter hour and the whistle on the hour. •

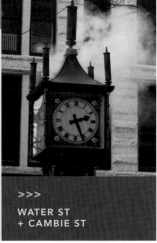

>>>
WATER ST
+ CAMBIE ST

36 UNTITLED (SFU) N.D.

> This large, backlit glass sculpture in Simon Fraser University's lobby was a gift from its creators, Harold Spence-Sales and his artist wife, Mary Filer. It's in three parts. The central panel suggests the plan of SFU's Burnaby hilltop campus. The left clearly is a map of the University of British Columbia—the cross-town rival. The right panel appears to be an urban and rural layout, perhaps based on Spence-Sales' career as a city planner. •

>>>
515 WEST HASTINGS ST

37 CELEBRATION 1986

> This painted wood sculpture, in the atrium of the redeveloped Sinclair Centre, shows a man high-stepping, waving his briefcase and holding what looks like a glass of draft beer. A woman is holding a bouquet of flowers and a glass of wine. John Hooper created it during the centennial sculpture symposium. He was born in England, raised in China, served in the British Army in India and settled in New Brunswick, finally dedicating himself to art and earning an Order of Canada. •

>>>
757 WEST HASTINGS ST

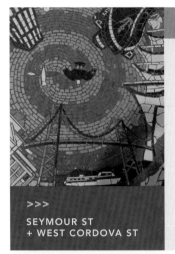

38 BIRD'S EYE VIEW 2006

> A bald eagle and a gull spiral against an orange and yellow sky. This central image in the mosaic is ringed by familiar sights and landmarks. Shown are a cruise ship docked beside the canvas roof of Canada Place, the lights of Gastown, the SeaBus passing by Lions Gate Bridge, the former Vancouver courthouse and trains next to grain silos. The "EM" on the side of the train stands for artist Elia Mishkis. •

>>>
**SEYMOUR ST
+ WEST CORDOVA ST**

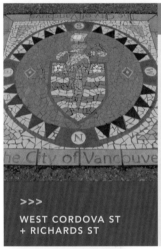

39 CITY OF VANCOUVER 2001

> The Vancouver coat of arms is based on James Blomfield's 1903 design, with a modified design registered with the College of Heralds in London in 1969. The shield is flanked by a logger and fisherman; this mosaic shows the crest, but without the logger and fisherman. The original motto, "By Sea and Land We Prosper," now adds a reference to "air." Check out the Burrard Bridge for the second-last version; there's another one behind Captain Vancouver at City Hall. •

>>>
**WEST CORDOVA ST
+ RICHARDS ST**

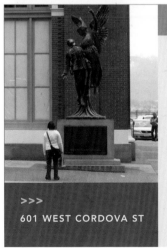

40 ANGEL OF VICTORY 1921

> Of the 600,000 Canadians serving during WW I, over 66,000 died. This statue by sculptor Coeur de Lion MacCarthy, of an angel carrying a soldier to heaven, was commissioned by the Canadian Pacific Railroad to honour its employees who served in the war. Three versions were cast in Mount Vernon, NY; the other two are in Winnipeg and Montreal. MacCarthy was one of the designers of the lion and unicorn on the main archway of the Peace Tower of the Parliament Buildings in Ottawa. •

>>>
601 WEST CORDOVA ST

41 CPR STATION PAINTINGS c. 1914

> The first Canadian Pacific transcontinental train arrived in Vancouver in 1887. This beaux arts building, completed in 1914 as Vancouver's third CPR station, has evolved into a multimodal hub. The exterior of the building is protected by a municipal heritage designation, but this interior is not. High on the walls around the central hall are a series of oil paintings by Adelaide Langford that represent the scenes an early traveller would have seen while riding the train across Canada. •

>>>
601 WEST CORDOVA ST

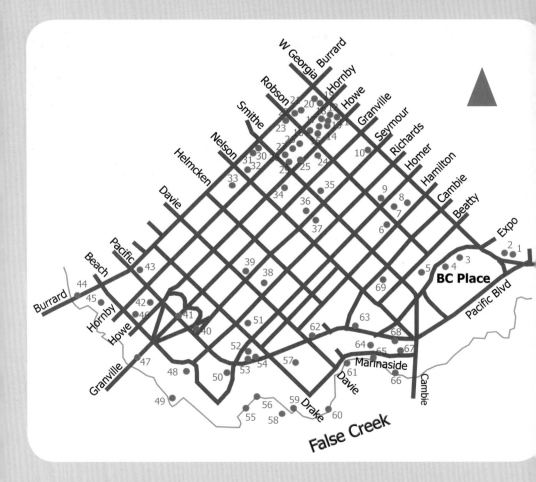

downtown south

1 THE GAME 1995

> Although hockey is Canada's game and General Motors Place is home to the NHL Canucks, curiously, this art installation by Liz Magor is more closely aligned with the Italian sport of bocce. Large aluminum and stainless steel balls are dispersed around the plazas as if a game were in progress. Each of the balls is worthy of attention, because of the variations in their designs and because each has a portrait of an athlete expressing some degree of stress or success. •

>>>
800 GRIFFITHS WAY

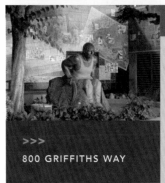

2 RICK HANSEN — MAN IN MOTION 1997

> When Rick Hansen set out in 1987 to go around the world in his wheelchair to raise funds and awareness of spinal injuries, he had no way of knowing that, over 20 years later, the impact of his courageous act would have helped raise millions of dollars towards research in spinal cord injury and rehabilitation. Sculptor Bill Koochin showed Hansen during the 8 hours he wheeled each day, covering 50–70 km. Artist Blake Williams created a photo collage of the 792-day journey. •

>>>
800 GRIFFITHS WAY

3 PERCY WILLIAMS 1996

> This bronze sculpture by Ann McLaren, just outside the BC Sports Hall of Fame at BC Place, shows Vancouver-born Percy Williams crouched at an incised starting line, ready to break another world record. He surprised the world and won the 100- and 200-m races at the Olympic Games in 1928 as a 20-year-old. Although injuries forced his retirement from running in 1932, he held the 100-m world record, 10.3 seconds, till 1940. •

>>>
GATE A, BC PLACE,
777 PACIFIC BLVD

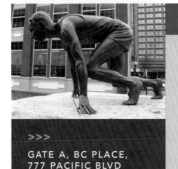

4 TERRY FOX MEMORIAL 1984

> One of Vancouver's largest public art installations was created by Franklin Allen and Ian Bateson but the public was disappointed, feeling that is was more "monument" than "Terry." Starting in Newfoundland in 1980 to run home to Vancouver to raise awareness and funds for cancer research, this one-legged man ran 42 km a day until lung cancer forced him to stop. His legacy remains, as millions of dollars are raised worldwide through the annual Terry Fox Runs. •

>>>
BEATTY ST
+ ROBSON ST

5 FULCRUM OF VISION 2003

> A small Downtown plaza became a sculpture garden for three pieces by sculptor Mowry Baden. Each piece (green lily leaf, patched cloud and bar seating) creates a unique sensory experience for the viewer—colour, size, shape, texture, weight and space are all experienced in different ways from various locations in the garden. It is worthwhile sitting on the seats provided at each form—the perspective changes once again. •

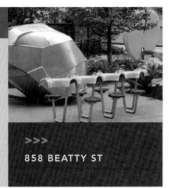

>>>
858 BEATTY ST

6 WALK OF CHAMPIONS 2008

> Some Vancouver teams, such as the Asahi Japanese-Canadian baseball team (winners of the Pacific Northwest championship from 1937 to 1941) and the Millionaires Hockey team, have disappeared over the years. However, support for the Whitecaps soccer team (wave logo), the BC Lions football team (lion pawprint) and the Canucks hockey team (Johnny Canuck player) remains strong. Bruce Walther created this mosaic as a tribute to the city's sports heroes. •

>>>
ROBSON ST
+ HAMILTON ST

7 FOUNTAIN OF TIME 1995

> The south side of the library is a popular spot on a sunny day. Water pours down a wall of fish-scaled tiles outside the children's library. The bottom has three bands of mosaic pieces that have been split apart to evoke ancient ruins. Joseph Montague, the artist, says the Roman numerals are reflective of the countdown to the Millennium. The second band has a Greek motif, the third has birds. To obtain different perspectives, look at it both from above and from inside the library. •

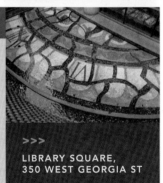

>>>
LIBRARY SQUARE,
350 WEST GEORGIA ST

8 APERTURE PROJECT 2005

> The Central Library building, completed in 1995, was designed by Moshe Safdie. Loosely based on the Roman Coliseum, the design was selected by the public in an architectural competition. To commemorate the library's tenth anniversary, the *Aperture Project* was initiated. Funded by a public art endowment, it consists of changing displays of large photo-based works in three openings in the upper promenade. •

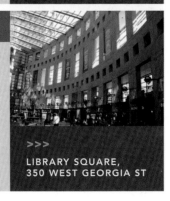

>>>
LIBRARY SQUARE,
350 WEST GEORGIA ST

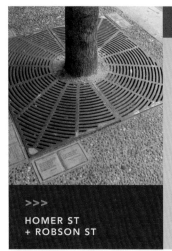

9 QUOTATIONS N.D.

> Around the trees along the sidewalks at Homer and Robson, 31 have a series of eight tiles surrounding their bases, each tile with two quotations. Do the math, that's a lot, but some are repeated. Drawing on their location adjacent to the library, the quotations, each presented on the page of an open book, cover a wide range of topics and sources, from Groucho Marx's witty comment shown in the picture to song lyrics by Van Morrison and Neil Young. Bob Dylan and Dylan Thomas. Mordecai Richler writing about Wayne Gretzky. Politicians and philosophers. "'Curious and curiouser!' cried Alice." •

>>>
HOMER ST
+ ROBSON ST

10 ENTERPRISING BEGINNINGS 2005

> In 1670, King Charles II gave the 18 investors in the Company of Adventurers of England Trading into Hudson's Bay (HBC) almost 40 per cent of what is now Canada. The HBC opened its first Vancouver store in 1887, eventually building its current store in phases from 1914 to 1949. This mosaic by Liz Calvin shows a team of horses pulling a wagon with the HBC logo. Sponsored by the HBC, it raises the question of whether this is public art or advertising. •

>>>
SEYMOUR ST
+ WEST GEORGIA ST

11 SPANNING TIME 2005

> This mosaic by Bruce Walther shows the Lions Gate Bridge, which was opened to traffic in 1938. In an amazing example of modern engineering, the entire deck surface was replaced and the sidewalks reconfigured on the outside of the bridge structure during 2000–01; the bridge was not closed during the day nor was there any interruption in the 60,000 to 70,000 car trips per day made across the bridge. •

>>>
WEST GEORGIA ST
+ HOWE ST

12 BC CENTENNIAL FOUNTAIN 1966

> To create all that dancing water, the fountain's pumps move more than 1.3 million litres of water an hour. Artist Alex Svoboda completed the sculptures and mosaics and landscape architect Robert Savery developed the basic design. It was built to commemorate the centennial of the union of the Colony of Vancouver Island and British Columbia. Forms include the Earth goddess and the sea-going Celts. •

>>>
**HORNBY ST +
WEST GEORGIA ST**

13 UNTITLED (LIBRARY LIONS) 1910

> The redesign of Robson Square closed the former court-house's main entrance but the stairs between the two lions remain a popular spot to lounge. The lions were carved from granite from Nelson Island by John Whitworth, Herbert Ede, John Bruce and James Hurry. In 1942, dynamite blasts (still an unsolved mystery) split the back end off the west lion. Whitworth and Ede carved new hindquarters from the same granite and neatly fitted it so that only a thin line is visible. •

>>>
750 HORNBY ST

14 SQUID HEAD 2001

> Artist Kim Adams describes these reconfigured vehicles as "at once animal, industry, commerce and entertainment —a combination that could be described as a squid-like, space-age hot dog stand." The objects are joyful both in colour and intent and, because they can be moved about on the art gallery plazas, they provide opportunities to think about public space and its relationship to art inside and out-side the gallery, as well as the roles of vehicles in our lives. •

>>>
750 HORNBY ST

15 BIRD OF SPRING 1979

> Abraham Etungat, from Cape Dorset, Nunavut, created this bronze replica of a 14-cm tall original design. Sculptures by Etungat have been shown throughout Canada and the United States, including at the United Nations. In 1981, he was commissioned by Prince Charles' personal secretary to create a sculpture as a wedding gift for Charles and Diana. •

>>>
**ROBSON ST
+ HORNBY ST**

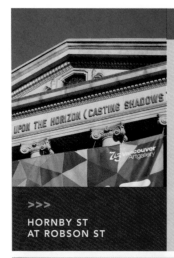

**HORNBY ST
AT ROBSON ST**

16 PLACED UPON THE HORIZON 1990

> The artist, New Yorker Lawrence Weiner, is a noted leader in conceptual art—the artistic concept may exist in the absence of an object, as its representation may be described but not produced. Meaning is obtained through the context of the work. Since 1968, Weiner has sculpted mostly in words and mass-produced posters. The cedar letters PLACED UPON THE HORIZON (CASTING SHADOWS) were commissioned by the Vancouver Art Gallery. The VAG information brochure notes that the statement could "refer to the non-existent sight-line that is obscured by the city" while "casting shadows … describes one of the work's physical properties."•

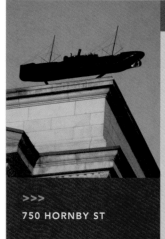

750 HORNBY ST

17 FOUR BOATS STRANDED 2001

> Look up at the roof corners of the Vancouver Art Gallery. Internationally famous Vancouver artist Ken Lum created four different coloured boats representing aspects of Vancouver as a port city with a complex past. Black: the *Komagata Maru* is the Japanese steamer carrying Indian immigrants turned back in 1914. Yellow: in 1999, over a hundred illegal Chinese immigrants were unloaded on an isolated Vancouver Island beach by a mysterious fishing vessel. White: Captain Vancouver's sailing ship. Red: a First Nations longboat. •

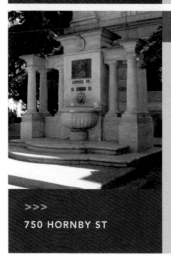

750 HORNBY ST

18 KING EDWARD VII FOUNTAIN 1912

> Charles Marega designed this fountain for the Imperial Order of Daughters of the Empire. Originally facing Georgia Street, it was relocated in 1983 when the courthouse was redeveloped into the Vancouver Art Gallery. King Edward VII, memorialized in the bronze relief, reigned from the death of Queen Victoria in 1901 until his own death in 1910. Oh yes, there's another lion! •

19 HOTEL VANCOUVER 1928-1939

> The Great Depression forced the Canadian National and Canadian Pacific railways to work together to finance and, after 11 years, complete the Hotel Vancouver. The third hotel by that name, it was built a block away from the original two. Many architectural features representative of the time of its construction—wall medallions, gargoyles, crests and the iconic peaked copper roof—are now duplicated on modern condos throughout the city. •

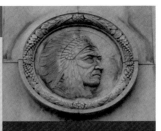

>>>
900 WEST GEORGIA ST

20 THE SWING OF THINGS 2005

> This mosaic by Liz Calvin pays tribute to band leader Dal Richards, a.k.a. "Mr. Swing," a legend in the music world of Vancouver. His big-band sound from the Hotel Vancouver was heard weekly on CBC Radio and for 25 years he played 5 nights a week in the ballroom at the hotel. He has played for 73 (and still counting!) consecutive New Year's Eve parties in the Vancouver area. •

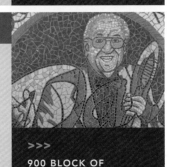

>>>
900 BLOCK OF
WEST GEORGIA ST

21 SYMBOLS OF THE CUNEIFORMS 1960

> This metal sculpture with white Plexiglas backlit highlights, created by Patricia and Lionel Thomas and F. Lachnit, is on a dark marble base. Cuneiform writing was developed in Mesopotamia. The building was first used as Vancouver's main library branch; when it was renovated in the mid-1990s, this piece was retained. Thomas and his wife, Patricia, created numerous other sculptures in the city. •

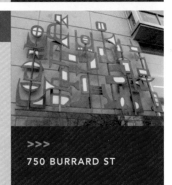

>>>
750 BURRARD ST

22 SOUNDS AROUND TOWN 2005

> From classical music to jazz, from reggae to English baroque, the sounds of music can be heard in community centres, nightclubs and theatres throughout Vancouver. From the Folk Music Festival to the Early Music and Jazz festivals—there are festivals held year-round to suit every music lover in the city. Artist Liz Calvin chose a variety of musical instruments to direct our thoughts to the role that music plays in our daily lives. •

>>>
ROBSON ST
+ BURRARD ST

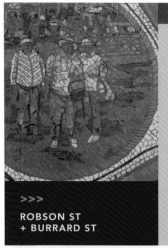

>>>
**ROBSON ST
+ BURRARD ST**

23 ON THE SCENE 2005

> For a "shop 'til you drop" tourist or city resident, Downtown Vancouver has a shop or restaurant for every need and indulgence. From imported chocolates to First Nations jewellery, from Malaysian to Swiss food, the streets and shops provide a window into the multicultural environment that Vancouver has become. This mosaic by Liz Calvin shows happy tourists on a sunny day, enjoying their wander through Downtown streets—and no doubt enjoying the public art as well. •

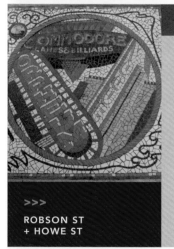

>>>
**ROBSON ST
+ HOWE ST**

24 NEON NIGHTS 2005

> From the "Roaring '20s" until the '50s, Vancouver had more footage of neon lighting (one sign per 18 residents) than any city other than Shanghai. This mosaic by Liz Calvin captures three of the more impressive signs that can still be seen, on the Orpheum and Vogue theatres and the Commodore Ballroom. Neon signs—which use neon gas, a waste product of purified oxygen or argon, excited by electricity to create the light—are making a comeback. •

>>>
**ROBSON ST
+ HORNBY ST**

25 JOY OF FREEDOM 1995

> Fifty years after the liberation of the Netherlands during WW II, in which Canadian troops played a pivotal role, sculptor Geert Maas created this bronze sculpture as a tribute to the Canadians who fought in his homeland. The hands represent the oppression and suppression that occurred under the Nazi occupation. The "V" is the universal sign for victory with the form of a person rising hopeful and victorious despite overwhelming events. •

26 SPRING 1981

> Alan Chung Hung immigrated to Canada from China in 1969. An engineer by training, he turned to art in Vancouver. Hung said, "I thrive on rule and order ... appreciate definitions we make in our cultural history ... love fairy tales ... fantasies ... and illusions flashing across my mind!" This coil is reminiscent of both the spring from our mothers' old wooden clothespins that anchored our T-shirts to the line and the spring that squeezed the pieces of Claes Oldenburg's 45-ft-high clothespin in downtown Philadelphia in 1976. Hung died in his 40s, but he left several significant pieces of public art here. •

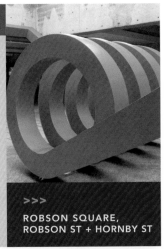

>>>
ROBSON SQUARE,
ROBSON ST + HORNBY ST

27 PRIMARY NO. 9 1981

> The colourful painted-steel forms by Michael Banwell immediately invite exploration of the colours, spaces and shapes. At times, Banwell has used guerrilla art—the spontaneous, unauthorized placement of his works in public spaces—to express his activist opinions. He taught at the Emily Carr University of Art + Design until his retirement. •

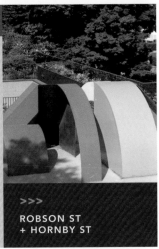

>>>
ROBSON ST
+ HORNBY ST

28 LORD DENNING 1995

> Sculptor Jack Harman created this bronze bust of Lord Denning, a British barrister known for interpretations and decisions that helped shape the common law. His challenges to binding judicial precedent and his ongoing judicial activism demonstrated his questioning and innovative approach to the law. In the same area are busts of other judges, including Nathanial Nemetz, whose legal career in BC covered 51 years and included a position as Chief Justice of the BC Supreme Court. •

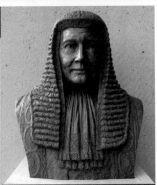

>>>
800 SMITHE ST
COURTHOUSE LOBBY

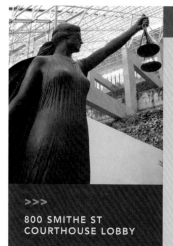

**800 SMITHE ST
COURTHOUSE LOBBY**

29 THEMIS, GODDESS OF JUSTICE 1982

> This bronze by Jack Harman is located in the Great Hall of the Law Courts Building. It's reported that Harman designed covers for Harlequin romances as a student, but he is known more for his significant sculptural output and for establishing a local foundry. The Goddess of Justice, blindfolded and holding scales, has a long tradition. Themis is generally shown with a sword representing the force of law; here she holds a scroll. No pictures please—a letter was required to get special exemption from court rules for this photograph. •

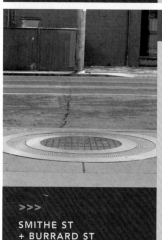

**SMITHE ST
+ BURRARD ST**

30 UNCOVERINGS 1998

> Four sites in the Downtown area have illuminated glass and steel manhole covers connected to an underground central heating system. The vapour outlets emit steam and the textured tops collect water. Through the words "collected" and "dispersed" and the individual words—"money, power, visitor, memory"—that they selected for each cover, Jill Anholt and Susan Ockwell explore relationships and exchanges with individuals and within the city. •

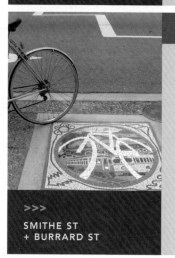

**SMITHE ST
+ BURRARD ST**

31 TRANSPORTED THROUGH TIME 2008

> Bruce Walther created this mosaic as a historical record of transportation methods in Vancouver. In the background are a First Nations boat, an electric interurban streetcar, buses, a seaplane, an ocean liner and #374—the engine of the first transcontinental train to reach Vancouver. Many of the "old" transportation systems are seeing a revival as the cost of gas makes driving a car a more expensive proposition. •

32 UNTITLED (BC HYDRO MOSAIC) 1957

> It is now a classy condominium, the Electra, but when it was constructed in 1955, this building housed British Columbia Electric (later BC Hydro). Its tapered shape, designed by architect Ned Pratt, was unique for its time. Vancouver artist B.C. Binning used tiles in hues of blue, green and black to create this design at the entranceway and approach to the building. The decorating scheme used in the renovated building picked up on this early work and repeated it in the interior. •

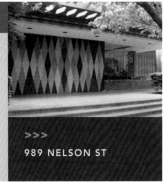

>>>
989 NELSON ST

33 WALL CENTRE 2001

> Phillips Farevaag Smallenberg state they are committed to developing "memorable public spaces and closing the gap between planning principles and built design." These goals are realized at the Sheraton One Wall Centre, where green space and granite surfaces meet in the summer and provide a glistening surface in the winter, and glass lotus-leaf-shaped rain shelters protect the pedestrian and lead the eye to the fountain and beyond. •

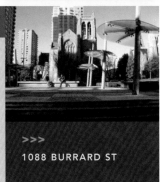

>>>
1088 BURRARD ST

34 CLOUDS 1991

> While not as high as the clouds that swirl around the local mountaintops, these steel outlines of clouds by artist Alan Chung Hung are at the top of a tall office building. Hung's use of strong, simple lines, space and place can be seen in each of his sculptures. Architect Bing Thom commissioned the sculpture, demonstrating his commitment to associating outstanding public art with the buildings he designs. •

>>>
983 HOWE ST

35 CLAIM TO FAME 2005

> The Orpheum opened in 1927 as a vaudeville theatre and later became a cinema. Since its restoration and reopening in 1977, it has been the home of the Vancouver Symphony Orchestra. This mosaic by Bruce Walther captures Red Robinson (Canada's first rock 'n' roll disc jockey), jazzman Louis Armstrong and actor Errol Flynn, all of whom performed live in Vancouver. •

>>>
601 SMITHE ST

36 TEN THOUSAND FAUCETS + DOORKNOBS 1998

> The population of Downtown Vancouver is approximately 80,000 people, all of whom open doors to offices, apartments, restaurants and businesses throughout the day. Unobtrusively located near columns are pieces of building hardware (including doorknobs) sealed into polyurethane and embedded into the sidewalk. American artist Joey Morgan states that the piece provides "a pathway... narrative detail and a cadence of collective memory beneath its form." •

>>>
933 SEYMOUR ST

37 HAIDA EAGLE AND FROG TOTEM POLE 2002

> This pole was designed by Bill Reid and carved in the late 1980s by others. According to an article in *BC Business*, it was put up for auction in 2002. The bidding didn't make the reserve price; it was withdrawn and sold later that year for $90,000 plus commission. When it was installed, it was encased in a large Plexiglas tube for protection from the weather and vandals. Its dominant feature is an eagle holding a frog, with a smaller eagle on the top. •

>>>
940 SEYMOUR ST

38 WATCH yOUR STEP 2002

> Knowing that the artists of these tiles were street youth creates new challenges for the observer. The large mosaics in South Park provide vivid images and the smaller tiles in the other projects deal with death, spirituality and cultural origins. The writers/artists appear more prepared to tackle social issues than many artists; consider the statement "52 and counting. If we valued all instead of judging—one missing woman would have been too many." Other mosaics in this series, coordinated by Leah Decter, are found north of the Roundhouse Community Centre, at the Gathering Place (609 Helmcken Street) and at David Lam Park. •

>>>
**DAVIE ST
+ RICHARDS ST**

39 MOVING PICTURES 2005

> The home of the Vancouver International Film Festival theatre and offices is the perfect site for this interactive art installation. Vertical viewfinders capture the real- and "reel"-time movements on the street and invert their images. Artist and architect Jill Anholt states, "*Moving Pictures* illustrates cinematic elements of changing perspective and the play of time, to create a greater understanding of film media." •

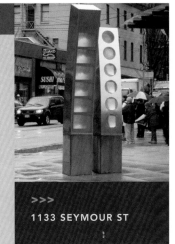

>>>
1133 SEYMOUR ST

40 UNTITLED (GRANVILLE BRIDGE MURALS) 2005

> Skateboarders and pitbulls are often placed in the same "not in my neighbourhood" category. The one artist depicted both dog and owner with somewhat worried expressions, rather than aggressive ones. The overall mural suggests questions about the use of public space in Vancouver. Along the on-ramp to Granville Street there are over a dozen additional murals depicting First Nations themes and hip-hop styles. The murals were created as part of the City of Vancouver's annual competition. •

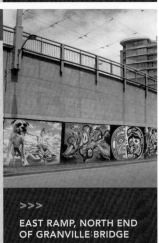

>>>
EAST RAMP, NORTH END
OF GRANVILLE BRIDGE

41 HIP HOP MURAL 2005

> This mural by 23 artists in Restart is a colourful outcome of Vancouver's Graffiti Management Program. The program allows for artistic and community expression on walls that already have graffiti. Mural art has been shown to be effective in enhancing communities and deterring graffiti known as "tagging." Within city guidelines (no direct advertising, no trademarks, no racial/religious/political acts, etc.), the program provides materials and facilitates community consultation. Property owners work with artists to develop the theme and payment terms. •

>>>
700 PACIFIC BLVD, UNDER
GRANVILLE BRIDGE

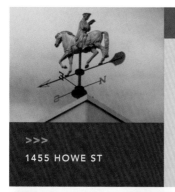

42 WEATHERVANE 2008

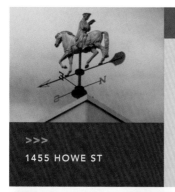
>>>
1455 HOWE ST

> Vancouver photo-conceptualist Rodney Graham uses video, photography, film and music to create his projects. The person seated backwards on the horse is Erasmus (1466–1536), a theologian and humanist who devoted his life to applying logic and reason in the pursuit of pure scholarship. Erasmus's face is a self-portrait of Graham and this piece shows Graham's subtle sense of humour as well as his interest in time, history and repetition. •

43 FIREWORKS OVER ENGLISH BAY 2008

>>>
BURRARD ST
+ PACIFIC ST

> For many, the HSBC Celebration of Light fireworks festival is a celebration of summer in Vancouver. In a setting voted three times by *Condé Nast Traveller* magazine as one of the "best cities in North America," four evenings of pyrotechnic shows by three competing countries provide spectacular entertainment. This mosaic by Bruce Walther shows English Bay with landmarks such as the Planetarium, Vanier Park and the Burrard Bridge. •

44 BURRARD BRIDGE 1932

>>>
BURRARD ST

> Captain Vancouver named Burrard Inlet after Sir Harry Burrard, who was never in this area but had been his lieutenant on an earlier voyage to the Caribbean. Look carefully (not while driving!) just below the busts on the Art Deco central structure and either a "B" for Burrard or a "V" for Vancouver on the boat prows can be seen. If you have time, you can count the lions— there are at least 64 on the bridge. The busts are by Charles Marega who also created the lions on the Lions Gate Bridge. •

45 UNTITLED (BLACK BALL) 1993

>>>
808 BEACH AVE

> The original idea that landscape architect Jerry Vegelatos had for this water feature was to force a stream of water up the slope of the hill to duplicate the struggle of salmon returning to their spawning grounds. This was a clever reference to the salmon streams that flowed into False Creek before it was industrialized. Modification of the design resulted in the black granite sphere and stones within the stream. •

46 GRANtable 1998

> Polish the wine glasses, find the fine linen and have an elegant dinner at this 20-m-long concrete table designed by artists and architects Bill Pechet and Stephanie Robb. This sculpture is at the base of wide stairs leading into Mae and Lorne Brown Park. The stairs provide a grand entrance into the "dining room" and the whole setting creates questions of indoor and outdoor spaces. The artists view the table as "urban architecture when occupied or sculpture when empty." •

>>>
BEACH AVE
+ HOWE ST

47 GRANVILLE ISLAND MURAL 2002

> In any season, Granville Island provides a delightful setting for wandering, shopping, romancing or enjoying the theatre. False Creek Yacht Club members and artist Greg Davies reproduced the view that could be seen if the bridge footings weren't in the way. The picture is alive with the aquatic activities that happen throughout the year and the sea life found under the water's surface. It's a colourful record of life in, on, under and around "The Creek." •

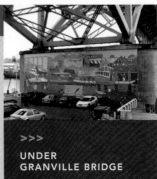

>>>
UNDER
GRANVILLE BRIDGE

48 UNTITLED (WAINBORN FOUNTAIN) 2004

> George Wainborn would have enjoyed this fountain at the top of the park named after him. He was Vancouver's longest-serving parks commissioner (33 years). His contributions to local traditions include the Carol Ships, the Stanley Park Christmas train and the group of lighted trees along Beach Avenue. The park was designed by PWL Partnership. The fountain and surrounding pools replicate, in miniature, many of the natural wilderness environments in British Columbia. •

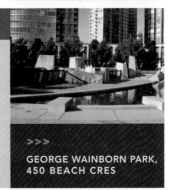

>>>
GEORGE WAINBORN PARK,
450 BEACH CRES

49 KHENKO 2006

> *Khenko* is a First Nations word for the great blue heron. The location of this installation by Vancouver artist Doug Taylor celebrates the rehabilitation of False Creek from its industrial past and the return of the fish and herons. The wings flap slowly, like a large whirly-gig, driven mechanically by the wind-catchers above. It was commissioned by Concord Pacific, developer of much of the inner-city waterfront and, by far, the most significant corporate donor to Vancouver's Public Art Program. •

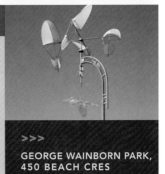

>>>
GEORGE WAINBORN PARK,
450 BEACH CRES

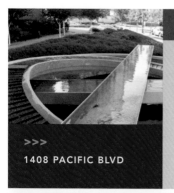

1408 PACIFIC BLVD

50 PACIFIC SPIRAL 2003

> Surrounded by water, Vancouver has also become a city with many fountains—water features and fountains are often provided to meet a developer's public art requirement. This fountain by Judith Schwarz uses crossover bridge troughs lined with slate that have water moving in different directions before, finally, falling over the edges and through a grate. •

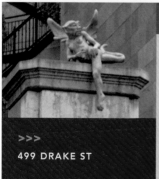

499 DRAKE ST

51 HELGA 2004

> This building's sculptural detailing is by Vancouver Island sculptor Derek Rowe. The gargoyle at the left of the entrance, called *Helga*, is cast concrete from an edition of 30. To the right is *Persuasive Pamela*. There are many other decorative elements, including the rose window in a 20-ft high patterned wall. Note the other details based on the goddesses of joy, beauty, charm, happiness and feasts. •

1300 BLOCK OF HOMER ST

52 COLLECTION 1994

> A curious mix of memories is captured by a series of time capsules and garbage containers. The three red wedges are topped by a list of the articles contained inside: for example, Volume 1 of Karl Marx's *Das Capital*, a child's compass, one 33 rpm record, one copy of *Bulgaria on Five Dollars a Day*, 37 cents in pennies, one Vancouver Canucks hockey ticket and assorted other items. This is artist Mark Lewis's expression of "the power of propaganda." •

1300 PACIFIC BLVD

53 FOOTNOTES 1994

> Gwen Boyle created a subtle piece that reflects the full breadth of Vancouver's history. A word-based installation, it has 57 black granite tiles set into the boulevard pavers. Depending on which way you walk, a different perception is gained. In one direction, you start in a natural place and arrive in an urban environment—and vice versa. Our history is told in a series of carefully selected words: "shoreline, tides wept, mussels, oolichan oil, blackbird, #374, stone shadows." •

54 PASSWORD 1994

> This kinetic art by Vancouver artist Alan Storey was commissioned by Concord Pacific when it developed the former Expo 86 lands. His works often have moving components—art that works. Built into retaining walls, three sets of rotating cylinders are driven by exhaust fans in the parkade below. The letters on the cylinders, as they spin randomly, will periodically form words. It usually doesn't take much of a wait to see your first words: for example, BEST POTS.•

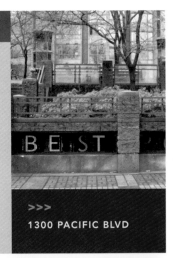

>>>
1300 PACIFIC BLVD

55 RED HORIZONTAL 2005

> The red enamel line embedded into the back of these concrete seats reveals pictures of the interior of many of the apartments, seniors' residences, lofts and condominiums in Yaletown. With small living spaces, the outside parks and walkways become part of the live, work and play areas in this high-density area of the city. In the 257 photographs, Gisele Amantea brings visions of the inside to our outside awareness. The artist stated she used the horizontal line to contrast with the tall buildings and the red colour to provide a visual richness to the concrete and steel environment. •

>>>
NORTH FALSE CREEK
SEAWALL, DAVID LAM PARK

56 MARKING HIGH TIDE/WAITING FOR LOW TIDE 1996

> At the tide line, a circle of granite stones complements a circle of concrete pillars that has this inscription: "The moon circles the earth and the ocean responds with the rhythm of the tides." The installation by Don Vaughn, a landscape architect and artist, helps the viewer visualize the tidal changes in False Creek and appreciate the natural beauty of the stones that were found on the site. •

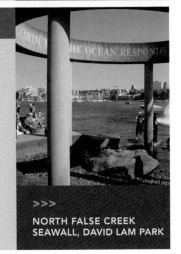

>>>
NORTH FALSE CREEK
SEAWALL, DAVID LAM PARK

181 ROUNDHOUSE MEWS

57 TERRA NOVA 1996

> This installation by artist Richard Prince is well sited close to the CPR's Engine #374, the engine that pulled the first transcontinental train across the country. The artist's intent was to "celebrate human curiosity and our quest for knowledge." On the brick wall is *Theatre of Discovery*—a bronze curtain held open by an arm, revealing a hoop. Above that, a pair of birds. The second piece is the *Cone of Analysis*—a sliced and truncated cone, the pointed piece sitting on a small wagon. •

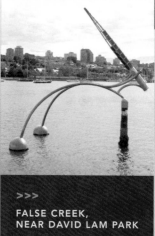

FALSE CREEK, NEAR DAVID LAM PARK

58 BRUSH WITH ILLUMINATION 1998

> This metal brush designed by Buster Simpson represents an ancient writing tool: the calligraphy brush. It is suspended over the "inkwell" of False Creek. Powered by solar panels, it is supposed to collect environmental information transmitted and translate it into ideograms—symbols that stand for the object itself. This sculpture depicts a link between ancient and modern means of communication and demonstrates the speed, scientific accuracy and extensive information available in our daily interactions. In describing why he likes to create public art, Simpson stated, "The challenge is to navigate along the edge between provocateur and pedestrian, art as gift and poetic utility." •

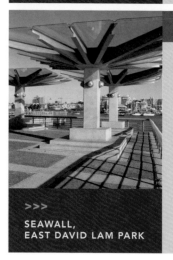

SEAWALL, EAST DAVID LAM PARK

59 GLASS UMBRELLAS 1995

> Don Vaughn, a landscape architect, designed these green glass and steel shelters. They shine at night like beacons or lighthouses and define the east side of David Lam Park (named after the first Chinese Lieutenant Governor in British Columbia). They also quite appropriately serve as rain shelters since Vancouver receives 1117 mm (44 inches), with 10 per cent of that falling during the summer months. With a nickname like the "Wet Coast," it's no wonder we love our umbrellas. •

60 WELCOME TO THE LAND OF LIGHT 1997

> The phrases on this curving railing are printed in English and Chinook, which was a trade language developed in the 19th century by First Nations. The phrases, which use present-day condominium-marketing sales talk, have words such as LIVE LIKE CHIEF, WORLD SAME LIKE IN YOUR HAND. Henry Tsang created the project early in the development of Yaletown, where now even small apartments cost over $250,000 but appeal to those who want to "live like chief." •

>>>
SEAWALL, BETWEEN
DAVIE ST + DRAKE ST

61 STREET LIGHT 1997

> This metal and concrete structure has silhouettes of archival pictures of early Vancouver and, at sidewalk level, concrete walls with the history of False Creek. Although some people have taken issue with the heavy girders, they are a reference to the industrial past context of the project. Shadows of the photos are supposed to be projected onto concrete rectangles on the street at the time of year when the events occured. The artwork was created by Ernie Miller and Alan Tregabov. •

>>>
DAVIE CIRCLE AT NORTH
FALSE CREEK SEAWALL

62 CANADA LINE BILLBOARDS 2008

> One of the realities of ephemeral art is that you may see it one day, and want another look, but by the time you get back, it is gone. The artwork on billboards created during the massive construction throughout the city that resulted in the airport-to-city Canada Line may have been a concession to calm annoyed drivers, however, it also (for a short time) added interest and colour and civility in the face of significant disruption. •

>>>
DAVIE ST
+ PACIFIC BLVD

63 PERENNIALS 1997

> The key part, the pool, forms a leaf with intersecting, strongly veined lines. Other elements are a curved, shattered-glass screen of leaf images and granite seats, each one with nature-related word such as "transplanted, wild, perennial, seasonal, uprooted or cultivated." The designer, Barbara Steinman of Montreal, has provided an opportunity for thinking about the interactions of humans and plants in wild and urban environments. •

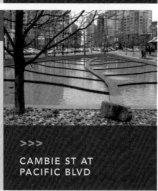

>>>
CAMBIE ST AT
PACIFIC BLVD

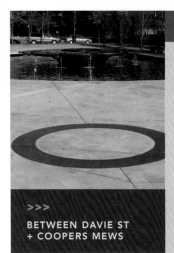

64 UNTITLED (LOTUS FOUNTAIN) N.D.

> One nickname for BC is "Lotusland," and this fountain designed by Al McWilliams has the appearance of an open lotus blossom. In Indian myths, the beautiful water blossom with overlapping symmetrical leaves is said to symbolize divinity, fertility, wealth, knowledge and enlightenment. The Asian lotus is seen as a symbol of purity and loveliness, and is placed here to note the contribution of Chinese immigrants to False Creek's original industries. •

>>>

BETWEEN DAVIE ST + COOPERS MEWS

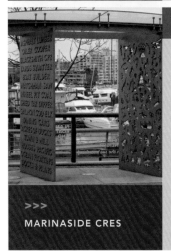

65 LOOKOUT 1999

> Noel Best and Chris Dikeakos created two separate glass, steel and concrete structures, with intriguing images and evocative words by poet Robin Blaser etched upon the adjacent glass barrier. These structures describe the industries, tools, animals, fish and activities common during the pre-European and early settlement years of False Creek. In the middle installation, look for five cast-bronze chairs that have a plywood grain—a subtle reminder of the place lumbering played in the economy of early Vancouver. •

>>>

MARINASIDE CRES

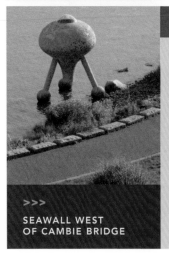

66 TIME TOP 2006

> Artist Jerry Pethick enjoyed the comic *Time Top* when he was young and used its last episode, when the titular vehicle was approaching Earth, as a basis for this work. He stated that the silicon-bronze sculpture "is a relic of reality, building on the idea of an alternate reality which we each share with a broad diversity." *Time Top* was his first public art commission and Margaret Pethick, Jerry's wife, completed the sculpture to his specifications following his death. This included immersing the structure in water with a charge from an electric current to hasten the crusted appearance. •

>>>

SEAWALL WEST OF CAMBIE BRIDGE

67 COOPERS MEWS 2002

> False Creek was once surrounded by primary industry: fisheries, sawmills and, in particular, the Sweeney Cooperage, which claimed to be the largest barrel maker in the British Commonwealth until 1981. This history is represented in overhead and on-ground tracks between two housing developments near Coopers Green Park. The highlight is the interactive art installation by Alan Storey, which has five overhead barrels and a sidewalk keyboard. Stepping on different boards causes the barrels to produce different musical notes as steam is emitted. •

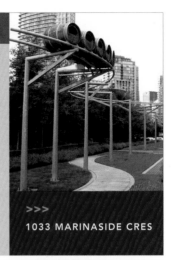

>>>
1033 MARINASIDE CRES

68 RING GEAR 1987

> This 20-ft round gear was originally installed horizontally in 1911 as a working component of the Connaught Bridge so it could be opened for ships to reach industry farther east on False Creek. When the current Cambie Street Bridge was built, this relic was set vertically in the Pacific Boulevard median to commemorate the designers and the bridges that have served False Creek. It provides a geometric and colourful counterpoint to the condominium towers now dominating the area. •

>>>
**PACIFIC BLVD NEAR
CAMBIE ST BRIDGE**

69 UNTITLED (TREE FORM) 1995

> This bronze sculpture is located in the courtyard between the two phases of the Pacific Place Landmark development. Sitting at the edge of an ornamental pool, its tortured trunk is evocative of a windswept tree—perhaps one painted by the Group of Seven. Its flowing lines are in contrast to the rectangular architecture that surrounds it. •

>>>
930 CAMBIE ST

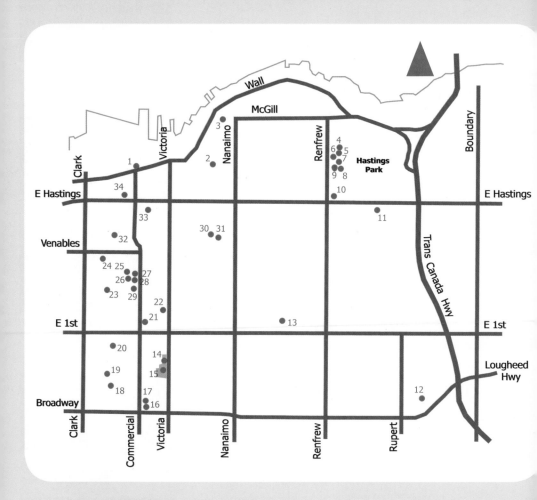

east vancouver

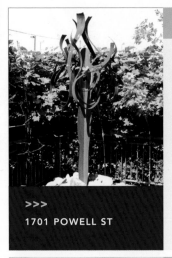

>>>
GARDEN DR AT OXFORD, CAMBRIDGE, ETON STREETS

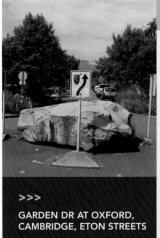

>>>
2305 McGILL ST

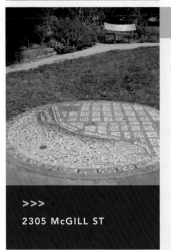

>>>
1701 POWELL ST

1 UNITY 2007

> ARC is a renovated East Vancouver warehouse with 80 live/work artist studios. A rental building, it requires that prospective tenants submit a portfolio to ensure that the units are reserved for practising artists and that its wood, metal, photo, pottery, dance and music studios are well used. One of its artists, Ukraine-born Elia Mishkis, sculpted this piece, which sits on the patio by the café. This rusting steel structure, with a heart and lungs of red stained glass, gives different effects under varying light conditions. •

2 TRAFFIC CIRCLES 1997

> At three locations along Garden Drive, neighbourhood-friendly traffic calming has been turned into public art. American artist Shauna Gillies Smith brought the underworld to the surface by placing large boulders as traffic circles at intersections with three residential streets. The surprise element of their location and size gives pause—and time for reflection and questions about what these rocks mean in our urban landscape. The moveable directional signs become part of the metaphor and the art. •

3 McGILL PARK MOSAICS 1997

> Wendy Oberlander and Sarah White worked with the community to create a series of mosaics, some integrated into the pathway, others larger, offset, independent circular images. The highlight is a large yin-yang symbol contrasting the urban grid with the ocean—the eyes are McGill Park and a marker in the ocean. The symbols in the mosaics reveal the character of the community; they include a peace sign, a rainbow flag, garden flowers and a ghostly figure silhouetted against a brilliant sky. •

4 RAIN 2000

> The Children's Piazza was designed by Phillips Farevaag Smallenberg to be universally accessible. On one wall is the poem "Rain" by Hone Tuwhare. He is of Scottish and Maori descent and considered to be New Zealand's first major poet. This poem was chosen in 2007 as New Zealanders' best-loved poem and, given our climate, should resonate with Vancouverites. Addressing many senses through its words, the poem, written in English, is flanked by metal "buttons" that reproduce it in Braille. •

>>>
IL GIARDINO ITALIANO AT HASTINGS PARK

5 COW 2000

> A large granite cow lying on a grassy knoll invites climbing and relaxation; it just makes one feel a whole lot better about the world. How does it fit into the context of the Italian Garden? It pays homage to the agricultural heritage of the Pacific National Exhibition. The circular enclosing bench replicates the circumference of a grain silo. The cow, sculpted in China, is a Chianina—crossbred in about 1500 BC from animals of Asian and African origin. •

>>>
IL GIARDINO ITALIANO AT HASTINGS PARK

6 THE DREAMER, CHRISTOPHER COLUMBUS
ORIGINAL 1870

> In the 1990s when a "green" restoration plan was adopted for Hastings Park, one hugely successful new component was the Italian Garden. A key feature is the statue of Christopher Columbus as a boy "dreamer." While other Europeans—notably the Vikings—had been to North America first, Columbus's voyages raised new awareness of the land across the ocean. Originally created by Giulio Monteverde in 1870, this copy was cast in Italy. This statue was a gift from the city of Columbus' birthplace, Genoa. •

>>>
IL GIARDINO ITALIANO AT HASTINGS PARK

7 NONNA'S FOUNTAIN 2000

> *Nonna* means grandmother in Italian, an obvious reference for this fountain donated by the Aquilini family, long-time Vancouver builders and current owners of the Vancouver Canucks. This is another project with great faces by Ken Clarke: four are weather gods (Pluvius, Tempeste, Vancouvus and Zeus) and various river gods and other faces spout water. This fountain, along with the adjoining piazza and canal, attracts kids like moths to candlelight. Slightly to the south of the park is Cloacina, Goddess of Sewers. •

>>>

IL GIARDINO ITALIANO AT HASTINGS PARK

8 OPERA WALK 2000

> Along the south edge of the Italian Garden is the Opera Walk. It is defined by a series of two sets of four concrete walls (the walls mimic the footprint of the original buildings on the site), the interior corners occupied by famous figures from Italian operas in the distinctive style of Vancouver's Ken Clarke. They include figures from the Italian (obviously!) operas *Falstaff*, *A Masked Ball*, *Turandot*, *The Barber of Seville*, *Rigoletto* and *Pagliacci*. While it's a great park in which to relax, the details add the extra dimension that makes it a very engaging space. These figures will amuse! •

>>>

IL GIARDINO ITALIANO AT HASTINGS PARK

9 MONUMENT HONOURING IMMIGRANTS 2000–2001

> Vancouver has a large and vibrant Italian community since many Italian immigrants settled in East Vancouver after WW II—and they contributed financially to the development of this park. Sculpted by Sergio Comacchio of Treviso, Italy, this free-standing statue represents the immigrant arrivals and has four reliefs illustrating some of the industries through which Italians contributed to the development of BC: lumbering, mining, railroads and fishing. •

>>>

IL GIARDINO ITALIANO AT HASTINGS PARK

10 THE MIRACLE MILE 1967

> Sir Roger Gilbert Bannister was the first runner to break the four-minute mile—possibly sport's most famous barrier. Australian John Landy soon beat his time and they met for the "Miracle Mile" in Vancouver at the British Empire Games in 1954. Sculptor Jack Harman caught Landy's tactical error of looking over his left shoulder. It's reported Landy later said, "While Lot's wife was turned into a pillar of salt for looking back, I am probably the only one ever turned into bronze for looking back." •

>>>
3100 EAST HASTINGS ST

11 COLOUR 2001

> When a functional requirement is enhanced by art, two needs of a community are integrated. Artist Nicole May was the design consultant for the Hastings Community water-park area. She engaged over 700 children to create mosaic designs on the retaining wall that snakes along the base of the slope around the play and water area. Rainbow-coloured mosaics are interspersed with brass water-spray heads. There is also a drinking fountain nearby with the same ceramic treatment. •

>>>
3096 EAST HASTINGS ST

12 PATTERNING: A TIME PROJECT 2001

> The residents of the Renfrew–Collingwood area worked with artist Cyndy Chwelos to create ceramic tiles with a majolica glaze that were placed on the foyer walls of the Thunderbird Community Centre. Symmetry and patterns were used within the designs. Chwelos has also worked with the ArtStarts program, which "provides innovative arts programs for young people, practical resources for teachers and artists, and leadership in advocacy for arts in education." •

>>>
2311 CASSIAR ST

13 LEAF PAVILION 1997

> Integrated architectural features are becoming more common as cities try to include art in the lives of their citizens. This kiosk, designed by Stephanie Robb, serves as both a notice board and as recognition for businesses and community members who contributed to the rejuvenation of the park area. It is topped by two leaf-shaped pieces of Corten steel. Small metal leaves embedded in the leaf-shaped concrete base recognize specific sponsors. •

>>>
2690 GRANT ST

14 LINKED BY THE GAMES WE'VE PLAYED 1998

> Jump rope, hockey, cribbage—pictures of the games children play are shown on ceramic tiles on the south side of the Queen Victoria Annex School. Games that are unfamiliar, such as "concors", represent the playfulness shared by the multicultural students. Artist Blake Williams linked the homes of the students to their school lives by having the student artists create matching tiles that are set into sidewalks, on the sides of houses and attached to fences within the neighbourhood. •

>>>
1850 EAST 3RD AVE

15 COMMUNITY GARDEN MURAL N.D.

> In a community garden not only are fruit and vegetables grown, but there are also unassigned common areas and educational programs that involve children and youth in gardening. Participating in these gardens produces fresh organic vegetables and also friendships, a sense of community and the psychological well-being that develops when gardening. Also in this area the silhouette are forms of children clinging to the fence alongside the tennis courts and schoolyard. •

>>>
2125 VICTORIA DR

16 MOSAICS (BROADWAY STATION) 2005

> In this SkyTrain station there are two oval-shaped mosaics by Liz Calvin. The first is all about how people move. There are tire tracks (mountain bikes, ten-speeds) and there are prints from shoes and boots. It's interesting to try to figure out, from the footprints, who was with whom. Where were they going? The second mosaic is in the "fare paid zone"—you need a ticket! It's a mosaic of a murder of crows (that's the collective noun for crows) and leaves. •

>>>
BROADWAY + COMMERCIAL SKYTRAIN STATION

17 subTEXT: COMMUNITY SIGNATURE PROJECT 1996

> There is the text (the names of people living in this area) and then there is the subtext that artist Susan Shuppli captured by placing tiles on the east pedestrian sidewalk across the Grandview Cut. Some tiles have signatures, others have images or statements like "Claire loves Marie." Bridges provide many metaphors on their own but Shuppli also observed that a monument "identifies and reclaims each individual for a larger collective history." •

>>>
COMMERCIAL DR AT EAST 8TH AVE

18 BIRD FEEDERS 1996

> Galvanized metal bird feeders, designed by Rick Gibson, that sit along the railing of a city bridge may not seem like public art but they are in this situation. Within the scope of environmental art, the feeders function to increase the wildlife observed in the city, and contribute to its overall greening as birds drop seeds into the Grandview Cut. For both the residents who maintain the feeders and others, increased awareness of our inter-relatedness with the natural world occurs. •

>>>
WOODLAND DR BRIDGE

19 RIVER OF LIFE 2001

> This river's source is on the side of Grandview School, where it is filled with all sorts of aquatic and sea life overlooked by forest creatures. It then flows across the playground to a representation of a First Nations long-house. Many of the children who attend the school have a First Nations background. Richard Tetrault, who led this project with the students, is a Vancouver artist who has gained world recognition for his large murals, prints and paintings. •

>>>
2055 WOODLAND DR

20 MOSAIC BIKEWAY 2000

> The Mosaic Bikeway provides a view of mosaics by Kirsty and Phillip Robbins and community residents that have been placed in the traffic-calming circles along Woodland Drive from Napier Street to East 14th Avenue. The mosaics are primarily geometric in design. The street gardens in the circles are cared for by local residents participating in the City of Vancouver's Green Streets Program, which is intended to encourage not only colourful and interesting streets, but also a sense of neighbourhood pride and ownership. •

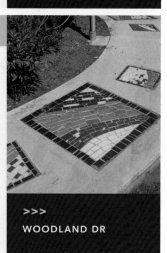

>>>
WOODLAND DR

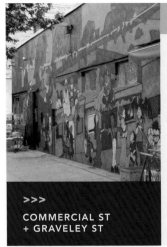

21 UNTITLED (RED CROWS) 2008

> There are so many crows in East Vancouver that the logo for the yearly November Eastside Culture Crawl is most often a crow. The Commercial Drive Business Society sponsored this vibrant mural by Jordon Bent and Jay Senetchko. Crows loom large over the Commercial Drive scene: they sit on tables and stare at crying clowns. By portraying various people, the culture of Commercial Drive is shown—the philosopher from the Philosophers' Café, the Latin dancers, restaurant patrons, a homeless person, youth. So why are the crows red? The artists said they were running out of black but had lots of red left. •

>>>

COMMERCIAL ST + GRAVELEY ST

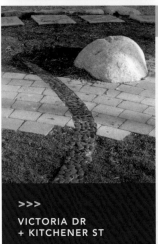

22 ANIMAL PATHWAY 1996

> Sea creature tiles were saved from destruction and used in the play area during a 2008 park renovation. Along the central pathway are three large rocks inset with pictures of the neighbourhood from earlier days, 1917 and 1966, and an explanation of why it is often called Little Italy. Buy a gelato from a Commercial Drive shop and return to enjoy the ambiance, particularly to watch the men play bocce! Get into the neighbourhood mood! •

>>>

VICTORIA DR + KITCHENER ST

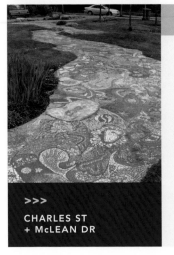

23 MOSAIC CREEK PARK MOSAICS 1996

> One of the most extensive displays of mosaics in the city can be found in this peaceful space. Over 500 people worked with artists Glen Andersen and Kristine Germann to design the mosaic stream that represents their wish for a stream running through the park. There is a diversity of images, as well as some eastside political sentiment. Look also for the pebble mosaic path near the herb garden, created by community members working with Glen Andersen and Marina Szijarto, and the climbing area designed in basalt by artist Sarah White. •

>>>

CHARLES ST + McLEAN DR

24 VANCOUVER SKYLINE 2004

> The laneway side of a small industrial warehouse features a mural painted with both spray paint and brushes—a challenging job, given that it's on corrugated siding. Pictured is the skyline at night, from the North Shore and Lions Gate Bridge through Downtown and past BC Place to Vancouver City Hall. It's a fabricated skyline—all the buildings are reflected in the water of Burrard Inlet regardless of their actual geographic location. The artist is Kris Friesen, a graduate of Capilano College. •

>>>
1500 VENABLES ST

25 WELCOME TO BRITANNIA N.D.

> The Britannia Community Centre, surrounding walls and hockey rink are a treasure trove of murals and art. Inside the arena is a larger-than-life mural of hockey players and figure skaters. See also *Clay Creations* by Moyra Stewart (1999) at the library door; the painted pole with First Nations figures at the elementary school; a soccer-field-length mural on the wall at the running track by Carole Davenport and Helen Spaxman (1995); as well as *The Drive*, a citizen-painted mural opposite the swimming pool. •

>>>
1661 NAPIER ST

26 MOVING PILLARS 1994

> Perhaps the Britannia Board of Management was honouring the Italian influence along The Drive with this art installation by Paul Calder. The pillars can be unbolted and moved around on the main platform, or moved to other bases in the area, creating interesting relationships depending on their positions. Still an area for new immigrants, the neighbourhood has seen a massive change in demographics in the last 20 years as westsiders drift east chasing character and affordable housing. •

>>>
1661 NAPIER ST

27 LUNA THE MOON 2001

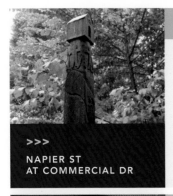

>>>
**NAPIER ST
AT COMMERCIAL DR**

> The walkway at Napier Street connecting The Drive to the Britannia Community Centre provides a shady haven. Observation will reveal 13 weathered posts that appear to have grown there. Detailed examination will reveal forms that artist-in-residence Pat Beaton encouraged workshop participants to carve as individual expressions of aspects or interests of their own lives, or the life of the Britannia community. Images are diverse: snakes, flowers, houses, stars and snails. •

28 DAYS OF SUN 1999

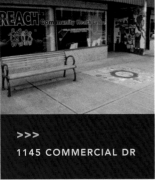

>>>
1145 COMMERCIAL DR

> It is difficult to miss the bright yellow mosaic sun outside the doors of the REACH Health Centre but, by continuing farther north, two more community welcome mats are also visible. As part of the Our Own Backyard Mapping Project, artist Anne Marie Slater worked with community members to develop the motifs. The Parks Board Neighbourhood Matching Fund matches up to $10,000 for projects that involve community members, develop community and build connections. •

29 CENOTAPH 1928, 1959

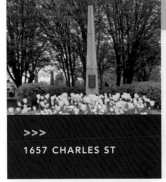

>>>
1657 CHARLES ST

> The first plaque on the original cairn was in memory of Grandview neighbourhood residents who lost their lives in WW I. By the time the present cenotaph was erected, another war had taken more lives and a second plaque is in memory of those "fallen comrades." The cenotaph was first dedicated in 1928, on November 11th, a day of remembrance for many throughout the world as the end of WW I (supposedly the "war to end all wars"). •

30 TRANS CANADA TRAIL MARKER 1998

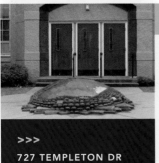

>>>
727 TEMPLETON DR

> At the entrance to Templeton Secondary School is a marker for the Trans Canada Trail. Proposed as a 21,500-km recreational hiking, cycling and paddling route (the world's longest, now about 70 per cent constructed) it passes through every Canadian province and territory. South on the sidewalk is *Trail Mix* (1998) by Templeton students who used mosaics to show the provincial birds of Canada. The British Columbia provincial bird—the Steller's jay—is one that loves trail mix! •

31 CELEBRATION FRIEZE 1998

> A ribbon of 308 tiles, created by members of the Hastings–Templeton community, wraps around the Templeton swimming pool. The tiles are grouped into sections by their dominant colour, separated by larger black and white tiles. Cyndy Chwelos was part of the Artist in Residence Program funded by the Parks Board, which helps artists to develop a relationship with the people in a community and work with them to complete an art project. •

>>>
700 TEMPLETON DR

32 WOODLANDS TREE 2000

> While some might think it is a modern totem pole, this sculpture was carved by over one hundred visitors to and residents of the neighbourhood with the guidance of Eric Neighbour. Non-traditional in design, it spans time and cultures. Seed pods appear ready to open and the style of carving matches the First Nations theme within the park. See also the Eagle Bear totem pole (2001) by Mike Dengali located beside a circle garden with over 20 species of native plants. •

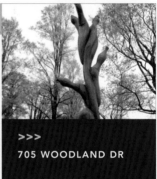

>>>
705 WOODLAND DR

33 TOTEM POLE 1990

> Each of 13 developments built by the Vancouver Native Housing Project has its own pole, carved by various Native artists, standing as a sentinel. Roy James Hanuse, from the Kwakwaka'wakw Nation, carved four of these poles. The industrious beaver is this pole's main crest animal: his large flat tail, with its cross-hatched design, is drawn up against the front of his body. At the top are the Three Watchmen, in their traditional protective role of watching over the houses and their residents. •

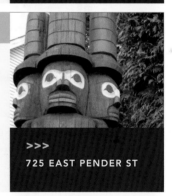

>>>
725 EAST PENDER ST

34 TOTEM POLES N.D.

> The totem poles carved by Henry Robertson of the Kitlope Nation that stand on either side of the front doors of the Vancouver Aboriginal Friendship Centre provide both a cultural reaffirmation and a landmark. Over 40,000 First Nations people live in the area from 41st Avenue to the waterfront. The centre provides career, employment and transformative justice programs and other iniatives to help aboriginal people to make a transition into the urban environment. •

>>>
1607 EAST HASTINGS ST

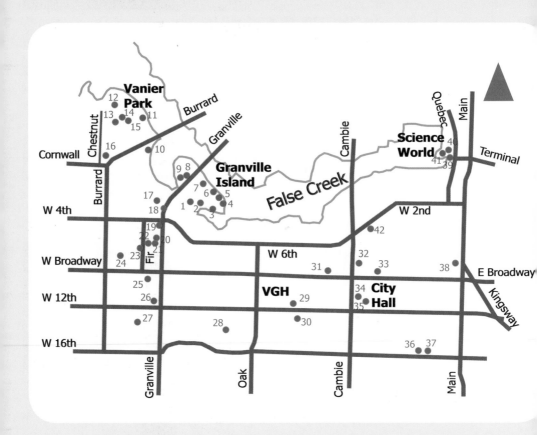

false creek south

1 FALSE CREEK TOTEM 1999

**SUTCLIFFE PARK,
GRANVILLE ISLAND**

> A kayak is not a traditional West Coast First Nations method of transportation, but it does represent a recreational water sport currently enjoyed by many False Creek residents. More than 800 volunteers helped artist Eric Neighbour to carve this totem pole and he believes their discussion, assistance and questions brought clarity to the project as it evolved. A time capsule, to be opened in 2099, is in the pole's base. •

2 COLOURS OF THE CREEK AND BENCH 2006

**FALSE CREEK
COMMUNITY CENTRE**

> Using glass tiles and the help of False Creek community members, artists Corinna Hanson and Lindsey Delaronde created a series of 10 mandalas at the entrance to the community centre. In Sanskrit, *mandala* means "having and containing." In common use, it is a symbol of the universe. Its circle is used by many cultures to represent wholeness. There is also a bright curving bench created as part of the project overlooking Alder Bay south of the centre. •

3 UNTITLED (METAL FORMS) *c.* 1980s

**SW BOARDWALK,
GRANVILLE ISLAND**

> Similar in scale to Henry Moore's sculpture in Queen Elizabeth Park, these two forms look as though they could be relics from Granville Island's industrial past. Indeed, given that Granville Island was called "Industrial Island" when it housed industries from lumber mills to chain-link manufacturers, this might be the reference that the sculptor intended. It is reported that he donated the sculptures to the Island, but he also left the mystery of both his name and the name of the sculpture. •

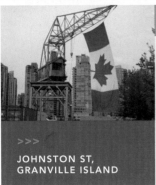

4 UNTITLED (CRANE) N.D.

**JOHNSTON ST,
GRANVILLE ISLAND**

> In 1915, the Vancouver Harbour Commission created Granville Island using soil dredged from False Creek. A diversity of industrial development here went through periods of prosperity and, finally, serious decline. In the 1970s, the Canada Mortgage and Housing Corporation, the landlord, led the transformation of the Island into the destination it is today. Ocean Cement is the only original business left on the Island, but this relic, evokes its industrial heritage. •

5 MEMORIAL TO BARBARA DALRYMPLE AND JOHN ROCKINGHAM 2000

> A memorial garden is an alternative to a more formal statue or bust for recognizing a valued person. Barbara Dalrymple was an architect and dedicated volunteer in Vancouver and John Rockingham was her engineer husband. Dalrymple redesigned an old 1920s machine shop on Granville Island to create the versatile Performance Works theatre space. In recognition of the couple, many Island business owners contributed to the engraved glass plaque and restful garden created by Joel Berman Glass Studios and Sharp and Diamond Landscape Architects. •

>>>
NORTH SEAWALL,
GRANVILLE ISLAND

6 OCEAN COMMOTION 2007

> Ocean Cement has been selling construction materials on the Island since 1917, co-existing as the area evolved into a popular tourist destination. Using three colours of balls to represent water, cement and aggregate, this kinetic artwork interprets how concrete is made in the adjacent plant. Artists David Vandermeer and Cheryl Hamilton have a studio on Granville Island. They also created the *Memorial to Ron Basford* (2005) found at "The Mound." Basford is fondly known as "Mr. Granville Island" for his vision and perseverance that ensured the transformation of the Island. Thanks again, Ron! •

>>>
JOHNSTON ST,
GRANVILLE ISLAND

7 HOUSE POSTS 2000

> The Coast Salish house posts at the front of this carving shed were created by Xwa-Lack-Tun (Rick Harry) and five First Nations student apprentices from Emily Carr University. The salmon represent an important part of the cultural history of the Coast Salish people. Throughout the year, various First Nations carvers can be observed as they work on totem poles or posts that reflect the style of their heritage. The carvers are usually willing to answer questions about the process or meaning of their work. •

>>>
JOHNSTON ST,
GRANVILLE ISLAND

>>>
1502 DURANLEAU ST,
GRANVILLE ISLAND

8 HERRING BALL 1999

> The shapes of hundreds of herring were cut from stainless steel, bolted together and hung from a central cable by sculptor Sherrard Grauer to depict a "herring ball." This phenomenon is sometimes seen when herring are attacked by predators: they group together and rush to the surface to avoid becoming dinner. Herring balls as big as 1.7 km long and 18 to 30 m deep have been seen off the north end of Vancouver Island. •

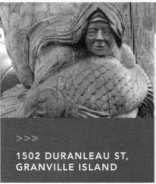

>>>
1502 DURANLEAU ST,
GRANVILLE ISLAND

9 MERMAID AND FISHERMAN 1984–85

> A fisherman dressed for a storm, intent on steering his course, seems unaware of the seduction of the nearby frolicking mermaid. Mermaids are said to have abilities to sing and distract even the most reluctant of sailors—often causing a shipwreck or taking them to their death in the watery depths. The wooden forms were carved by George Pratt, who usually works in stone, and who also started the popular Aquabus fleet in False Creek. •

>>>
SEAWALL, EAST OF
COAST GUARD STATION

10 WELCOMING FIGURE 2007

> When this welcoming figure was dedicated in 2007 it was the first in 110 years to be placed on land where the Squamish First Nation village of Snuaq used to exist. After the village burned down in 1913, villagers moved. Legal challenges returned the land to the Squamish Nation in 2002. First Nations artist Darren Yelton carved the figure from a 500-year-old red cedar from the Elaho Valley. It is the "grandfather" to the "grandmother" found at Ambleside Park in West Vancouver. •

>>>
VANIER PARK

11 SCANDINAVIAN STONE 1986

> To find this replica of a rune memorial stone, go to the flagpole west of the Coast Guard station. The stone was brought from Sweden and carved on-site to commemorate the arrival of the Vikings in Canada over 1,000 years ago. Runes are an ancient Germanic alphabet once used throughout northern Europe and Scandinavia. It had no horizontal elements, apparently because those strokes were hard to make against the grain of wood. •

12 GATE TO THE NORTHWEST PASSAGE 1980

> In 1979, Parks Canada sponsored a competition for a permanent sculpture to commemorate Captain George Vancouver's arrival in Burrard Inlet. Artist Alan Chung Hung's 5 m open, Corten steel square (cut and slightly twisted—like a paperclip) frames both mountain and city views. His initial training as a civil engineer may have influenced his design as well as the shapes of two navigational instruments that Captain Vancouver would have used—a plane table and quadrant. •

>>>
1100 CHESTNUT ST

13 THE CRAB 1968

> George Norris created this 6.7 m-high stainless steel crab. A native legend that a crab guards the entranceway to the harbour may have inspired his choice—one that fits well with the design of the building, which has a conical Haida hat as its roof. A time capsule, to be opened in 2067, is under the plaque in front of the crab. The crab is also the fourth sign of the zodiac, with positive characteristics reputed to be loyalty, tenaciousness, protectiveness and sensitivity. •

>>>
1100 CHESTNUT ST

14 DISCUS THROWER 1969

> This bronze statue of an athlete is similar to a famous discus thrower statue originally cast and completed about 430 BC by Myron, an Athenian sculptor who specialized in sculptures of athletes. Throwing a discus is one of 10 sports in the decathlon. The athlete is to throw the 2-kg disc as far as possible. The statue was donated by a community chapter of an international Greek-American advocacy organization "on behalf of all Hellenes" in honour of Canada's centenary. •

>>>
1100 CHESTNUT ST

15 MAJOR JAMES SKITT MATTHEWS 1986

> If any Vancouverite deserves the title of keeper of local history, Major James Skitt Matthews (1878–1970) would be the choice. For 37 years, he ensured that the visual and written records of Vancouver's past were collected, recorded and filed. Without his dedicated efforts, much of the information that today's visual artists, authors and historians use would have been lost. From the lobby, this bronze bust of Major Matthews by sculptor Elek Imredy surveys the Vancouver City Archives.•

>>>
1150 CHESTNUT ST

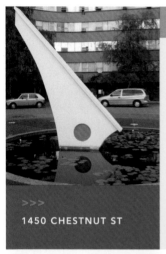

1450 CHESTNUT ST

16 SUNDIAL 1956

> Vancouver has a yearly average precipitation (rainfall and melted snow) of 1,200 mm with 5.2 hours of daily sunshine; compare this with, say, Perth Australia with 850 mm of yearly rain and 8 hours of daily sunshine. This large concrete sundial at the front of the "Y"-shaped apartment building leaves no doubt whether the sun is out or what the time is. The building caused outrage when it was built in 1956 in the quiet upscale neighbourhood after height restrictions were lifted. •

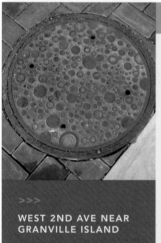

WEST 2ND AVE NEAR GRANVILLE ISLAND

17 MANHOLE COVERS 2004

> Sanitary sewage? Stormwater runoff? In 2004, the City of Vancouver launched the Art Underfoot competition to create a design for metal manhole covers. More than 640 entries were received. Jen Weih proposed a design of enlarged bacteria (or raindrops and bubbles) on the sanitary-sewer manhole covers. The second winning design, by Coast Salish artists Susan Point and Kelly Cannell, suggested stylized eggs and tadpoles emerging into frogs for the waste-water covers. If the topic of manhole covers intrigues, a world conference was held in Moscow in 2003; members brought over 3,000 images of manhole covers from 71 countries. •

WEST 4TH AVE + ANDERSON ST

18 AND THE RAVEN BROUGHT THE LIGHT 2008

> One of the more spectacular First Nations-themed murals to be seen in the city is this large stylized raven. It has the traditional red, white and black and uses many northern forms such as formline drawing, ovoid shapes, "U" and split-"U" shapes. The City of Vancouver's Graffiti Management Program sponsored this mural and the two other murals under the bridge. The mural was painted by Larissa Healy, Bill St-Jean, Corey Hunter and Amie Milot. •

19 UNTITLED (100) 1986

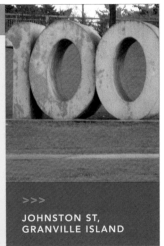

> Archaeological evidence shows that coastal First Nations people settled in the Vancouver area sometime after the glaciers retreated, about 10,000 years ago. The first European ships, from Spain and England, didn't arrive in English Bay until the 1790s. It was another 80 years until the small saw-mill settlement of Granville was started. The town received its charter on April 6, 1886, and was renamed after Captain Vancouver. These precast concrete numerals were donated to the City of Vancouver by Stonecoat Industries Ltd. on the city's 100th anniversary. •

>>>
JOHNSTON ST, GRANVILLE ISLAND

20 EMILY CARR AND FRIENDS 1985

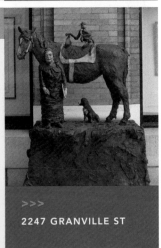

> Emily Carr focused on images of the West Coast and First Nations long before they were popular in the art world. Outside the Heffel Gallery, a glimpse of Carr's personal life is revealed in this bronze sculpture by Joe Fafard: during her 40s she was so discouraged with the lack of support for her painting that she became a dog breeder and also ran a boarding house. Her gravestone in Victoria gives perhaps the most lasting tribute: "Emily Carr, 1871–1945, author and artist/lover of nature." •

>>>
2247 GRANVILLE ST

21 UNTITLED 2003 STRUTS GAZE 2004 IRON LOVE 2004

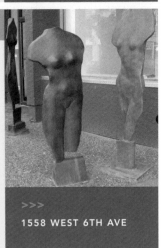

> Many of Edmonton sculptor Alan Reynolds' installations explore the human form, as do these three on the sidewalk in front of the Douglas Udell Gallery. He produces intriguing shapes that engage the viewer with their use of space, surface and meaning. Currently, he frequently uses welded steel as a medium having previously created large structures with laminated wood. Reynolds has also spent time mentoring young artists, ensuring that communities will continue to have contemporary art that provides enjoyment and poses questions. •

>>>
1558 WEST 6TH AVE

>>>

1590 WEST 7TH AVE

22 ANCESTOR SERIES 2002–2008

> Sculptor Michael Dennis uses the remains of trees—some hundreds of years old—salvaged from the rainforests of the BC coast to create large, abstract figures. He says that he "tries to sculpt the shadows" of the lives of the ancestors—those who went before us, as far back as the cave people. Through the combination of his careful selection of the trees and equally thoughtful carving, he is able to show both human gestures and stance while maintaining the spirit of the ancient trees. The Diane Farris Gallery hosts these figures in its courtyard. •

>>>

**FIR ST AT
WEST 6TH AVE**

23 ART GALLERY MURAL 2008

> In this mural of an art gallery, two artistic styles are contrasted. One is a Lawren Harris-type mountain scene from Western Canada. Harris evolved into an incredible and distinctive landscape painter focusing on mountain scenery in the 1920s, and later turning his brush to abstraction based in Theosophy. The second, close to a mountain bike rider coming through a door marked "Bienvenue" (a reference to the nearby French language school and restaurant), is a spray-painted wall, providing an interesting juxtaposition with the traditional Canadian landscape. •

>>>

2300 PINE ST

24 UNTITLED (POSTAL STATION D) 1967

> George Norris was a teacher in a number of BC's schools and colleges of art, a man of many trades and an artist who worked in stone, metal and wood. His 95-ft-long concrete abstract frieze probably wasn't called "integrated art" at the time it was created. However, in recent years, art on the facade of buildings, in the sidewalks or that which serves a dual purpose (such as seating and art) is gaining favour as green space for stand-alone art becomes more scarce. •

25 SCHOOL CHILDREN 1998

> Six families affiliated with the Access Foundation donated this series of life-sized bronze sculptures of joyful, active, exuberant and studious children. Holly Young had a well-established career in chemistry as a consultant to various industries and restoration projects when she turned to sculpting people. She states, "I am impressed with the open mindedness and wonder with which children view the world and often try to capture those qualities in my work." •

>>>
FIR ST +
WEST 10TH AVE

26 NATURE'S OWN GEOMETRY 1965

> The husband-and-wife team of Lionel and Patricia Thomas created both the abstract copper design and the entrance doors to this building. Lionel Thomas taught in both the School of Architecture and the Fine Arts Department of the University of British Columbia, while Patricia Thomas was a leader in architectural colour consulting. Both artists made contributions to the Modernist movement in contemporary art with installations that result in visual interest for the casual passerby as well as opportunities for a more complex engagement. •

>>>
2695 GRANVILLE ST

27 WIND BLOWN MOUNDS 1975

> It is difficult to see these drifting yellow fibreglass forms from the street since shrubbery has totally surrounded them—just as vegetation in the wild would grow over sand dunes or earth hummocks. Although artist Lutz Huafschild initially worked as a sculptor, he has gained international recognition for his stained-glass work since emigrating from Germany to Canada in 1969. He is responsible for a major regional work in the stained-glass windows of Westminster Abbey in Mission, BC. •

>>>
1616 WEST 13TH AVE

28 PEOPLING THE PLAYGROUND 1997

> Eight classes of French immersion students from L'Ecole Bilingue worked with artist Sally Gregson to ensure that the presence of children would be felt on the playground even during classroom hours. The retaining wall on the south side of the playground provided the canvas for drawings of children in all shapes, heights, clothes and activity. There is room for additional figures to be drawn in chalk—which often happens. On a nearby wall is a BC-themed mural completed in 2008. •

>>>
1166 WEST 14TH AVE

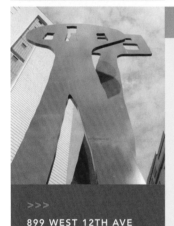

29 UNTITLED (RED FORMS) 2007

> After years of international recognition as a designer of resin, brass and steel functional art, sculptures and paintings, Martha Sturdy has entered a new phase of her artistic expression in producing large public art installations. She donated these 7.3-m and 8.5-m-tall poppy-red steel, Minimalist-style forms that represent people and the bonds they can form with each other. The pieces are located in the Vancouver General Hospital's Wellness Garden, an area that provides hope and healing to those who visit it. •

>>>
899 WEST 12TH AVE

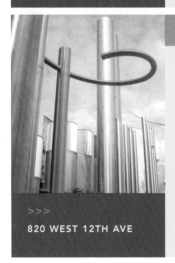

30 VGH ENERGY CENTRE 2008

> In *Espace Sculpture*'s Autumn 2002 issue, sculptor Alan Storey explained, "...a work of art in the public realm should intrigue and engage a passerby into an exploratory investigation of the content and its relationship to the surrounding site." The sweeping tubular steel directs us toward the modern world of medicine, while linking us to the functional needs of the institution. Like a body's heart and blood vessels, the tubes with dripping water, the pipes with escaping steam and the power plant below are an essential aspect of the hospital. Some weight-sensitive concrete pavers cause the pipes to emit steam. •

>>>
820 WEST 12TH AVE

31 UNTITLED (BROADWAY FOUNTAIN) 1980

> An imposing cast-concrete fountain by Paul Deggan is in the plaza of this business complex. Deggan also works in film and television, portraiture, interior and graphic design. In an enviable balance of life and work, he and his wife ran a summer art school for 25 years in the Auvergne, France. He continues to offer art classes on Bowen Island. Since 1962, he has not shown his own work "as a personal reaction to the inane trivialities of contemporary trends in art." •

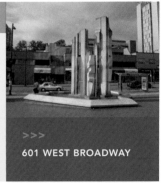

>>>
601 WEST BROADWAY

32 WALKING THE LINE 2007

> Property developer Grosvenor Canada Ltd. commissioned this piece by Douglas Senft. It's an ingenious way to turn a liability—namely the six concrete underground parking vents along the sidewalk—into a work of art. They are topped by galvanized steel grates, created using computer-guided high-tech plasma cutting. The design is based on the mountains and valleys of the BC coast. They can be enjoyed best by bending and lowering one's eye level to the mountaintops. •

>>>
2300 CAMBIE ST

33 UNTITLED (CLYDEMONT CENTRE) 1949

> The Clydemont Centre had a former life as the Vancouver Labour Temple, providing offices and a hall for the members of the specialized unions created during the early 1900s. The original Labour Temple had a history going back to at least 1918 when the first 24-hour general strike in Canadian history was called. Sculptor Beatrice Lennie included a beaver (a very hard worker) and the handshake of union members. The initials "TLC" stand for the Trades and Labour Congress of Canada. •

>>>
307 WEST BROADWAY

34 LOVERS II 1997

> Traditional though this sculpture may look, at one point it was an early example of guerrilla art in Vancouver. Sculptor Gerhard Juchum left it on the front lawn of City Hall, in gratitude for the opportunities Canada had given him. It caused quite a debate because of his unauthorized approach to donating the sculpture. Luckily, in the end, it was accepted and permanently installed. During the nine years that Juchum lived in Canada before his tragic early death, he produced over 100 sculptures. •

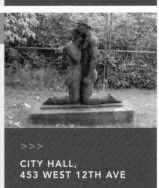

>>>
CITY HALL,
453 WEST 12TH AVE

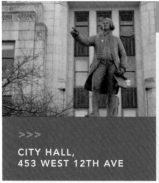

**CITY HALL,
453 WEST 12TH AVE**

35 CAPTAIN GEORGE VANCOUVER 1936

> English Captain George Vancouver arrived in English Bay in 1792, a year after the Spanish were first in the area. His goal was to find the hoped-for Northwest Passage connecting Europe to the riches of the Far East. Charles Marega created the bronze statue. At the front of City Hall is a bust of Gerald Grattan McGeer (1948), Vancouver's 23rd and 27th mayor, by artist Yanka Brayovitch. He initiated the idea of a central bank in Canada and addressed city financial problems and police corruption. •

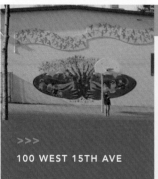

100 WEST 15TH AVE

36 MAINLY FOR THE BIRDS 1999

> Vancouver is close to the migratory pathway of hundreds of species of birds so it is possible to see a variety of species, ranging from hummingbirds to herons, throughout the city. The children of Simon Fraser Elementary School did a science project concentrating on birds, and worked with artist Pat Beaton to paint pictures of local species on a wood panel mural. A similar panel was painted for the south wall of the adjacent Mount Pleasant Community Centre. •

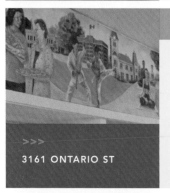

3161 ONTARIO ST

37 OUR NEIGHBOURHOOD MURAL 2002

> With the pace and scale of redevelopment in Vancouver, we sometimes have difficulty remembering recently demolished buildings. Artist Mandy Boursicot provided the people using the Mount Pleasant Community Centre and nearby park with an opportunity to document memories of their experiences, the buildings in the community and the friendly environment of Mount Pleasant. The oil-paint mural will be moved to the new community centre at 1 Kingsway. •

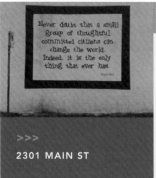

2301 MAIN ST

38 MARGARET MEAD QUOTATION N.D.

> In 1971, a handful of people lived out this quote from Margaret Mead, the American cultural anthropologist: they set sail from Vancouver in a fishing boat for Amchitka, Alaska, to protest American nuclear weapons tests. This group became Greenpeace—now a worldwide organization operating in more than 40 countries. Its mission is to use non-violent, creative confrontation to protect biodiversity, prevent abuse of the Earth, end nuclear threats and promote peace. •

39 TREE TRUNK CARVINGS N.D.

> Each carved tree-trunk person holds fish—probably salmon —once a staple in the diet of all of the Coast Salish people when they had their summer camps in the area. The words "Thank You," (*huychexw-a*) in Musqueam and (*heycvx w gu*) in Vancouver Island Halkomelem dialects on pavers by the fish and fossil artwork on the sidewalk in front of the tree trunks could also relate to salmon. The First Nations believed strongly in honouring and respecting the gift of salmon. •

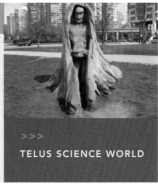

>>>
TELUS SCIENCE WORLD

40 TOWER OF BAUBLE 1986

> This audio-kinetic sculpture was originally built by New York sculptor George Rhoads for the interior of a shopping centre in Kamloops, BC. In 1995, it was donated to Science World and refurbished in 2001 thanks to a group of Vancouver men who were aware that small children (and adults) enjoy watching objects move through complex channels. All of the balls move by gravity in either the top or bottom sections, with a chain-operated hoist to return them to the top. •

>>>
TELUS SCIENCE WORLD

41 WEATHERVANE BOAT c.1997

> This weathervane was built by Ken Christian, a long-time Science World employee. He also built real boats, but this is his signature piece. It hangs on a welded steel structure south of the entrance. This piece has inspired Science World to bring more of their story outside—they are planning an outdoor science park that will include public art. This whimsical artwork deserves a close look for the handcrafted detail, such as the captain looking through the telescope—it's bound to amuse! •

>>>
TELUS SCIENCE WORLD

42 CONSONANCE 2006

> Coast Salish artist Susan Point designed this pod of swimming whales. Point said that the word "consonance" implies harmony and agreement among the components or a dialogue or repeated sounds. Whales dominate legends that show the interconnectedness of all life and are used extensively in First Nations art. The artist also repeated a theme used in other art she has created: the need for respect and an obligation to care for the whales and each other. •

>>>
**WEST 2ND AVE
AT YUKON ST**

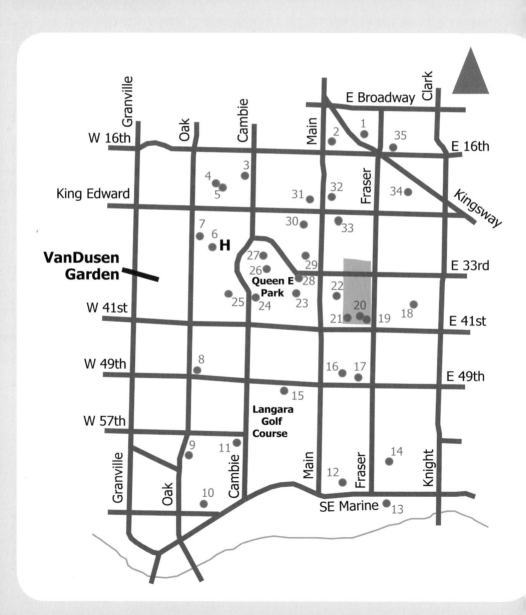

south central

1 75/50 MURAL 1996

> Artist Joey Mallett was commissioned to paint this mural to celebrate the 50th anniversary of the hospital on its present site. It depicts the history of Mount Saint Joseph Hospital which opened in 1921 when four Sisters of the Missionary Order of the Immaculate Conception came to Keefer Street to provide health and education services to the then mainly Asian population. Today, the hospital is a 208-bed acute and extended care facility serving a multi-faith and multicultural community. •

>>>

3080 PRINCE EDWARD ST

2 UNTITLED (MURAL) 1984

> This *trompe l'oeil* scene, looking east towards Mount Baker and set within an 18th-century ballroom design, was painted by Susan Baker. It is inside the hall that was built in 1914–16 for a post office and later used as the Dominion Agricultural Building and as offices for the Royal Canadian Mounted Police. In 1974, Heritage Hall was formally designated as a heritage building, among the first group of buildings in Vancouver to receive this protection. •

>>>

3102 MAIN ST

3 CHILDREN OF EDITH CAVELL 2004

> This major mural, painted by the schoolchildren led by artist Ann Thornsteinsson, is a delightful landscape cross-section, with various flora and fauna represented. As well as an ecological message, the scene provides a lot to smile about. Two other murals are also at the school: one of peculiar creatures in a tree scene and the other of Canada geese in quirky colours. Edith Louisa Cavell, after whom the school was named, was a British WW I nurse who helped hundreds of Allied soldiers escape from German-occupied Belgium. She was subsequently executed by the German military in 1915 to international outrage. •

>>>

500 WEST 20TH AVE

4 ETHNIC HARMONY MURAL 2001

> Working and playing together often helps us understand others from a different cultural background. Using this premise, the Vancouver School Board Race Relations Youth Advisory Committee invited students to participate in the painting of a mural for the Douglas Park Community Centre. Issues of colour, race and language within a common Canadian citizenship are addressed. Phrases like "Equality body wash. It's only skin" accompany the pictures. On the north side of the centre is the small *Our Community* mural. •

>>>
801 WEST 22ND AVE

5 DOUGLAS PARK BENCH PROJECT 1996

> When she created this bench project, artist Celine Rich must have listened to all those tired mothers who just wanted to rest while their children played on the nearby grass. With a graduate degree in environmental design, she brings many skills and perspectives to her work with community residents. There are a total of five benches in Douglas Park and nearby Heather Park. Each bench has messages written by community members on embedded copper plaques, now fading with time. •

>>>
801 WEST 22ND AVE

6 CANADIAN MEDICAL CORPS RELIEF c. 1940

> Reliefs by Beatrice Lennie are at the original entrance to the former Shaughnessy Hospital (in the courtyard off the cafeteria) which was built in 1940 as a health facility for WW II veterans. The images are soldiers being assisted by members of the Canadian Medical Corps. Interestingly, perhaps to avoid horrific memories for the injured who entered the hospital, the soldiers have no obvious wounds. A Medical War Memorial (1995) is outside the nearby Brock Fahrni Pavilion, which houses veterans needing extended health care. •

>>>
**SHAUGHNESSY HOSPITAL
CAFETERIA COURTYARD**

7 TILES 1982

BC CHILDREN'S HOSPITAL, OAK ST ENTRANCE

> A hint of abstract style adds interest and humour to the figures in this glazed tile work by artist Zbigniew Stanley Kupczynski. Born in Poland, he has lived in Canada since 1971. His art is in collections as diverse as those of the Vatican and the premier of British Columbia. As parents and children enter the hospital, it creates a welcome diversion. BC Children's Hospital, opened in 1982, treats over 168,000 children annually, with a daily average of 103 in the emergency department. •

8 SCULPTURES c. 1975

>>>

949 WEST 49TH AVE

> Although it looks like a swan with its beak reaching skyward, this untitled welded sculpture by Barry Holmes in the courtyard of the Unitarian Church is said to be a ballerina created in memory of the two daughters of a parishioner. A form made of carved fir, by Vancouver sculptor James Voth, is located to the east in the courtyard. Titled *Beginnings*, it is a stylized index finger and thumb. The human ability to oppose digits has allowed for the development of many skills, including sculpture. •

9 GARLAND 2002

>>>

990 WEST 59TH AVE

> Archways are used for many purposes—for the bride to walk under, to indicate the start and finish of a race, and to both support tall structures and create a soaring upward view in cathedrals. This archway constructed of steel pipe with cut and forged steel oak leaves leads toward the Marpole–Oakridge Community Centre, and according to artist Douglas Senft it creates a "memorable image of arrival, passage and place." The sculpture refers to oak leaves in nearby Oak Park. •

10 ST. VARTAN CAIRN 2008

>>>

1260 WEST 67TH AVE

> In ancient Armenia, during the first half of the 5th century, Vartan Mamigonian was revered as a great spiritual and military leader. He participated in a rebellion against Persia, whose leaders wanted Armenians to convert to their religion. Although he died in battle, the revolution was carried on by other family members and centuries later led to the autonomy of the Republic of Armenia. Also see the carved stone roses, "dedicated to all mothers," at the front door of the church. •

11 DRAGONFLY PROJECT 2000

> Yikes! And you thought the blackflies in northern BC were big in the summer? In 2000, 35 gigantic bugs, birds and mythical creatures were scattered throughout the Marpole community, on walls, fences and roofs. Eric Neighbour incorporates teaching others how to create art projects within his practice and teamed with the Independent Lifeskills Society to lead over a hundred community members in completing the fanciful project. However, because of the fragile nature of their fibreglass construction, many of them have since flown away. •

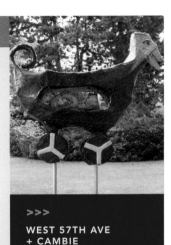

>>>
WEST 57TH AVE + CAMBIE

12 TRUDEAU BUTTERFLY PARK AND MOSAIC COLUMN 2003

> Artist Nicole May worked with artist-in-residence Alison Diesvlt and the parents and students from Trudeau Elementary School to create the mosaic column and plantings along West 62nd Avenue designed to attract butterflies. May has a degree in landscape architecture so including the natural environment in her art is easy. Butterfly gardens teach children many environmental and life lessons. They learn about the interdependence of the natural world and everyone can practise patience—sometimes it takes eight months for a butterfly to hatch. •

>>>
WEST 62ND AVE + PRINCE RUPERT ST

13 HORIZONS 1970

> Forms with razor-sharp edges balance on the lawn of the Wilkinson Company. However, this particular Wilkinson Company produces, among other things, piping, bars and steel plates and metal—not the Wilkinson Sword razor blades that have been used for over a hundred years. This company also specializes in steel and metal production for the resource-based industries of forestry, mining, agriculture and energy in the western provinces. Sculptor Gerhard Class designed the Corten steel structure to celebrate the company's 60th anniversary. •

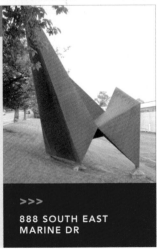

>>>
888 SOUTH EAST MARINE DR

>>>
7646 PRINCE ALBERT ST

14 WELCOMING WALKWAY 2001

> Using colours and shapes from the nearby Punjabi market and from East Indian fabrics, artists Glen Anderson and Marina Szijarto helped community members create colourful mosaics. One of the mosaic patterns—the droplet-shaped paisley—is a floral/leaf motif originating in ancient Persia. It is similar to the shape of the leaf of an Indian bodhi or mango tree and is also thought to represent the shoot of a date palm. The term "paisley" comes from the Scottish town of the same name, where—until the mid-1800s—thousands of shawls with the paisley design were produced. •

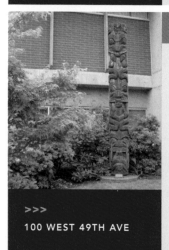

>>>
100 WEST 49TH AVE

15 TOTEM POLE c. 1970

> Don Yeomans carved this pole when he was a Langara College student in the 1970s. His interpretation perhaps gives insight into the struggles he felt or observed among aspiring native artists at the time. Bear represents the cruel world, the little man tells one to forget one's dreams, the second Bear devours you if you are not good enough for others to hear you and the upside-down man is devouring his own image. Yeomans has since become a successful carver and jewellery maker. •

>>> PRINCE EDWARD ST,
WEST 42ND AVE TO
MARINE DR

16 SOLAR PATTERNS I + II 2004

> Students from Pierre Trudeau Elementary School were asked to create images for banners. The image of the sun was selected for the metal banners and stamped into curb designs. The circles represent part of a figure eight "analemma" loop, which is the path of the sun when viewed in the same place at the same time of day through-out the year. Artist Shirley Wiebe chose the yellow and orange colours to reflect the nearby "Punjabi market spices and Chinese symbols for prosperity." •

17 UNIVERSAL BUDDHIST TEMPLE 1978

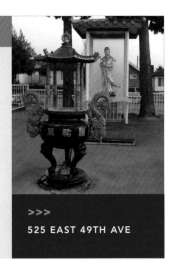

> Buddhism grew out of the teachings of Gautama Buddha, who taught that mental and moral self-purification can liberate one from the suffering inherent in life. The Buddha was not a god, but rather a human who attained enlightenment through his own practice. This temple was founded in 1968 by a group of lay people; the building was designed by Victor Kwan and built in 1978. The colourful building has lots of detail, including dragons in ceramic tile and exhortations to "Cease to do evil—endeavour to do good. Calm and cleanse the mind." There are also various statues on the site. •

>>>
525 EAST 49TH AVE

18 CONVERGING LINES 1998

> Thanks to City of Vancouver staff, who managed to leverage the design and construction of the 37th Avenue Ridgeway, this bike route includes numerous public artworks. *Converging Lines* consists of two nearby sites, both based on the traditional East Vancouver backyard clothesline. Hanging on wires strung between the utility poles is a collection of stainless steel shapes of teapots, houses, dogs and women putting clothes on the line. Elizabeth Roy, the artist, instructs at Emily Carr University. •

>>>
EAST 37TH AVE AT ROSS ST
+ AT CULLODEN ST

19 WILLIAM CHANDLER GRAVESTONE 1952

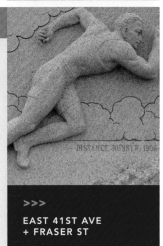

> Some may take exception to a gravestone being considered public art, but one could ask how is this different from several other three-dimensional works commemorating runners in Vancouver? Is it the location? Certainly the representation is artistic and cemeteries are public spaces. William Chandler was a virtually unbeatable middle-distance runner for many years in the Pacific Northwest. He competed at the 1908 and 1912 Olympics and set a Canadian record of 26:37.6 for the five-mile run in 1913. •

>>>
EAST 41ST AVE
+ FRASER ST

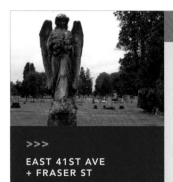

>>>
EAST 41ST AVE + FRASER ST

20 DELAYTE GRAVESTONE 1920

> Over 100,000 people have been interred at Mountain View Cemetery. One of them is Maude Evyline, daughter of Captain E.H. and Sarah Delayte, who died at the age of 30 in 1920. The stone of the family plot is surmounted by a winged angel and has the Masonic symbol showing her father's lodge affiliation. An identical angel—albeit with broken wings—is about 20 m to the west. •

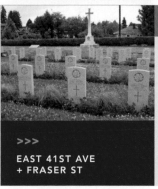

>>>
EAST 41ST AVE + FRASER ST

21 CENOTAPH N.D.

> This WW I cenotaph is located near the southwest corner of Mountain View and sits within a forest of gravestones of soldiers. "To the memory of those who died for King and Country in the Great War, 1914–1919," the inscription reads. Mountain View is the resting place of more than 12,000 veterans—the second-largest "Field of Honour" in Canada. Four recipients of the Victoria Cross (the Commonwealth's highest military honour) are interred at Mountain View. •

>>>
EAST 37TH AVE + PRINCE EDWARD ST

22 BACKSTOP: A STAGE FOR WORDSWORTH 1998

> Artists Todd Davies, Mark Grady and Karen Kazmer are right: the quote from English poet Wordsworth (1770–1850) located at the top of the stage describes Vancouver at its best. Wordsworth's early years in England's Lake District gave him a love of nature that he often incorporated into his poems. The stage, which the artists constructed from a baseball backstop, chain-link fencing and aluminum, waits for the drama to unfold as Vancouver grows and reinvents itself. •

>>>
EAST 37TH AVE + ONTARIO ST

23 BIG BIKE 1998

> Using super-sized bicycle parts to provoke reactions from passersby was part of the intent of artists Barry Luger and Bob Potegal. It is certain to do that, as well as mark the intersection of the Ontario and Ridgeway bicycle routes. The gigantic seat of the bicycle awaits the arrival of a very large bicyclist. Other art along the route includes *Bicycle Wheel* by David MacMillan (1997) at Main Street and the garden-themed *Utility* by Marko Simcic (1997) at Oak Street. •

24 MACHINA METRONOMA 1997

> On the cyclist-activated traffic-light poles of 37th Avenue where it intersects Granville, Cambie and Fraser streets, and at the Heather Street/King Edward intersection, there are fibre-glass and steel sculptures that may move like a metronome. Each has distinct icons related to movement, such as roller skates, and an amusing statement. Artist Dwight Atkinson has many talents and has worked as an architect, iconographer, radio documentarian, and as a landscape and mural painter. •

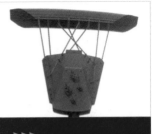

>>>
**WEST 37TH AVE
+ CAMBIE ST**

25 RCMP MEMORIAL 2004

> A pensive RCMP officer and a hat and gloves representing a deceased colleague are on the corners of this bronze and black granite memorial by Winnipeg sculptor Madeleine Vrignon. The modern-day RCMP was formed in 1920. The motto "Maintiens le droit" surrounds a buffalo head on the RCMP crest—a symbol recognizing both their peace-keeping role and the fact that in those early years, the buffalo provided them with both food and coats. •

>>>
**WEST 37TH AVE
+ HEATHER ST**

26 KNIFE EDGE TWO PIECE 1969

> This sculpture has a place of honour at the highest point in the city within Queen Elizabeth Park. Henry Moore, an English sculptor, is recognized throughout the world. One of his most iconic pieces, this sculpture was donated by Seattle lumber bar-on Prentice Bloedel. Four were cast between 1962 and 1965: one is opposite the House of Lords in London; another is at the former Rockefeller Estate in New York State; and the fourth is at the Henry Moore Foundation at Perry Green, north of London. •

>>>
**WEST 33RD AVE
+ CAMBIE ST**

27 PHOTO SESSION 1984

> Smile! Taking pictures of people taking pictures is a favourite pastime in the Queen Elizabeth Park gardens. This photographer, sculpted by American J. Seward Johnson, directs three life-sized bronze figures into the perfect picture moment against the backdrop of the Downtown skyline and the North Shore. With digital cameras, we no longer pose in this static way but the installation's sense of humour and details, such as the then fashionable corduroy jackets, are fun •

>>>
**WEST 33RD AVE
+ CAMBIE ST**

28 DEPARTURES AND ARRIVALS 2000

>>>

**EAST 33RD AVE
+ ONTARIO ST**

> This *Millennium Story Stone* records the transitions and memories of Bernadette Gonzalez-McGrath, an immigrant from the Philippines. She starts with the sadness of leaving her home, arriving in Vancouver with broken English and a broken spirit, and longing for years to get away from rainy, boring Vancouver. After trying other places, her gradual realization that Vancouver was indeed now her "home" will ring true for many of Vancouver's citizens and those still to come. •

29 WELCOMING WALL 1999

>>>

**EAST 33RD AVE
+ ONTARIO ST**

> Riley Park Community Centre commissioned artist Joey Mallett to work with people from the surrounding community to create a mural representing their diversity and similarities. The result on the outside west entrance wall is a tree sheltering people, from different cultures, in a variety of activities. Outside the Percy Norman swimming pool in a garden, are terracotta tiles set in a circular pattern with designs *Labyrinth* (2000) by Judy McNaughton and community members. •

30 PARK 2008

>>>

**CHANGING LOCATIONS,
ONTARIO ST GREENWAY**

> Sculptor and architect Marko Simcic created two car-sized, moveable steel sculptures now placed among parked cars and moved intermittently along the Ontario Street Greenway. Homeowners were surveyed to see if they would host the sculptures in front of their houses for varying lengths of time. By engaging the community in the development of this artwork, Simcic has encouraged discussion, questions, dissent and an appreciation of public art and its place in our lives. •

31 STEPPING THROUGH OUR NEIGHBOURHOOD 2005

>>>

**EAST 23RD AVE
+ QUEBEC ST**

> On the boulevard in front of the Vancouver Fountain Alliance Church is a mosaic hopscotch game—perhaps the most playful of all the various mosaics in the city. Artist Glen Anderson worked with Riley Park and Little Mountain community members area to produce 38 in-ground mosaics throughout the community. Other mosaics can be found in Grimmett Park at East 19th and Quebec, along the neighbourhood boulevards and at the north edge of Douglas Park. •

32 MID-MAIN MURAL PROJECT 1998

> Adults and children representing the multicultural heritage of those who might attend the Mid-Main Health Unit march, run and roll gaily towards the main doors of the clinic. These murals by Joey Mallett and community members emphasize equity and accessibility (at least in healthcare provision) for the citizens of the area. Main Street is experiencing revitalization, with many young families moving into this area of new restaurants, specialty shops and artist studios. •

>>>
3998 MAIN ST

33 DRY STREAM 1997

> The majority of the streams that once flowed through the forests where Vancouver now stands have been covered and destroyed. This dry stream, fanciful in nature with its colourful stones and inlaid forms, runs along the edge of the lane near where a stream once flowed towards the False Creek mudflats. Artists Glen Anderson and Sarah White remind us of what we have already lost and what we need to be mindful of in the future. •

>>>
LANEWAY, BETWEEN 4197 + 4217 JOHN ST

34 WINDSOR WAY: MOMENTS, MEMORIES AND OBJECTS 2003

> For some cultures, "talking with your hands" is natural. Artist Karen Kazmer photographed the hands of members of the Riley Park community as they talked about and shared personal objects and memories. Twenty pictures were made into outline images that were welded to perforated aluminum banners and mounted on street-light poles. Such images are both intimate and universal and provide an opportunity to reflect on cultures and neighbours. •

>>>
WINDSOR ST, BETWEEN EAST 13TH + 32ND AVE

35 LEAF BENCH I + II 1997

> The Prince Albert Greenway provides a spot for children to play and for neighbours to meet. There are opportunities to rest or sit and read on these two steel benches designed by Douglas Senft. Their subtle pattern creates shadows that reproduce the veins of the leaves on the surrounding trees—truly beautiful, functional art. But watch out! Don't step on the bright butterflies, dragonflies and flowers in the mosaics at the base of the benches. •

>>>
EAST 15TH AVE + PRINCE ALBERT ST

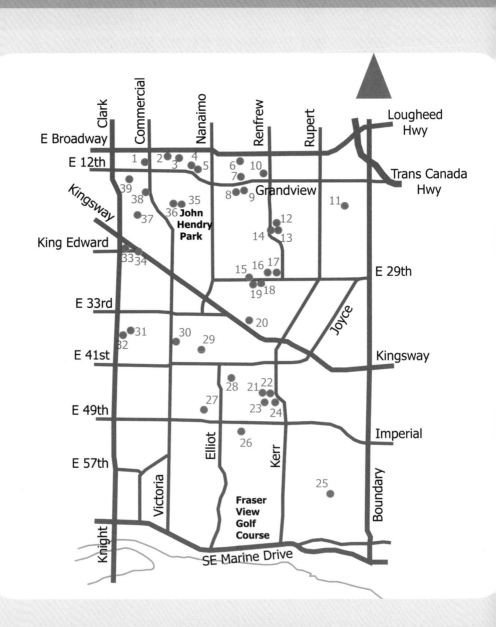

south east

>>>
COMMERCIAL DR AT
EAST 10TH + 11TH AVE

1 MOSAIC PLANET 2002

> Four large tile mosaics in the sidewalk reflect local community life in the area around The Drive. One features a bicycle amidst a collection of faces, hands, hearts, eyes and flowers. Another illustrates Illuminares, BC's first and oldest lantern festival. The third focuses on nature: fish, frog and beetle. The fourth shows activities seen around The Drive, from entertainment to shopping, but ends up at home— where the heart is. All four are by Glen Anderson and Marina Szijarto. •

>>>
VICTORIA DR BRIDGE
NEAR EAST 10TH AVE

2 HEALING THE CUT—BRIDGING THE GAP 1996

> The Grandview Cut was dug in the early 1900s to provide another rail route into the heart of Vancouver. In the 1990s it was slated for freeway and is currently used for the SkyTrain Millennium Line. This work, by Janis Bowley and Oliver Kellhammer includes plantings on the slope, nesting boxes and a telescope placed for viewing of the wildlife that has begun to frequent the area. This environmental art helped the city engineers to find alternatives to a concrete corridor. •

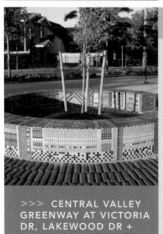

>>> CENTRAL VALLEY
GREENWAY AT VICTORIA
DR, LAKEWOOD DR +
NANAIMO ST

3 PIXELATED BENCH, STEPS, RING 2003

> One meaning of "pixelated" refers to an image that has been digitized is now visible as a pattern of pixels, like a fine-grained mosaic. Another is "amusingly whimsical." The patterns on the walls of Laura Secord Elementary School were used as a reference for the bright colours and designs on three benches commissioned by TransLink. Each bench has a different shape: a sofa for comfort, steps for waiting and a ring that encloses a tree. Artist Sally Michener "think[s] of them as musical chairs—alluding to a childhood game or a reference to musical improvisation." •

4 POSTURE 2003

> Remember as a child throwing whirly-gig maple-seed wings into the air and watching them spiral to the ground? Artist Douglas Senft used the image of vine-maple-seed wings to create the form for these steel benches. Silhouettes of crows on poles overlook four benches. Every night on their way back to their roost in Burnaby, thousands of crows fly over their metal counterparts. There are another two benches one block to the east. •

>>> CENTRAL VALLEY GREENWAY AT EAST 11TH AVE

5 CuTArT CROSSROADS: COMMUNITY SOFA 2003

> Sculptor David Fushtey recycled granite curbs from the 1920s to construct the seating area in this park where neighbours meet and a yearly garden party is held. Small metal fastening pieces contain words like "Jervis Inlet"—likely the source of the granite—and "wheel, rail, conduit." A vertical stone has a sightline to the North Star. Fushtey believes, "Stone speaks of the history of our planet and our civilizations; it is the earliest and persistent record of lives lived, beliefs and aspirations." •

>>>
CENTRAL VALLEY GREENWAY AT GARDEN DR

6 TOTEM POLE AND RELIEF N.D.

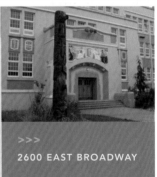

> Vancouver Technical Secondary School offers a full curriculum to over 1,700 students. It is fitting that there is a totem pole at the school since it has the second-largest number of First Nations students in Vancouver. The pole has a whale, raven and eagle and human faces at the bottom. There is also a painted relief over the front door of the school showing the transition of students from school (welcomed by Athena, the Greek goddess of learning) to the workforce. •

>>>
2600 EAST BROADWAY

7 COYOTES 2002

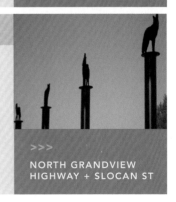

> Douglas Senft placed six profiles of coyotes—in various poses from hunting to howling—on steel posts. Coyotes, Canis latrans, are part of the dog family. Coyotes are carnivorous, eating primarily small mammals like rabbits and mice, but they will also "take" cats and small dogs. First noticed in the early 1980s in larger parks, coyotes now number about 250 in Vancouver. Watch out, Fluffy! •

>>>
NORTH GRANDVIEW HIGHWAY + SLOCAN ST

8 ITALIAN ARMY MEMORIAL BUST 1985

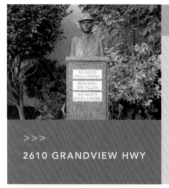

>>>
2610 GRANDVIEW HWY

> This bust on a granite base of a soldier in the Italian army "honours the fallen" (in Italian, English and French) from two world wars. He wears the hat with a feather worn by the Alpine troops. In WW I, Italy lost 651,010 soldiers and 301,400 in WW II. This sculpture by Severino Trinca, commissioned by three Italian-Canadian veterans' associations, was unveiled during Vancouver's centennial in 1986 with the president of Italy observing. •

9 PAGAN 1972

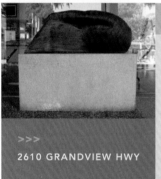

>>>
2610 GRANDVIEW HWY

> A welded steel sculpture by Severino Trinca is situated in the Piazza Guglielmo Marconi at the Italian Cultural Centre. With its undulating shape, it appears to represent mountains—perhaps those of Italy or Canada—but, in fact, the sculptor said it is the form of a pagan Roman sprawled on the floor stuffing himself with food. Trinca, who has since returned to live in Italy, sculpted numerous pieces that can be seen at Simon Fraser University. •

10 YET ANOTHER WAY TO KNOW PEOPLE VARY 2001

>>>
RENFREW
SKYTRAIN STATION

> To get from street level to train level, there is an elevator on each side of the track. Affixed to the glazing frames of each one are three pieces of screens and grids. On the grids are words to intrigue commuters—"contract, precision, bargain, absolute"—readable from the street and from inside the elevator. Some words appear designed to rotate as they moved. The work is by Dwight Atkinson, a retired architect (named as iconographer), and Ian Watson (artificer). •

11 COMMUNITY HALL MOSAIC 2008 + MURAL N.D.

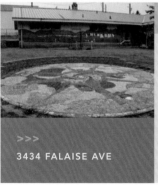

>>>
3434 FALAISE AVE

> For today's young people, "hanging out" has a whole different meaning but the mural on the community hall shows an original interpretation, with a mother hanging out the laundry on a bright sunny day. With energy costs soaring, wind-powered clothes drying may regain favour. A colourful mosaic provides a central focus to a small planted area in front of the community hall. Wetland gardens have been installed to encourage the retention of rainwater. •

12 EAGLE AND EAGLET POLE 2001

> A powerful mother eagle holds her baby eaglet on this 2.4-m-high totem pole carved by Gerry Sheena and young apprentices. Community members observed the process and participated in the raising of the pole. Eagles build their large nests in tall trees and generally lay two eggs, although the first hatchling often dispenses with its sibling. Eaglets make their first flight 11 to 14 weeks after hatching. •

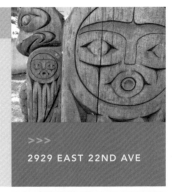

>>>
2929 EAST 22ND AVE

13 HELPING HANDS 2005

> This artwork was created by Bruce Voyce "in recognition of all of the people who've helped make this project a reality." The "project" was an expansion of the Renfrew Community Centre to include a new aquatic centre. The work is a wall-mounted lotus shape of blue screens with green hands cast in polymer representing the helping hands of volunteers. Voyce says that in his work he is "creating hybrid forms that are simultaneously natural and artificial." •

>>>
2929 EAST 22ND AVE

14 ALL OUR KNOWLEDGE HAS ITS ORIGINS IN OUR PERCEPTIONS 1999

> The title is a quote from Leonardo da Vinci. Our perception is defined as the process by which the sensory stimulation gained through sight, sound, smell, taste, feel and movement is translated into an understandable experience. This copper, aluminum and glass sculpture by Brian Baxter and Markian Olynyk is intended to "challenge the viewer's perceptions ... by making references to the mysteries of the mind and universe, and the search for truth." •

>>>
2969 EAST 22ND AVE

15 COMMUNITY SPIRIT MURALS 2007

> On both sides of the bridge over the SkyTrain line are brightly coloured murals sponsored by TransLink, designed and painted by Yoko Tomita and the Slocan neighbourhood community. The dominant theme for the north parapet is primarily spawning salmon (with their distinctive red colour, humped back and elongated jaw) swimming upstream towards a fierce-toothed predator. The south parapet is based on city scenes, organized through the changing seasons, with lots of birds. •

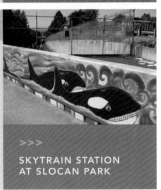

>>>
SKYTRAIN STATION
AT SLOCAN PARK

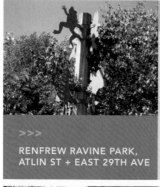

>>>

**RENFREW RAVINE PARK,
ATLIN ST + EAST 29TH AVE**

16 SCULPTURE POEMS 1996

> This work has two components: the shorter are five bronze poem markers, along the path on the east side of Renfrew Ravine; the taller ones are 10-m-high welcoming poles, with metal shapes at the two pathway entrances. The tall poles are distinctive Sam Carter—there are similarities with his other public art, such as *Flower Totems* at Kingsway and King Edward. Metal figures (birds, trees, fish, frogs, leaves, etc.) are attached near the tops of the faceted wooden poles. •

>>>

**RENFREW RAVINE PARK,
ATLIN ST + EAST 29TH AVE**

17 RENFREW RAVINE SANCTUARY 2002

> At the southeast entrance to the park, there is a welcoming path with a pebble-mosaic fish by Carmen Rosen. Along the path is a carved wooden seat with a First Nations theme by Doug Baker. Further along, a labyrinth formed by rocks set in the grass encourages meditation. A double curving bench is at the northeast corner of the park. Site-specific environmental art projects such as this one are gaining favour among cities that want to encourage art in harmony with the site. •

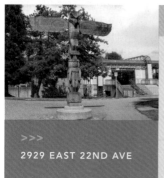

>>>

2929 EAST 22ND AVE

18 GUARDIAN OF THE PARK 2000

> Beside the SkyTrain station in Slocan Park, this totem pole has an eagle with outstretched wings protecting four human figures. The pole was carved by Gerry Sheena and assistants. Community members contributed ideas about what should be on the pole and watched the progress of the work. In First Nations mythology, eagles represent powerful hunters, intelligence, power and vision. Eagle feathers are believed to have healing properties and are used in ceremonies and rituals. •

>>>

2750 EAST 29TH AVE

19 DUCHESS WALKWAY AND CONSTELLATION LANTERNS 2002

> Various pebble mosaics, created by community members as part of the Collingwood Renfrew Arts Pow Wow, are embedded in the walkway here and around the *Constellation Lanterns* of Slocan Park. The walkway crosses what was originally Still Creek and the designs have a water-related theme. The banner-topped *Constellation Lanterns* have designs ranging from recognizable Vancouver images like the Woodward's "W" to generic suns, dragons and orcas. •

20 CHOCOLATE FOUNTAIN 1997

> In 1907, Richard Purdy opened his first chocolate store on Robson Street. The copper fountain on the chocolate factory's front lawn was created to celebrate the company's 90th anniversary in 1997. It was constructed from two cream beaters and a vacuum cooker. Today, the company still chooses to use four cream beaters and slowly cook its cream centres over a slow gas flame rather than using the speedier vacuum-cooking process. •

>>>
2777 KINGSWAY

21 RAINWATER GARDEN N.D.

> Environmental art respects the needs of a site and often involves restoring the area to its natural state or integrating art in such a way that it is in harmony with the site. The small plaza area here has a concrete section that maps the bog that once existed here, with lines to indicate the streams. The engraved stone tells the viewer about the need to conserve rainwater runoff and return it to the water table. •

>>>
EAST 45TH AVE
+ KILLARNEY ST

22 LEANING TOWARDS FRAME DRAGGING 2005

> Artist Alan Storey is fascinated by art that has moving pieces and a complex interpretation. The basis of this steel art piece refers to Albert Einstein's Theory of Relativity and "the possibility that the time/space frame can be distorted or dragged towards a large rotating gravitational mass." The anemometer at the top of the pole drives the hands on the instrument at the base and measures time by millennia and also metaphorically measures the events and lives of community members. •

>>>
EAST 45TH AVE
+ KILLARNEY ST

23 PASSAGES, TRACES AND WHISPERS 1997

> One hundred and fifty individuals, family groupings and youth groups worked with Kristine Germann on 80 sections of small tile mosaics that show community life in the Killarney neighbourhood. These tiles, in the lobby and hallways of the Killarney Community Centre, have European colouring and style. They are mounted on a backing so they can be saved and moved during renovations—solving a problem with mural or tile work that is fixed onto the walls of a structure. •

>>>
6260 KILLARNEY ST

24 JABUKA 2005

>>>
6205 KERR ST

> When 465 people (most with very little experience in carving) work in small groups together for 13 weeks, what can they produce? If they have artist Eric Neighbour as a teacher and mentor, anything is possible. In this case, the Killarney community members carved a large bird, which was mounted on the trunk of an upside-down tree. The bird is named *Jabuka*, which is a Slavic term of endearment meaning "little apple." •

25 COUNTRY LIVING IN THE CITY 2000

>>>
3350 MAQUINNA DR

> Until the 1970s, Vancouver's last remaining agricultural areas were in the Killarney and Victoria–Fraserview neighbourhoods (see *'til The Cows Come Home*). Artist Andrew Currie worked with community children and adults to capture some of that peaceful existence. The jigsaw-puzzle painting represents an environment—a beaver pond, fruit trees in bloom—and activities such as fishing, which local children used to do in streams in the area •

26 VIVIEN CREEK COMMUNITY MARKER 1997

>>>
EAST 49TH AVE
+ VIVIEN ST

> *Collected Memories* is a book created after hundreds of community members were interviewed by local students and Celine Rich and Carol Moore to capture their memories of southeast Vancouver. The impetus for this memory book, events and the accompanying 138 community markers, was rapid growth and the obliteration of some old landmarks. Vivien Creek was a stream in which children could swim or fish, and which, in winter, they could dam to create a skating rink. •

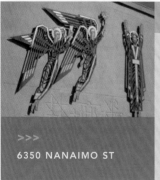

27 CORPUS CHRISTI CHURCH 1962

>>>
6350 NANAIMO ST

> The large ornate structure of Corpus Christi Church tells little of its humble beginnings in 1914, when priests from the Oblate Mission held services in a log-cabin church on Marine Drive. After moving to other locations over the years, a church, designed by W.R. Ussner, was finally built at this location. On the front wall are bronze figures of Jesus and two angels ascending to Heaven while the south wall has the twelve apostles, all sculpted by Jack Harman. •

28 'TIL THE COWS COME HOME 2005

> Six cows, cut out of one-inch-thick steel plates, contentedly graze down the side of a local road that dead ends at Avalon Dairy. The dairy is a family business founded in 1906 and is the oldest continuously operating dairy in BC. Half of the cow shapes are positives, their forms cut from the steel plates; the other half are negatives, outlined by the remaining rectangles. Douglas Senft, a graduate of the Vancouver School of Art, sculpted these pieces. •

>>>
EAST 43RD AVE
AT CLARENDON ST

29 RIGHT TO THE CITY 2004

> "Ours, yours, his, hers, mine, theirs"—these words are cutouts on the six metal window and door frames located along the Ridgeway Greenway. A few of the capsules containing ordinary objects that were embedded at East 41st Avenue and Nanaimo Street can also be seen. Artist Kirsten Forkert used her structures to question who owns, and who has "a right" to, the city. She says, "The elements in this project explore the contradictions and ambiguities of public and private space." •

>>>
5500 NANAIMO ST;
5800 CLARENDON ST

30 ALUMINUM PETROGLYPHS 1998

> Along the Ridgeway Greenway, there are numerous interesting sculptures at the user-controlled crossways. Artist Tom Burrows used aluminum petroglyph forms as the concept for the tops of two poles. Petroglyphs (rock carvings) and pictographs (rock paintings) are found at over 500 sites in British Columbia. The sites of these early artistic creations were often associated with places of strong spiritual significance. •

>>>
EAST 38TH AVE
+ VICTORIA DR

31 KENSINGTON ENTRANCE MURAL 2003

> Look closely at what appears to be an abstract form and the people and activities that artist Joey Mallett has embedded into the shapes will emerge: swimming, judo, dancing, etc. The community centre is high up, with great views to the North Shore, and the Lions can be seen in the background of the mural. Look even more closely, through another layer, and the geometric shapes spell out "Kensington." To the left of the door is *First Nations Board* by Doug Baker (2006). •

>>>
5175 DUMFRIES ST

>>>
KNIGHT ST
AT EAST 37TH AVE

32 GATES 1986

> Driving north on Knight Street over the rise, you will be confronted with a spectacular view across Vancouver. This black-painted steel structure, set into the lawn of Kensington Park, presents a silhouette of Vancouver buildings with the North Shore mountainscape in the distance. It was created by Douglas Senft as part of Vancouver's centennial sculpture symposium. *Gates* was donated to the City of Vancouver by readers of *The Vancouver Sun*. •

>>>
KINGSWAY
+ KNIGHT ST

33 THE PEACEABLE KINGDOM 2008

> The 22 animals in Tom Dean's sculpture are placed in unusual but friendly groupings. They can be found hanging from a trellis, playing by a waterfall and looking down at passersby throughout the inner courtyard of the King Edward Village development. Curator Ann Pollock notes, "This installation is a continuation of Dean's explorations about the presence and absence of paradise, and how we gain it for but transient moments, while also hoping for mercy." •

>>>
KINGSWAY
+ KING EDWARD AVE

34 FLOWER TOTEMS 1980

> Three components of the Japanese flower-arranging art of ikebana gave artist Sam Carter inspiration for the steel enamelled flowers at this busy intersection. "Shin (neutral), Soi (sunny) and Tai (shady) ... interact with ... red (romantic), blue (calm and stoic) and yellow (energetic)" for this arrangement. For over 600 years, practitioners have created arrangements based frequently on the shape of a scalene triangle that represents heaven, earth and man, or sun, moon and earth. •

>>> SOUTHEAST OF
TROUT LAKE COMMUNITY
CENTRE, 3350 VICTORIA DR

35 CIRCLE OF STONES 1995

> A tall post, carved with shapes representing the park's plant and animal life, stands on a stone and faces a circle of other stones. Artists Glen Anderson and Patrick Foley designed the site—said to be located on an energy line—as a community meeting place. It has been suggested that a grid of energy, or ley lines, can be drawn over the Earth and these lines will intersect at specific points that dictated the location of ancient spots such as Stonehenge. •

36 TROUT LAKE COMMUNITY CENTRE MURAL 2000

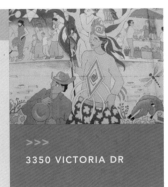

> In the mid-1800s, Trout Lake, once a peat bog, provided water via a flume to power the Hastings lumber mill on Burrard Inlet. The mill was owned by a John Hendry—giving rise to the name of the surrounding park. The mural images are based primarily on current activities and the nature found at Trout Lake. Artist Linda Pearce used a qualitative research method to elicit themes the community thought should be in the mural. •

>>>
3350 VICTORIA DR

37 PERSONALIZING OUR PARK 1995–2008

> Greenways within a city present an opportunity to encourage environmental awareness, natural resource and wildlife protection, pedestrian and recreational activities, and to link communities. These mosaic stepping stones, which artists Tom Chavez and Karen Stanley helped community members to create, can be found among the grasses and flowers and brighten the walkway area. In the 1880s, the Cedar Cottage neighbourhood was a farm and had a plant nursery. •

>>>
1500 BLOCK,
EAST 19TH AVE

38 COMMUNITY WALLS, COMMUNITY VOICES 2003

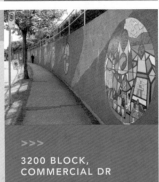

> Artists Dan Bushnell, Richard Tetrault and Jerry Whitehead, worked together for over a year with 300 people from the Kensington–Cedar Cottage neighbourhood and the Native Education Centre to beautify this long concrete retaining wall. The theme of "origins" resulted in 28 circular mosaics designs depicting both the participants' multicultural origins and community events. These mosaics need to be viewed from various distances to appreciate their words, photos and other images. •

>>>
3200 BLOCK,
COMMERCIAL DR

39 UNTITLED (OUR LADY OF FATIMA) 1970

> A metal outline of Our Lady of Fatima is located on the outside wall of the Catholic church of the same name. Our Lady of Fatima (or, Lady of the Rosary) was a name given to the Virgin Mary after three shepherd children in Fatima, Portugal, reported her appearance to them on the 13th day of each month, for six months in 1913. The sculptor of this piece was internationally recognized Elek Imredy, who came to Canada after the 1956 Hungarian revolution. •

>>>
1457 EAST 13TH AVE

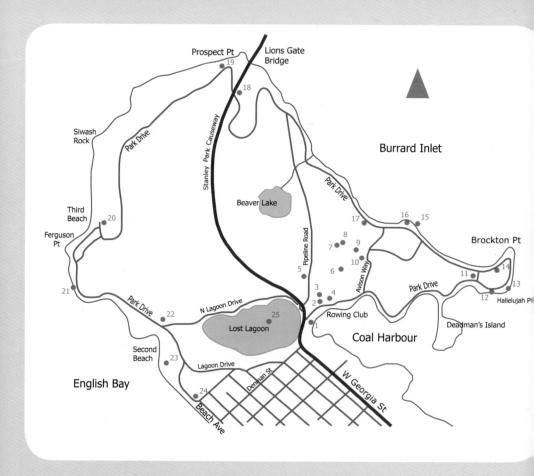

stanley park

GEORGIA ST ENTRANCE

1 UNTITLED (WINDFALL) 2007

> In December 2006, Stanley Park was hit by gale-force winds (up to 120 km/hr) that levelled significant areas and more than 10,000 trees were lost. It will take decades before the heavily hit areas regenerate into a healthy forest. As in every "situation" in Vancouver, controversy arose: from previous predictions that a "designer forest" would lead to vulnerability, and after the storm how deadfall should be dealt with. From the devastation new opportunities emerged—a forestry management plan was initiated and over 16,000 trees were planted. This piece, at one of the busiest park locations, is a stark sculptural thought-piece. •

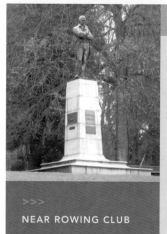

NEAR ROWING CLUB

2 ROBBIE BURNS MEMORIAL 1928

> Paul Grant and Laurie Dickson's *The Stanley Park Companion* notes that much of BC was opened up by Scottish explorers, cartographers, botanists, fur traders and Hudson's Bay Company merchants. This statue of the 18th-century Scottish poet is one of three copies of George Lawson's 1881 original in Ayr, Scotland. Plaques on the granite base have a few lines from Burns' poems, which are also illustrated in relief. It was dedicated by Ramsay MacDonald between his two terms as Britain's prime minister. •

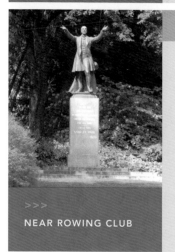

NEAR ROWING CLUB

3 LORD STANLEY 1960

> Lord Stanley, son of a British prime minister, was selected by Queen Victoria as Canada's Governor General. He dedicated the former 1,000-acre military reserve now known as Stanley Park in 1889, "To the use and enjoyment of people of all colours, creeds and customs." He is also famous for donating hockey's Stanley Cup. At his death in 1908, he was one of the world's richest men. Stanley was inducted into Canada's Hockey Hall of Fame in 1945. Britain's Sidney March was this statue's sculptor. •

4 QUEEN VICTORIA MEMORIAL FOUNTAIN 1905

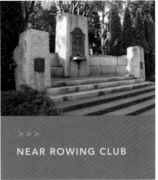

NEAR ROWING CLUB

> The plaque reads, "In memory of Victoria the Good, this monument is erected by the school children of Vancouver." During the time Victoria was Queen, from 1837 to 1901, she never visited Vancouver. It's reported that this is the first example here of a city-initiated sculpture. Bronze and the same granite as the lions at the old courthouse was used. The artist was James Blomfield, who created the city's original coat of arms. If you look closely, you'll find nine lions. •

5 SHAKESPEARE MEMORIAL 1935

NEAR ROSE GARDEN

> This is one of three monuments to authors in the park. John Francis Watson was the artist. William Shakespeare (1564–1616) died over 150 years before the first Europeans saw Vancouver. As the monument says, "He was not of an age, but for all time." It was to have been the centrepiece of a garden of all the plants Shakespeare wrote about. An attempt was made on a similar theme in New York's Central Park in 1890, but focused on Shakespeare's birds. Note the nose job! •

6 HARDING MEMORIAL 1925

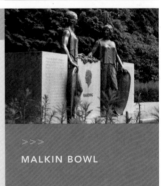

MALKIN BOWL

> In 1923, Republican Warren Harding of Ohio was the first American president to visit Canada (Lyndon Johnson was in Vancouver in 1964; Bill Clinton in 1993 and 1997). Considered handsome, he was elected in a 1920 landslide—the first election in which women voted. This installation, paid for by Kiwanis Club members, features a profile of Harding flanked by two female figures with shields, and eagles—lots of symbolism. Around the back, another lion, thanks to sculptor Charles Marega. •

7 CORN STALKS 2004

NEAR THE
MINIATURE TRAIN

> The Stanley Park Ecology Society used traditional cob building to upgrade its popcorn stand near the Miniature Train. An army of volunteers, building by hand, used clay, water, sand, straw, stones and recycled granite—consistent with their sustainability focus. Recycled bottles let in light. Check out the environmentally sound green roof. Charles Reynolds, a Vancouver graphic designer, added the public art touch: stalks of corn on the north end. •

8 VARIETY'S CHILDREN 1991

> > >
NEAR THE
MINIATURE TRAIN

> The Variety Club commissioned this totem pole to be carved at its 64th annual international convention, held in Vancouver. The pole, honouring the children of the world, shows a mother at the top embracing young twins with an older sister between the mother's knees. Below, the father is shown with a son. It is appropriately located at the entrance to the Children's Farmyard. The Coast Salish artist, Francis Horne, now lives in Chilliwack, BC. •

9 JAPANESE-CANADIAN WAR MEMORIAL 1920

> > >
NEAR AQUARIUM

> The city has many monuments to various nationalities acknowledging their sacrifice in Canada's defence. Most moving is this memorial, as it reminds us of how Japanese-Canadians were interned in WW II. It documents the WW I battles that Japanese soldiers participated in; for example, Vimy Ridge, which historians suggest defined Canada's coming of age as a nation. It lists C.W. Mawatari and M. Tanaka, two Canadian soldiers who fell in WW II. The architect was James Benzie. •

10 KILLER WHALE 1984

> > >
AQUARIUM

> Controversy surrounds the Vancouver Aquarium: should animals be in captivity? Since opening in 1956, it has housed many whales. Many have died; some were moved to San Diego. The orca show was a longstanding attraction but the aquarium now focuses on other aspects, such as the Wild Killer Whale Adoption Program. The plaster cast of Bill Reid's large bronze *Killer Whale* (a.k.a. *Chief of the Undersea World*) is mounted in the Canadian Museum of Civilization in Hull, Quebec. •

11A BEAVER CREST POLE 1987

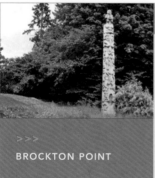

> > >
BROCKTON POINT

> Nisga'a artist Norman Tait's family carved this pole. It tells how they adopted the beaver as their family crest after over-hearing two beavers-turned-humans discussing how the beaver family was being destroyed by hunting. A man from the Eagle clan holding the raven introduces the story of how Eagle and Raven met and agreed to share the skies. The other crests are a human form with Frog and Eagle, faces of five brothers who were hunting the beaver, and numerous beavers. •

11B CHIEF WA'KAS POLE 1987

> The original pole, modelled on a chief's ceremonial talking stick, was carved in 1897 and erected at Alert Bay. The present pole was carved in 1987 by Doug Cranmer. The ornate pole has the raven's beak open to allow ceremonial entrance into the house, using the lower beak as a ramp, and the rest of the raven body painted on the outside walls of the house. Forms are Thunderbird holding Killer Whale, Wolf, Wise One, Hux-whukw (mythical cannibal bird), Bear and Raven. •

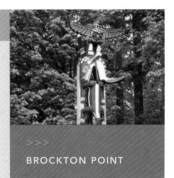

>>>
BROCKTON POINT

11C GA'AKSTALAS 1991

> This pole was designed by Russell Smith and carved by Wayne Alfred and Beau Dick. It tells how the Kwakwaka'wakw people obtained their first canoe and the right to use the sea-kingdom masks and magic. Forms include Quolos, a legendary bird; Red Cedar Bark Man with canoe; Sisyutl, a double-headed serpent; Siwidi, who made a journey to the Undersea; Killer Whale; and Dzunukwa, the giantess who gave wealth and magic but also represented danger. •

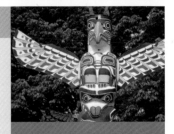

>>>
BROCKTON POINT

11D KAKASA'LAS 1955

> Mungo Martin and his niece Ellen Neel (the first woman among Northwest Coast carvers) carved five poles for the first shopping mall in Edmonton, Alberta. In 1985, when three of the poles were returned to BC, this one was loaned to Stanley Park by the Museum of Anthropology. The forms are Eagle, Sea Bear standing on the shoulders of a woman holding a frog, who stands on Bak'was, wild man of the woods, and Dzunukwa, the giantess with her feet between the ears of Raven. •

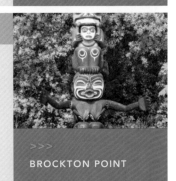

>>>
BROCKTON POINT

11E OSCAR MALTIPI POLE 1968

> The middle totem pole was carved by Kwakwaka'wakw artist Oscar Maltipi, who learned his craft from the respected artist Henry Hunt while working at the Royal BC Museum. It was raised in Stanley Park in 1987. The carvings tell of real or mythical events in the lives of a family or person or tribe. The crests are Thunderbird, who is a powerful mythological bird, and Killer Whale, who represents the sea and is preyed upon by Thunderbird. •

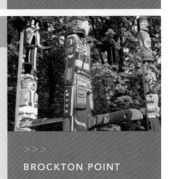

>>>
BROCKTON POINT

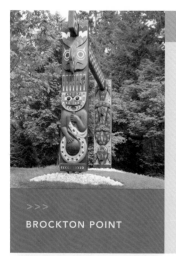

BROCKTON POINT

11F PEOPLE AMONG THE PEOPLE 2008

> For its first *Storyscapes* art installation, the Vancouver Public Art Committee chose three portals to welcome people to the most visited tourist site in British Columbia. They honour the three local groups within the Coast Salish Nation: the Musqueam, Squamish and Tsleil-Waututh. Coast Salish artist Susan Point used designs from traditional baskets and weaving as well as contemporary interpretations of Welcoming People and the Thunderbird, Whale, Sea Serpent, Salmon and Herring found in First Nations myths and legends. Faces of children are complemented by the forms of grandparents who have passed on the stories and lessons that link each generation. •

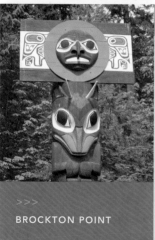

BROCKTON POINT

11G SKEDANS MORTUARY POLE 1964

> This pole is a replica of one originally carved in Haida Gwaii in the late 1800s and brought to Vancouver in 1936. Bill Reid and his assistant Werner True carved this replica in 1964, and Don Yeomans later recarved the moon face. In 1983, during a restoration project, fragments of the original were found discarded in the Stanley Park woods and were returned to Skidegate. The forms are the hereditary crests of the Chiefs of Skedan: Moon, Mountain Goat, Grizzly and Whale. •

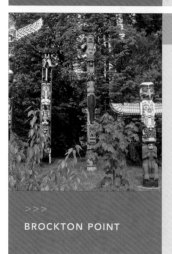

BROCKTON POINT

11H SKY CHIEF POLE 1988

> Showing a more contemporary carving style than many, this pole was carved by Tim Paul, a Hesquiat artist, and Art Thompson, a Ditidaht artist. The forms are Sky Chief holding the moon, Kingfisher, Humpback Whale, Thunderbird, Lightning Snake, Wolf and Man of Knowledge holding a Tupati, which was used in special marriage ceremonies and challenges. Lightning Snakes help Thunderbird by killing whales with their lightning strikes so Thunderbird can grab the whales. •

11| THUNDERBIRD HOUSE POST 1987

> Charlie James carved the original post in the early 1900s. It was intended to support the large roof beams of the house of Kwakiutl Chief Tsa-wee-nok in Kingcome Inlet. The post appeared in a 1914 film about Northwest Coast natives called *The Land of the Headhunters*. James was one of the first carvers to use colours and a bold style of design, and he influenced many young carvers. This replica, with Thunderbird on top of Grizzly Bear holding a human, was carved by Tony Hunt. •

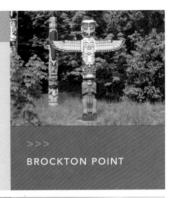

>>>
BROCKTON POINT

12 HARRY WINSTON JEROME 1986

> This memorial is one of several in Vancouver that celebrate runners. Born in Saskatchewan, Jerome moved to North Vancouver when he was young. The "world's fastest man" was the second Vancouverite, after Percy Williams, to set a world record in the 100-yard sprint. Running in three Olympics, he won bronze in Tokyo in 1964. He worked hard for young athletes and black Canadians. In 1971, he was named BC's Athlete of the Century. This statue is by Jack Harman. •

>>>
FACING COAL HARBOUR

13 NINE O'CLOCK GUN 1894

> This gun is still fired daily, except for during maintenance and when it was kidnapped as a prank in 1969. It was also silenced during WW II, so as not to alarm the public. Cast in England in 1816, it is a 12-lb. muzzleloader, originally installed so sailors could synchronize their timepieces for accurate tide readings. In 1986, the gun and the small granite and mesh pavilion were restored. Just before 9 p.m.: "Caution: Flashing Lights Indicate Gun Is About to Fire!" •

>>>
NEAR
HALLELUJAH POINT

14 CHEHALIS CROSS 1906

> In 1906, the steam tug *Chehalis* was rounding Brockton Point with a load of sunbathers when it cut in front of the CPR steamer *Princess Victoria*. Eight passengers and crew drowned when the *Chehalis* sank. Captain Griffin of the *Princess Victoria* was charged with manslaughter but acquitted. This monument was erected by shipmates and friends of those lost. The tug was named after the Chehalis Nation from the Agassiz area. In their language, the word *chehalis* means "beating heart." •

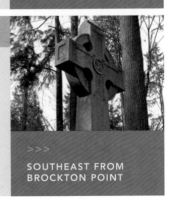

>>>
SOUTHEAST FROM
BROCKTON POINT

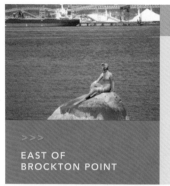

>>>

**EAST OF
BROCKTON POINT**

15 GIRL IN A WETSUIT 1972

> Initially, there was talk of recreating the *Little Mermaid* from Copenhagen's harbour, but luckily, a West Coast image was used instead. Many people refer to her as a mermaid, but she is a scuba diver with flippers. The pre-existing granite rock was raised so the statue would always be above high tide. A fibreglass version was made from a plaster mould by sculptor Elek Imredy and then cast in Italy. Most divers recognize a mask on the forehead as a signal of distress. •

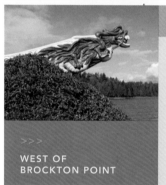

>>>

**WEST OF
BROCKTON POINT**

16 EMPRESS OF JAPAN 1960

> The *Empress of Japan* was built in 1891 for the Canadian Pacific Railway. Crossing the Pacific 315 times (she held the speed record of just over 10 days for the crossing), she carried mail, silk and tea, and many Asian immigrants to Canada. During WW I, she was fitted with guns for war service. She was scrapped in 1928 and her figurehead was installed along the seawall. In 1960, the original was moved and replaced by this fibreglass copy. •

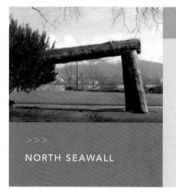

>>>

NORTH SEAWALL

17 LUMBERMAN'S ARCH 1952

> The first *Lumberman's Arch* was built downtown in 1912, as one of 10 lining the parade route of the Duke and Duchess of Connaught. It looked like a small Greek building, with different columns celebrating the variety of BC trees. Afterwards, it was floated to the current site where it remained until 1947, when it was demolished. The current *Lumberman's Arch* stands on the site of one of several Coast Salish villages that were in the park before European settlement. •

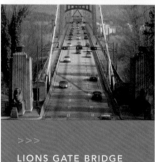

>>>

LIONS GATE BRIDGE

18 LIONS 1939

> The Guinness family of Irish brewery fame built this bridge to access their 4,000 acres on the North Shore. The lions are by Charles Marega; who sculpted more lions in Vancouver, by far, than anyone else. *Lions Gate* by Lilia d'Acres and Don Luxton describes the lions being sculpted in clay, cast in plaster and poured in concrete. The heads (2 tons) and bodies (6.5 tons) were placed just months before Marega died. Smaller lions were recently added to the overpass immediately to the south. •

19 SS *BEAVER* TABLET + CAIRN 1925

PROSPECT POINT

> This cairn memorializes the SS *Beaver*, which ran aground at Prospect Point in 1888. Built in Blackwall, England, for the Hudson's Bay Company, she became the North Pacific's pioneer steamship. Wooden-hulled, she had a sidewheel. As noted on the plaque, "The story of the *Beaver* is the story of the early development of the western coast of Canada." At very low tides, remains of the ship can be seen. The SS *Beaver* is also remembered at the entrance to the Marine Building downtown. •

20 PAULINE JOHNSON MEMORIAL 1922

FERGUSON POINT

> Johnson's wish was for no memorial, but here it is—reported to be the resting spot of her ashes. She was born in 1861 on the Six Nations Reserve in Upper Canada to an English mother and Chief G.H. Johnson. She blended her English heritage and Mohawk legends into her poetry and, after adopting the Mohawk name Tekahionwake, became highly popular in Canada and Europe. In 1909, she moved to Vancouver, dying in 1913. The memorial's artist was James McLeod Hurry. •

21 BALANCING STONES ONGOING

BETWEEN SECOND
+ THIRD BEACHES

> For a number of summers, Kent Avery has been creating sculptures by balancing stones, and sometimes driftwood, on the beach. Disappearing with the daily tides, the ephemeral aspect adds substantially to their power, as they are "in the moment." He says the stones are balanced by feel. Metaphorically, he says, he has communion with them. To support his work he accepts donations and sells photographic greeting cards. Buy one to keep him going! •

22 UNTITLED (FACE IN THE WOODS) N.D.

NEAR SECOND BEACH

> No one seems to know who carved this artwork or when it was done. It takes a bit of looking to find the face, carved into a large stump but, as soon as it comes into view, its power becomes evident. Apparently unsanctioned, it qualifies as guerrilla art. It's not far from the Aaron Webster Shelter. Webster was murdered at age 41 in 2001 in a vicious assault, described as a gay-bashing hate crime. •

23 AIR INDIA MEMORIAL 2006

> In 1985, Air India Flight 182 blew up off the Irish coast, killing 329 people in Canada's worst terrorist incident—the bomb was loaded in Vancouver. In a related explosion, two baggage handlers died at Tokyo's Narita airport. This memorial is at the edge of the playground. Controversy arose as the site, earlier rejected for the *AIDS Memorial*, was considered appropriate to commemorate the death of the 82 children. By Erik Lees and Associates, it was completed 21 years after the incident. •

24 DAVID OPPENHEIMER 1911

> David Oppenheimer, born in Germany, followed the gold rush to California, eventually coming to Vancouver and becoming, with his brother, a successful grocer. Oppenheimer was key in establishing Vancouver's streetcar system to support development of his eastside lands in rivalry with the CPR-led westside interests. The second mayor of Vancouver, from 1888 to 1891, he donated land for Hastings Park and the Rogers sugar refinery. Both a park and school are named after him. This bust's artist was Charles Marega. •

25 JUBILEE FOUNTAIN 1936

> The name "Lost Lagoon" comes from Pauline Johnson, who lamented that low tides caused the cove off Coal Harbour to be "lost" to her. When the causeway was built into Stanley Park, it cut the tidal saltwater flats off from Coal Harbour, creating a freshwater lake. The fountain, purchased from Chicago's 1934 World's Fair to celebrate Vancouver's Golden Jubilee, was modified by engineer Lennox McKenzie. It was restored for Expo 86. In 1992, University of British Columbia engineering students mounted a Volkswagen on it. •

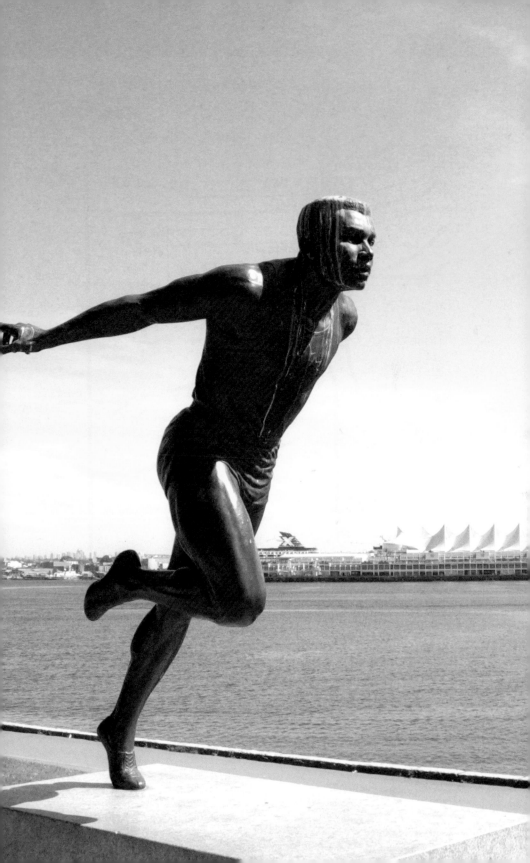

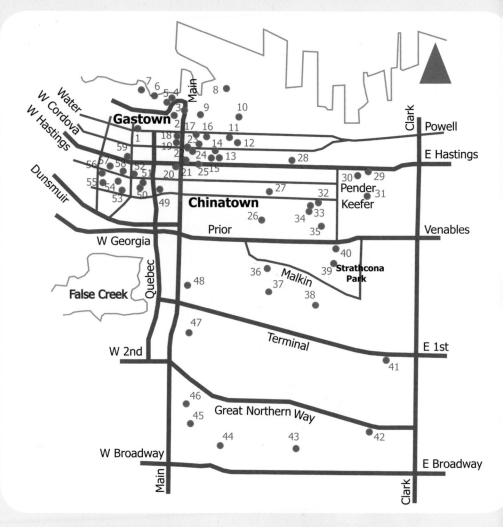

strathcona/chinatown

MAPLE TREE SQUARE,
CARRALL ST + WATER ST

1 GASSY JACK 1970

> Gastown was named for an Englishman, John "Gassy Jack" Deighton. A retired riverboat captain, he arrived in 1867 intending to open a saloon to quench the thirst of hard-working mill hands from nearby Hastings Mill. His business plan for the Deighton House Hotel consisted of "a barrel of whisky and a smooth talking manner." This copper statue has Gassy Jack (named for his "gassy" monologues) standing on that barrel of whisky. The sculptor was Vern Simpson. •

111 ALEXANDER ST

2 TO CONNECT 2008

> When Metro Vancouver replaced the Columbia Pump Station, a new installation was created by Sheila Hall to engage viewers in stories of the site and thinking about how a city changes. It includes bricks with words in 26 languages, a First Nations *Halkomelem* translation, a reconstructed CPR signal box and three interpretive windows showing the past (historic image), the present (live camera feeds of the waterfront) and the future (image with "water" in 26 languages). •

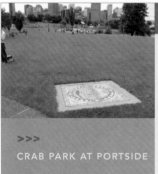

NORTH END
OF MAIN ST

3 SHANGHAI LIONS 1995

> A pair of sculpted lions tops the Main Street rail overpass, one of the few public entrances to the port. The western marble base has the inscription in Chinese, the eastern in English: "In Commemoration of Sister Port Relationship between Shanghai and Vancouver. Presented by Shanghai Port Authority." The lions are very similar to others at the Chinese Cultural Centre and the Chinatown Millennium Gate. In nearby CRAB Park is a concrete lantern from the Port of Yokohama. •

CRAB PARK AT PORTSIDE

4 NORTH SHORE FERRY 2001

> In 1868, John Thomas, better known as "Navvy Jack," began a ferry service from the North Shore to support the building boom in Hastings, Moodyville and Gastown. The first scheduled "official" ferry ran from 17th Street in West Vancouver to English Bay in 1909. The opening of the Lions Gate Bridge in 1938 provided an alternative. Since 1977, the SeaBus (two double-catamaran boats, the *Burrard Otter* and *Burrard Beaver*) has carried pedestrians across Burrard Inlet. •

5 RAVENS REVIVAL 2006

> This circular mosaic brightly replicates the faded paint version on the IRLY Pavilion just to the west. It represents a raven, dolphin and crab (after CRAB Park). Under the direction of Leah Decter, the artists were Dave Douglas and Allen Cardinal. The major image is surrounded by a ring of square tiles created by "community kids." Images include boats, fish, mermaids, starfish and, obviously, lots of crabs. Reflecting the children's perspective, there are several versions of SpongeBob SquarePants. •

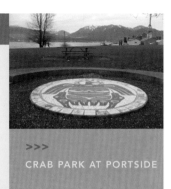

>>>
CRAB PARK AT PORTSIDE

6 HEART STONE 1997

> This stone sits above CRAB Park Beach. It states, "The Heart has its Own Memory." A documentary film of the same title, by Audrey Huntley and Folkard Fritz, features interviews with family members of missing aboriginal women. The stone honours those murdered in Vancouver's Downtown Eastside, many of whom were women and often aboriginal. Five years after this stone was dedicated, Robert Picton was arrested and convicted of murdering Downtown Eastside women. •

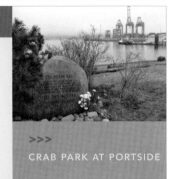

>>>
CRAB PARK AT PORTSIDE

7 CELESTIAL ERRATIC 1986

> This rectangular-framed structure near the pier is constructed of cedar timbers that frame a large rock. An erratic is a large boulder carried by glacial ice and deposited some distance from its place of origin. This work is by Volker Steigemann, a Cortes Island sculptor who specializes in the integration of wood and stone sculptural elements into large-scale artworks and architectural structures. Carved into the timbers are a variety of details: swirls, faces and patterns. •

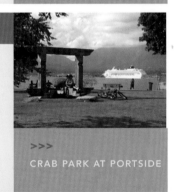

>>>
CRAB PARK AT PORTSIDE

8 HASTINGS MILL MONUMENT 1966

> The Queen Anne house here was built by BC Mills Timber and Trading Company to showcase their product. It is now the Flying Angel Club. In the yard is a Gerhard Class three-part granite sculpture commissioned by the Vancouver Historical Society. Each piece has carved line drawings and a narrative that commemorates Hastings Mill (1865–1928), which "fostered the settlement that grew to be Vancouver" through "the supply of her great timbers to the world." •

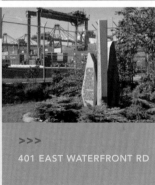

>>>
401 EAST WATERFRONT RD

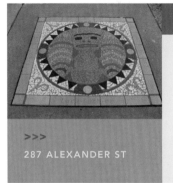

287 ALEXANDER ST

9 LUCK-LUCK-EE 2001

> The original name for this area was the First Nations phrase *luck-luck-ee* meaning "grove of beautiful trees." Before European settlement, it was the summer camp for both the Squamish and Musqueam peoples. The False Creek mudflats reached just south of Gastown and, although there was a sandy beach on the Burrard Inlet side and a large stand of maple trees, the Gastown area was generally swampy. At high tide, the two bays linked, creating a temporary island to the west. •

487 ALEXANDER ST

10 1942 2001

> Many Japanese people contributed to the growth of the Canadian West—working on the railway, in canneries and lumber mills, and building a fishing fleet. Despite this, over 22,000 Japanese lost their land, possessions and civil rights after war was declared between Japan and Canada in 1941. They were interned in camps in the Interior of BC and farther east in Canada. In 1988, the Canadian government made an official apology and offered redress. •

528 POWELL ST

11 V6A ART 1995

> Postal codes, a pair of three alpha-numeric characters, are often used to cross-reference census data. Advertisers use this information for focused mailings but not many aim at the V6A area, reputed to be Canada's poorest postal code. Teresa Gaiters and Debra Gibson led workshops to create this mural at the Living Room, a safe environment for adults with serious mental illness. The mural has over 300 sections, ranging from happy faces to a version of Edvard Munch's *The Scream*. •

131 DUNLEVY AVE

12 PINK FLOWERS N.D.

> Parts of Vancouver have adopted security measures to keep homeless people from camping out in dry, recessed doorways. They are usually utilitarian grating, but this folk art response adds some whimsy to an otherwise rundown streetscape. The stalks are made from painted scrap-metal strips; the flowers from circular saw blades. The flowers remind the urban art explorer to keep looking for the gems that appear from time to time—not part of any corporate program, but still with merit! •

13 MARCH TO OTTAWA 2001

> In 1935, during the Great Depression, work camps were set up to house and feed the men working on federal projects for 20 cents a day. Frustrated with camp conditions, 1,500 men organized a protest that resulted in the "On to Ottawa" trek to present their demands to the prime minister. The protest ended in Regina where a policeman was killed and 120 men arrested. Eight men did go on to Ottawa, but little came of their presentation. •

>>>
EAST CORDOVA ST
+ JACKSON AVE

14 POWELL STREET GROUNDS 2001

> The Powell Street Grounds have served as playing fields, a meeting place for the Japanese residents of the area and a rallying spot for members of unions and socialist movements. Renamed Oppenheimer Park after a former mayor, the park hosts events like the Powell Street Festival. The Japanese symbol for the festival—cherry blossoms and open fans—is a reference to the local community. The baseball diamond acknowledges the Asahi club, which won many city championships. •

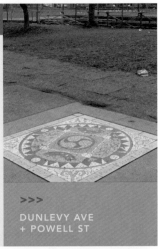

>>>
DUNLEVY AVE
+ POWELL ST

15 OPPENHEIMER MEMORIAL TOTEM POLE 1997

> This memorial pole and the eagle bench commemorate those who have died in the Downtown Eastside. At the time of its dedication, poet Sandy Cameron wrote that the pole was a symbol that the Native people would "rededicate themselves for hope and justice from one generation to another." In the 1930s, there were many demonstrations by the unemployed in the park; these days, the voiceless, faceless homeless often haunt the park and, if we let them, our conscience. •

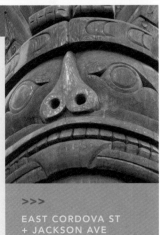

>>>
EAST CORDOVA ST
+ JACKSON AVE

300 POWELL ST

16 SUNRISE MARKET MURALS 2004

> Sunrise Market, an always crowded eastside landmark, specializes in fresh produce, although there is also an unlimited variety of special Asian sauces, fish and meat. There is one mural along the west facade behind the vegetable displays and another beside the rooftop parking. Designed by Cristina Peori and painted by the Creating Employment Through Art (CETA) co-op, the upper mural has a variety of images, from potatoes and local neighbourhood buildings to a dragon and a totem with the words "Gone but not forgotten." The murals were completed as part of the City of Vancouver's Graffiti Management Program. •

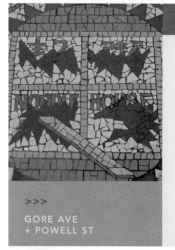

GORE AVE
+ POWELL ST

17 1907 2001

> Michael Barnholden's book *Reading the Riot Act* documents Vancouver's riots: the free speech riots of 1910, the Rolling Stones riot of 1994, the Stanley Cup riot of 1994, APEC in 1997, Riot at the Hyatt in 1998, the Guns N' Roses riot of 2002, etc. This mosaic commemorates the riot of 1907, when sentiment along the West Coast held that Asians working for low wages were stealing jobs. A riot in Bellingham, Washington, spread to Vancouver's Chinatown and then on to Japantown where local resistance stopped it. •

233 MAIN ST

18 JUBILEE GARGOYLES 1992

> Ken Clarke created this frieze of 10 painted faces, moulded in fibreglass, on the Jubilee Building. Two side-by-side rooming houses with reputations as a crack house and a brothel were renovated in 2000 by social justice entrepreneur Hart Molthagen, creating 78 single-occupancy rooms. The building also houses Jacob's Well (a tenant-support organization) and the Hungry Thumbs Studio, where Clarke and other artists work. The faces, demonstrating a range of emotions, are bound to make everyone smile. •

19 FIRE HALL MURAL 2005

> This mural by Milan Basic showcases the history of the Vancouver Fire and Rescue Services, from horse-drawn equipment to today's modern trucks. Vancouver was incorporated on April 6, 1886. At its second meeting, city council authorized a volunteer fire brigade, but no funds were available for equipping it. Vancouver burned down almost completely in the great fire of June 13, 1886; eight days later, the city ordered its first firefighting equipment. •

>>>
199 MAIN ST

20 CARNEGIE CENTRE 2001

> In 1901, Andrew Carnegie, the American industrialist and philantropist, donated $50,000 to build a library here. Designed by local architect George Grant, it was constructed of Indian Arm granite and Gabriola Island sandstone. As stated in *Exploring Vancouver*, "redolent of high-minded Victorian philanthropy, it is now, paradoxically, the flagship of Skid Row." A community resource, it has been referred to as the living room of the Downtown Eastside. There is great art inside. •

>>>
MAIN ST +
EAST HASTINGS ST

21 HEART OF THE COMMUNITY 2001

> A red heart/bear paw emerges from an Ionic column drawn from the front portico of the nearby Carnegie Centre. The corner of Main and Hastings, an early heart of the city, was always a meeting place and bordered a busy shopping area. Gradually the area changed and became the haunt of the disenfranchised. Now revitalization plans have painted a new face on the community—but questions about how to share the public space with all the residents remain. •

>>>
MAIN ST +
EAST HASTINGS ST

22 BRUCE ERIKSEN PLACE 1998

> Bruce Eriksen was an artist, social activist, founder of the Downtown Eastside Residents Association and a Vancouver city councillor. The art on this social-housing project has two elements. The lower portion has photo-based panels by Blake Williams about the perceived class conflict on the Downtown Eastside. On balconies facing Main Street, he created tiles with words reflecting eastside political attitudes: "share, change, vote," etc. The architecture firm was Henriquez Partners. •

>>>
380 MAIN ST

312 MAIN ST

23 A RECOVERING HEROIN ADDICT 2000

> As part of a millennial initiative, 230 yellow plaques were put on street poles. Each tells the personal story of a neighbourhood resident. This plaque, outside the door of the Downtown Eastside police station, tells Darren Stratton's story of "chasing the dragon." "I lost my youth as a slave to my addictions," he says. "Either you quit or you die, and I don't want to die." A CD and a book of the collected stories are available at the Vancouver Museum. •

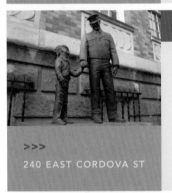

>>>
240 EAST CORDOVA ST

24 POLICE AND GIRL STATUE 1987

> This statue, by R. Broom, sits outside the Vancouver Police Museum located in the historic city morgue and Coroner's Court. The museum has lots of interesting stories to tell—for example, the autopsy of Errol Flynn was conducted here in 1959. The half-life-sized statue shows an officer holding hands with a smiling young girl. The plaque says it is to "honour those who have gone before us and challenge those who will come after us." •

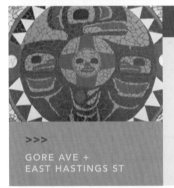

>>>
GORE AVE +
EAST HASTINGS ST

25 RAVEN CREATED THE WORLD 2001

> Raven is one of the most important beings in the mythology and art of the North Coast First Nations. He has many personas in stories, depending on the lesson that the story teaches. The raven in this mosaic has a star and a human-like face in its stomach. Traditional forms and colours (red, black and white) are used for the design, which acknowledge the many First Nations residents in the area. •

>>>
EAST GEORGIA ST +
JACKSON AVE

26 CHIEF MALCOLM MACLENNAN 2001

> Drugs, prostitution and firearms are not new problems in the Downtown Eastside of Vancouver. In 1917, the chief of police was killed while assisting his constables with an armed drug addict who was shooting out his window. The mosaic police badge is surrounded by prison chains, poppies in remembrance and doors representing houses of prostitution. Maclennan is one of 16 members of the Vancouver Police who have been killed in the line of duty since 1886. •

27 2000 VIEWS OF STRATHCONA 2000

> Martin Borden worked with local residents on this mural in the lobby of the Strathcona Community Centre. It is made up of 2,000 photographs that draw a compelling community portrait, from the large fish plants at the port to colourful details of the heritage homes—people working, playing and celebrating their culture. If a picture is worth a thousand words, 2,000 pictures add up to 2,000,000 words. That's a lot to say about one of Vancouver's most intriguing neighbourhoods. •

>>>
601 KEEFER ST

28 UNTITLED (FISHERMAN'S UNION) 1968

> This white, precast-concrete relief on three sides of the former Fisherman's Union Building was created by Leonard Epp. He came to Canada in 1951 from Germany, graduating from the Vancouver School of Art in 1960. Three forms were used: two featuring fishing boats, the other featuring fish. The flowing lines of the design are such that each complete panel consists of various arrangements of the three forms. The building was designed by architect Robert Harrison. •

>>>
803 EAST HASTINGS ST

29 RAY-CAM MURAL 1991

> The Ray-Cam (named after nearby streets) Community Centre, started in 1979 by local residents as a co-operative food store, has evolved into a full community centre. This large, bold mural on the centre's side is by Richard Tetrault. The mural depicts a row of community residents facing the street. There are aboriginals with traditional symbols, Sikhs, Japanese and blacks. People skateboard, they roll in wheelchairs and one has spiky hair. •

>>>
920 EAST HASTINGS ST

30 STRATHCONA HISTORY MURAL 2004

> This mural documents interesting vignettes from an area that was one of Vancouver's most colourful before WW I. One house, now owned by the Sisters of Atonement, is believed to be the oldest house in Vancouver. Another house, 504 Alexander, was once a bordello. The Hotel Patricia hosted legendary musicians such as Duke Ellington and Ferdinand "Jelly Roll" Morton. The mural is by Cristina Peori with CETA. •

>>>
CAMPBELL AVE +
EAST HASTINGS ST

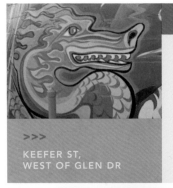

> Railways sometimes create barriers. Following protests, an overpass was built over the CPR line to provide a safe link between two communities. This artwork is mostly paint on concrete by Richard Tetrault and local children but it includes a wooden gate with dragon-like teeth. There's also a terrific Raven holding the sun like a jewel in its beak, illustrating a traditional First Nations myth. Like the overpass that links areas on both sides, this installation links cultures. •

>>>
KEEFER ST,
WEST OF GLEN DR

32 TRANSFLEXION 2008

> Arnt Arntzen, originally from Vancouver's North Shore, now works in the heart of funky Strathcona. Here, he shares the artist-owned Panificio Studio (a former bakery) with other creative artists at the original core of the Eastside Culture Crawl, a 300-artist open-studio festival held yearly in November. His work focuses primarily on functional sculpture, such as *Rocket* and *Helicopter Chairs*, mostly based on salvaged and recycled metal and wood. •

>>>
800 KEEFER ST

33 BRIDGE THE TWO COMMUNITIES 1997

> Concrete tiles with cast glass (handprints, footprints, fish and cameras), made in community workshops with children, were set in painted columns at both ends of a bench. Looking like London's Tower Bridge, it is meant to be a link between the communities of Strathcona and Ray-Cam. Artists are Wayne Harjula and Miyuki Shinkai. The park is named after M.A. MacLean, the first mayor of Vancouver. •

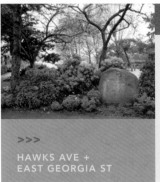

>>>
HAWKS AVE +
EAST GEORGIA ST

34 AT HOME ON KEEFER 1999

> Vancouver, like everywhere else, is full of stories. On a *Millennium Story Stone* at MacLean Park, Dr. Anthony Yurkovich tells of his life in Vancouver after his father died of tuberculosis in 1935. He recalls the fun: movies at the Royal Theatre on Hastings, free swimming lessons at Stanley Park, splashing in the spray of the water truck. Later, he finds his family address listed in an old phone book in the Vancouver Archives: where his family name should have been, it had only "Widow." •

>>>
HAWKS AVE +
EAST GEORGIA ST

35 UNTITLED (UNION STREET) 1997

> This is a contribution to the local street, a popular Vancouver bikeway, by the sculpture's owner, Tony Pantages, an award-winning commercial and music-video director. He met the sculptor, Davide Pan (originally from Italy), while shooting a video in the former derelict Versatile Shipyard on the North Shore, where Pan was recycling materials into this sculpture. •

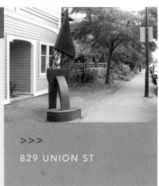

>>>
829 UNION ST

36 A TALE OF TWO CHILDREN: A WORK FOR STRATHCONA 2005

> On the back wall of the City of Vancouver's National Works Yard, two large aluminum panels tell different stories of parental pressure by combining photographs and text. One is "What an idiot!" on a red background. On the positive, green side, a woman tells her daughter, "You so smart." This piece is by Ken Lum, an internationally recognized artist, and a distinguished visiting professor at UBC, who grew up two blocks away from the works yard. •

>>>
MALKIN AVE
+ THORNTON ST

37 ROLLER 2004

> This relic at the city's works yard, a brightly painted Buffalo Springfield roller (ever wonder where the name of Neil Young's 1960s rock band came from?), was used in construction in Vancouver during the 1930s and '40s. There are three metal silhouettes of the paving crew: the driver, the raker and the shoveller. The lead designer working with the city was Richard Prince, UBC professor and artist. Another of his works, in a much different vein, is seen at Roundhouse Mews. •

>>>
THORNTON ST
+ NATIONAL AVE

38 PROJECT FOR A WORKS YARD (CROSS SECTION) 2004

> At the southeast corner of the City of Vancouver's works yard is a large and interesting structure—a mostly to-scale section of a street, including both the utilities, normally buried, and above-ground street furniture. Appropriate to the context of the works yard, it shows those utilitarian components that we vaguely know about but take for granted. There is also, of course, a street tree. Gary Snider's work both educates and entertains. •

>>>
NATIONAL AVE
+ CHESS ST

>>>
SOUTH OF
CAMPBELL AVE

39 STRATHCONA PARK PAVILION 2005

> On a small mound at the centre of the park, is a rain shelter—posts and a roof—with intriguing decoration. Pat Beaton led a community art-making process based on cut-paper designs. The structure, designed by architect David Rose, uses both metal cut-outs and positive wood forms affixed to panels. The upper images, cut into symmetrical metal forms set in the frameworks, are birds. Below are wooden shapes that are delicate and whimsical. •

>>>
PRIOR ST
ENTRANCES

40 STRATHCONA PARK MOSAICS 2004

> At each of the three entrances to Strathcona Park there is, set within a large tile circle, a solar system of one large and several smaller circular mosaics by CETA and Bruce Walther. The western one focuses on eastside images: the Knight Street bus, symbols from Chinatown, the Woodward's "W." The middle one has mostly park activities like skateboarding (with a curious reference to "Canablis"). The eastern one has a more varied set of images, including Canada's flag, geometric designs and eyes. •

>>>
TERMINAL AVE
+ GLEN DR

41 MURAL (TERMINAL AVENUE) 2006, 2007, 2008

> This mural by Restart, on the south abutment of the overpass across the CNR has been growing each year. The east (first) section shows a variety of animals wearing or holding country flags in a green setting with coloured maple leaves; the middle section is more urban, a sinister scene featuring an "ace of spades" punk pointing his spray can at the viewer; and the west (third), while carrying the maple leaf theme, is more cartoonish and rooted in traditional graffiti. •

42 MEANS OF PRODUCTION 2003–04

> What may look like a jumbled garden in China Creek North Park is, in fact, an environmental art project growing art supplies, such as willow branches for baskets and other art projects. The project is "a working model of an inner-city sustained organic forestry." There is a large granite block with the words "Means of Production" etched into its north and south faces. Artist and writer Oliver Kellhammer is committed to including aspects of ecology in his art, writing and teaching and has done previous projects such as *Memory Trees*, which compiles oral histories that Marpole residents told about the community trees. •

>>>
EAST 6TH AVE +
ST. CATHERINES ST

43 COMMUNITY FENCE 1994

> "Don't take a fence down until you know why it was put up," said the American poet Robert Frost. Artists Merle Adison, Pat Beaton and Haruko Okano worked with local residents, using wood-burning tools to carve personal messages, images and designs into the funky cedar pickets that enclose the community garden. The fence in this case is not a barrier, but the demarcation of the garden, the result of many people from culturally different backgrounds working together to beautify and green their neighbourhood, contribute to a sustainable community and lessen the stress of city life. •

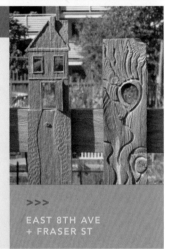

>>>
EAST 8TH AVE
+ FRASER ST

44 RECLINING FIGURE 1991

> While many sculptors use bronze in a classical Greek or Roman style to create a human form, Michael Dennis uses driftwood cedar pieces. He said that much of his work addresses ancestors and, in a poem titled *Gestures*, he wrote, "We get so much from body language/Before the words/Beyond the words." This form, gracing the lawn of Guelph Park, has a truly laid-back West Coast style. •

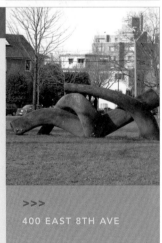

>>>
400 EAST 8TH AVE

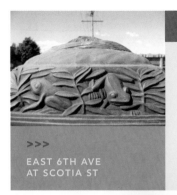

>>>

EAST 6TH AVE
AT SCOTIA ST

45 BREWERY CREEK OBELISKS 1994

> There are several bronze obelisks along the 1897 alignment of Brewery Creek from Tea Swamp to False Creek. Including history by Bruce MacDonald, they were designed by Bob Turner and George Rammell. The detailed motifs were inspired by the creek (fish, dragonflies and frogs) and the brewing industry originally along the creek (wheat and cascading water). Interpretive insets tell the history of Thorpe & Co., producers of drinks called Iron Brew, Kola Champagne and Sarsaparilla. •

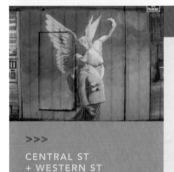

>>>

285 EAST 5TH AVE

46 WIL SAYT BAKWHLGAT TOTEM POLE 1985

> This tall portal pole, "the place where the people gather," was carved by Norman Tait and his family to tell how Man came to live in harmony with creatures. Each creature is important to the carver—Raven with Moon, Killer Whale, Black Bear holding a Wolf Cub and a human holding the rope that encircles the door. The Native Education College provides work experience, counselling and adult education. There is also a mosaic on the back of the building. •

>>>

CENTRAL ST
+ WESTERN ST

47 ANGEL OF VICTORY MURAL 2007

> One of the key elements of the city's Graffiti Management Program is an annual mural competition on bridge abutments or other structures such as this city-owned industrial warehouse. The best of the local spray-paint artists compete and their work deserves a serious look. The images are diverse and eclectic, and include local scenes like the inukshuk and Siwash Rock. There are several lions. This version of the *Angel of Victory* by Alex Cielsky was one of the 2007 award winners. •

>>>

MAIN ST
+ TERMINAL AVE

48 MARKER OF CHANGE 1997

> In a shooting spree at Montreal's École Polytechnique in 1989, a gunman separated women from men, then killed 14 women and injured 13 others. This tragic event is commemorated in Thornton Park in front of Vancouver's bus and train station. Fourteen benches of pink Quebec granite, each with the name of a murdered woman, are inside a large circle of 500 tiles acknowledging donors. Beth Alder of Toronto created this sociopolitical piece. •

49 CHINATOWN MEMORIAL MONUMENT 2003

> Arthur Shu-ren Cheng uses a worker and a soldier to show the diverse roles of the Chinese in Canada, whether it was building the railway in the 1880s or serving in Canada's army. The main column is a stylized version of the Chinese character for "centre." The couplet on the front and the back tells us we are only riding on the shoulders of our ancestors. Check out the statue on a summer weekend when the Chinatown Night Market is open along Keefer Street. •

>>>
KEEFER ST
+ COLUMBIA ST

50 DR. SUN YAT-SEN 1989

> Dr. Sun Yat-Sen had a huge impact on China. During long periods of exile, he developed his ideology. He became president of China after the 1911 revolution, ending the Imperial dynasties. He was unable to unite China, but he is held in high regard as the father of modern China. He visited Vancouver three times—in 1897, 1910 and 1911. This bust, by Tsang Juk Wan, is at the entrance to the formal gardens. In the plaza in front is a Chinese horoscope with mosaics for each sign (Rat, Pig, Snake, etc.). To the east on Columbia Street is the Footprints mosaic *Bridge to China*. •

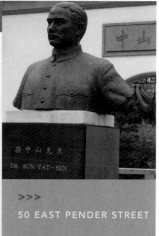

>>>
50 EAST PENDER STREET

51 CHINA GATE 1986, 2005

> After Expo 86, the world's fair that drew 22,000,000 people, the gate from the China pavilion was moved to the Chinese Cultural Centre. Meant to be temporary, it deteriorated. The main structural elements remain, but new carved marble sections were added. Vancouver artist Arthur Shu-ren Cheng, who emigrated here in 1990, designed the new gate from marble donated by the city of Guangzhou. Some of the plaques on the base still refer to the original Expo gate, but it is gone. •

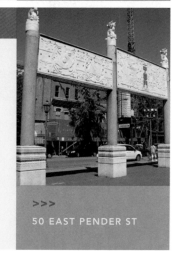

>>>
50 EAST PENDER ST

EAST PENDER ST
+ CARRALL ST

52 ASSOCIATIONS 2001

> In the mid-1800s, many Chinese came to work in BC's saw-mills, goldfields, coal mines and canneries. In the 1880s, at least 15,000 Chinese were contracted to come to Canada to help build the Canadian Pacific Railway. As Chinatown grew, the Chinese formed associations to aid each other socially and financially, as well as to provide housing. The buildings used by these clan and benevolent associations, generally based on surnames or places of origin, still line Pender Street. •

>>>

550 TAYLOR ST

53 SUAN PHAN: ABACUS 2005

> This abacus is at the seam between Chinatown and Downtown. The area is being redeveloped into a high-rise residential neighbourhood, but retains strong links to Chinatown. This installation is on the Silk Road path, linking Chinatown to Downtown. An elegant piece, its additional delight lies in the interactivity designed by Gwen Boyle. Jade pieces slide up and down for playful calculations by shopkeepers or customers who might pass by on the Silk Road. •

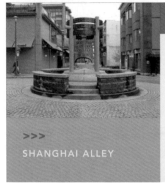

>>>

SHANGHAI ALLEY

54 GUANGZHOU BELL 2001

> This large bell is the centrepiece of the commemoration of the original Chinatown. It was a gift to Vancouver from the city of Guangzhou, honouring the 15th anniversary of the twinning of the two cities. The bell is a replica of a Han Dynasty (200 BC) bell found during the excavation, in 1983, of a major hotel in central Guangzhou. Descriptive panels provide a detailed and moving account of Chinatown and some of its more interesting residents. •

>>>

88 WEST PENDER ST

55 NEON (TINSELTOWN) 1999

> Vancouver used to have many commercial streets of small-scale buildings, whose storefronts sported unique, colourful neon signs. Then came sign bylaws and backlit canvas canopies; small properties were assembled into bigger sites that gobbled up the funkiness of the street and bland set in. However, two of the Tinseltown faces are decorated with bright neon, evocative of Vancouver's neon history. •

56 CHINATOWN MILLENNIUM GATE 2002

> This 15-m-tall gate, which cost about $1,000,000, was funded by three levels of government under the Vancouver Agreement, as part of a marketing plan for Chinatown and the Downtown Eastside. The gate is on the downtown side of Chinatown, on the Silk Road pedestrian route intended to encourage tourists on Pender Street to visit Chinatown. There are two large stone lions at the base of the exterior columns. The gate was designed by architect Joe Y. Wai. •

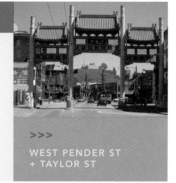

>>>
WEST PENDER ST
+ TAYLOR ST

57 SPIRIT OF HARMONY 2000

> This large piece is above the main entrance to a mixed-use building developed by the Vancouver Native Housing Society. All of their buildings follow a Northwest Coast tradition of placing art at the front of a house. The longhouse facade was constructed by Ronae Theabeau from Galiano Island cedar. The painted wood carving, by Roger Gerhardt, forms a face around a central standing watchman figure with the traditional Haida hat. •

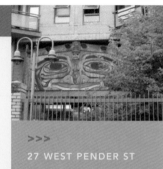

>>>
27 WEST PENDER ST

58 REDDY KILOWATT N.D.

> The book *Gaslights to Gigawatts: A Human History of BC Hydro and Its Predecessors* notes that the Reddy Kilowatt symbol was created in 1926 by Ashton Collins of the Alabama Power Company and later adopted as the logo of the private electric-utility industry. It's reported that the symbol was made over by Walter Lantz, the creator of Woody Woodpecker. This lightning-bolt man remains, still lit, high on the back brick wall of the former BC Electric building. •

>>>
23 WEST PENDER ST

59 INTERURBAN 2001

> This mosaic commemorates the electric interurban street-car service started in 1891, which connected communities in the Lower Mainland and Fraser Valley. The wide glass opening in the building to the south is where streetcars entered the BC Electric Railway storage facility. The adjoining Pigeon Park, a popular rough-and-tumble Downtown Eastside spot, is on the former CPR line that serviced rail yards along the north shore of False Creek, including the Roundhouse. •

>>>
CARRALL ST
+ WEST HASTINGS ST

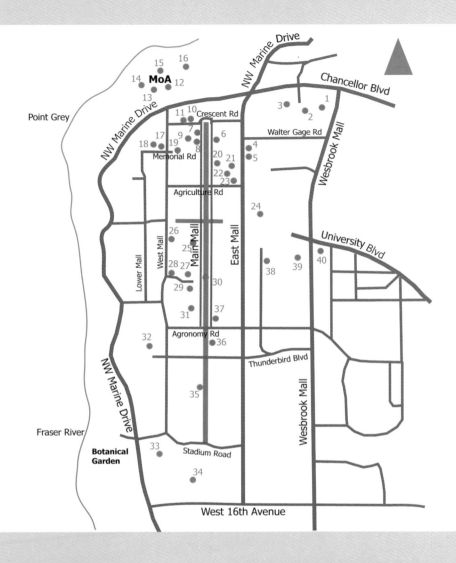

Point Grey

NW Marine Drive

NW Marine Drive

Chancellor Blvd

Crescent Rd

Walter Gage Rd

Wesbrook Mall

Memorial Rd

Agriculture Rd

Agriculture Rd

Main Mall

East Mall

West Mall

Lower Mall

University Blvd

Agronomy Rd

Thunderbird Blvd

Wesbrook Mall

NW Marine Drive

Fraser River

Botanical Garden

Stadium Road

West 16th Avenue

MoA

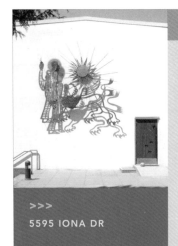

>>>
5595 IONA DR

1 THE LION AND ST. MARK 1957

> The UBC Catholic Theological College was named after St. Mark. Sculptor Lionel Thomas used welded bronze and gold to depict St. Mark ready to write the second gospel. The lion is a symbol of St. Mark, who was one of the four evangelists (Matthew, Mark, Luke and John) and the one believed to have written the oldest canonical gospel. The Christian Coptic Orthodox Church of Egypt is based on the teachings of Mark. •

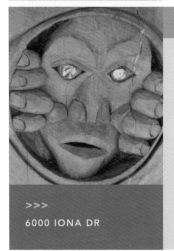

>>>
6000 IONA DR

2 ALL MY RELATIONS 2006

> This totem pole was carved by Coast Salish artist Jack La Sah Timothy to mark the 21st anniversary of the renewal of a covenant with the Native Ministries Consortium. It shows Raven holding the Moon, Salmon, Frog, Bear, Chief and Eagle. Human faces look out from the past with a vision for the future in which all creatures can live in harmony. Eagle is located at the bottom to indicate that without vision, nothing can stand. Close by is an octagonal labyrinth modelled by landscape architects Perry and Associates after the stone labyrinth at Chartres Cathedral in France. •

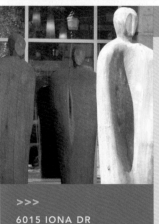

>>>
6015 IONA DR

3 THE MENTORS 2004

> Three tall figures, carved from logging slash from the west coast of Vancouver Island and Denman Island, welcome residents to Chancellor House. Sculptor Michael Dennis stated they are "an allusion to our academic forebears ... our ancestors ... and the trees that came before us ... they are the wise elders at whose feet we go to sit in order to learn." Not so long ago, Dennis was an academic himself, a professor of medicine at Harvard and the University of California, Berkeley. •

4 UNTITLED (SYMBOLS FOR EDUCATION) 1958

> Artists Lionel and Patricia Thomas created a mosaic of 54 separate blocks of enamelled ceramic tiles, using symbols to represent the various faculties and departments at the university in the 1950s. Lionel Thomas was a member of the UBC Fine Arts and Architecture Department from 1950 to 1980, and enjoyed "lighting a torch … to release the students from the rigidity of everyday thinking." Patricia was an innovator in the field of architectural colour consultancy. •

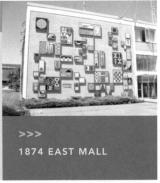

>>>
1874 EAST MALL

5 VICTORY THROUGH HONOUR 2004

> Totem poles throughout the UBC campus recognize that Coast Salish people have lived in this area for over 10,000 years and participate in campus programs. This 3.65-m-high pole is a replica carved by Calvin Hunt, Mervin Child and John Livingston. The remains of the original carved by Alert Bay artist Ellen Neel in 1948 have been returned to Alert Bay. Neel was the first female carver to create totem poles and her leadership helped renew carving practices among other artists. •

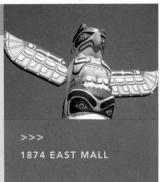

>>>
1874 EAST MALL

6 CONFIGURATION 1960

> Welded sheet copper (its green patina surface now often used by naughty students as a chalkboard) was shaped into abstract forms by sculptor Gerhard Class for the entrance to the Buchanan Building. Initially, he had followed his family's tradition of sculpting in stone, and this project was his first use of metal. He taught sculpture at the Vancouver School of Art, UBC and the Emily Carr University of Art + Design. •

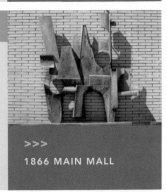

>>>
1866 MAIN MALL

7A BECAUSE … BAGHDAD 1991

> Created during the first Gulf War in Iraq, this digital print on a mesh-flex billboard continues to be a thought-provoking statement—*Because … there was and there wasn't a city of Baghdad*. The picture was taken during artist Jamelie Hassan's student days in Baghdad in the 1970s. In 1992, it was displayed in downtown Vancouver. It continues to serve as a visual and political memory, in the face of the destruction of parts of Baghdad and its architectural treasures. •

>>>
1825 MAIN MALL

>>>
1825 MAIN MALL

7B WOOD FOR THE PEOPLE 2002

> A woodpile worthy of any rural farmhouse is stacked outside the Belkin Art Gallery. All of the 230 concrete logs created by Vancouver sculptor Myfanwy MacLeod are identical. MacLeod said she created the work to represent a barricade. In his poem *Mending Wall*, Robert Frost wrote, "Before I built a wall I'd ask to know/What I was walling in or walling out/ And to whom I was like to give offence." What does this wall represent related to the role of a university? •

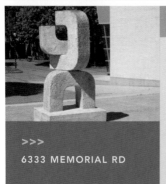

>>>
6333 MEMORIAL RD

8 THREE FORMS 1956

> Three concrete "C" shapes rest upon one another while facing up, down and sideways. To get into graduate school, three Cs won't help—you must have a minimum A- (80 per cent) average. The form creates a play of light and shadow— as elusive as that A grade. BC sculptor and architect Robert Clothier constructed these forms, which won the UBC purchase prize in the 1956 Outdoor Sculpture Show. A multi-talented artist, he gained fame as "Relic" on *The Beachcombers*. •

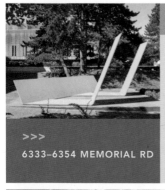

>>>
6333–6354 MEMORIAL RD

9A CUMBRIA 1966–67

> After stints in Toronto's City Hall plaza and Battery Park in Manhattan, this Corten steel structure by Vancouver-born sculptor Robert Murray was located at the newly opened Vancouver Airport in 1969. However, it caused so much dissent that eventually the airport removed it and donated it to UBC. In his early career, Murray frequently worked with single sheets of metal and developed a reductivist approach that encompassed both formalist and cubist perspectives. •

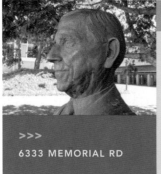

>>>
6333 MEMORIAL RD

9B BUST OF DR. NORMAN MacKENZIE 1976

> Local sculptor Jack Harman created this bronze bust of "Larry" MacKenzie who, from 1944 to 1962, served as the third president of UBC. He was a leader during major expansions of the university campus and supported the development of the schools of architecture, music, theatre and fine arts during his tenure. He was later appointed to Canada's Senate and became a Companion of the Order of Canada. •

9C ASIATIC HEAD 1977

> Whether in sun-dappled light or deep shadow, the calm and inscrutable face of a person with Asian features stares at passing, hurried students. What is he thinking about? In 1977, Gerhard Class created this marble, sand and polyester resin replica of a form made in 1958 by German sculptor Otto Fischer-Credo, who lived in Vancouver from 1957 until his death in 1959. •

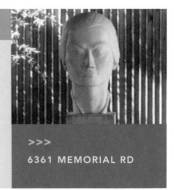

>>>
6361 MEMORIAL RD

10 TRANSCENDENCE 1961

> Perhaps the name of this sculpture and the figures' upward flight is a call to women students to continue to excel and develop new responses to the extraordinary challenges of today. But is that a glass ceiling we see above their heads? Sculptor Jack Harman built the first sculpture foundry in BC (now located in Sylvan Lake, Alberta) and he was one of the first to encourage West Coast First Nations artists to begin casting their carvings in bronze. •

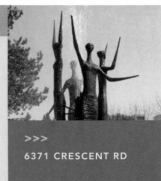

>>>
6371 CRESCENT RD

11 NATIVE HOSTS 1991–2007

> The aluminum signs with backwards statements and BC First Nations names seen throughout the UBC campus were created and donated by Hock E Aye VI Edgar Heap of Birds, who is of Cheyenne/Arapaho descent. He states that "some of the text written in reverse represents looking back at all history, all BC tribes." Red symbolizes "the blood of Native peoples, which also symbolizes renewal." The signs remind us that UBC is sited on traditional Coast Salish lands. •

>>>
VARIOUS
UBC LOCATIONS

12 IMICH SIIYEM—WELCOME GOOD PEOPLE 1997

> This welcoming figure, whose head has celestial forms around it, holds a fisher. The fisher is believed to carry special powers, both negative and positive. At the bottom of the figure is a face that welcomes people from around the world. Susan Point created this figure in the Coast Salish/Musqueam tradition for the 100th anniversary of the Royal Bank Financial Group, which donated the piece to the Museum of Anthropology. •

>>>
MUSEUM OF
ANTHROPOLOGY

13A FROG CLAN (TAIT FAMILY) TOTEM POLE 1978

> Norman Tait, from the Nisga'a Nation, had few mentors when he started carving. He travelled internationally to study Nisga'a work. In 1977, he had a one-man show at the Museum of Anthropology: the first for a First Nations artist. Now he has international commissions for his work in wood, precious metals and graphics. The pole depicts Norman holding Raven—his family crest—with his children, Isaac and Valerie below. His wife, Jessie, is in the form of a frog—her family crest. •

13B HOUSE POSTS 1997

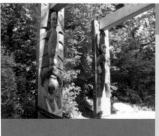

> Coast Salish artist Susan Point used a contemporary style to carve these house posts, which traditionally would have held a roof beam for a large house. The designs use a distinctive Coast Salish approach with a dominant human form. Coast Salish artists did not traditionally carve totem poles but did carve house posts, house boards, welcoming figures and mortuary posts. These posts were commissioned by the Royal Bank Financial Group in honour of its 100th anniversary. •

14A MORTUARY HOUSE FRONTAL POLE 1960–62

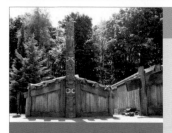

> Bill Reid and Doug Cranmer carved this reproduction of a fallen pole discovered by Bill Reid in 1957 in the forests of Haida Gwaii. The forms are Three Watchmen, Raven, Face, Grizzly Bear, Small Raven, Frog, Mosquito, Bear Cub, Grizzly Bear, with Small Frog in Bear's mouth and Wolf Cub between his legs. The remains of high-ranking members of the community were first placed in a mortuary house (such as the one behind this pole) and later in a grave box within mortuary poles. •

14B HOUSE FRONTAL TOTEM POLE 1982

> The crests, status and affiliations of the families that indicate the owners of the house were carved by Jim Hart on this pole. They are Raven, Frog, Seabear with Cub, Human, Bear with Frog, and Grizzly Bear with Sculpin. Legend relates that the bears of Haida Gwaii pursued and taunted the lowly frogs, so they fled from the islands and were only reintroduced in recent years. The original pole once stood in Beacon Hill Park in Victoria after being moved from Haida Gwaii in 1901. •

14C RESPECT TO BILL REID POLE 2000

> Over 2,500 people took part in the pole-raising to honour one of Canada's most celebrated contemporary First Nations artists, recognizing his role in the re-emergence of Native cultural traditions. The pole was carved by Haida artist Jim Hart and four assistants to replace a deteriorating pole carved by Bill Reid and Doug Cranmer in the '60s. The crests on the pole are Three Watchmen, Eagle, Grandmother (Eagle), Raven, Grandmother (Raven) and a wolf that represents Bill Reid. •

>>>
MUSEUM OF
ANTHROPOLOGY

14D SINGLE MORTUARY POLE 1960–62

> Bill Reid and Doug Cranmer carved this pole with the figures of Bear Mother and Bear Chief each holding one cub of twins and a frontal board with an eagle design. The remains of the deceased would be put in the pole behind the frontal board. Cranmer was from the Kwakwaka'wakw people and had carving instruction from master carver Mungo Martin. He became an innovative artist in his own right, producing abstract paintings and major sculptural works. •

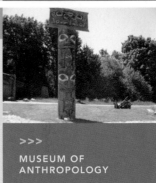

>>>
MUSEUM OF
ANTHROPOLOGY

14E MEMORIAL TOTEM POLE 1960–61

> This pole was carved by Bill Reid and Doug Cranmer in the Haida tradition. The crests are Raven (removed), a segmented Chief's hat, Beaver with Bear Cub between the ears and a human face on the tail. A beaver is often depicted as carrying a chewing stick, and said to have once been a woman. The rings shown in the picture are *skils,* or potlatch rings, and indicate the number of potlatches sponsored by an individual or by his family. •

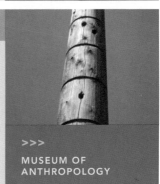

>>>
MUSEUM OF
ANTHROPOLOGY

14F DOUBLE MORTUARY POLE 1960–61

> In the Haida tradition, double mortuary poles have a platform at the top behind the frontal board upon which the remains of the deceased are placed in a grave box. The pole stood outside the deceased person's former dwelling. The form on the frontal board represents a shark (dogfish), that in First Nations legends is often shown as a woman. Bill Reid and Doug Cranmer carved this pole and the others to represent the culture and skill of Northwest Coast artists. •

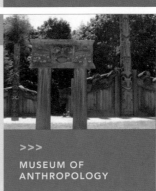

>>>
MUSEUM OF
ANTHROPOLOGY

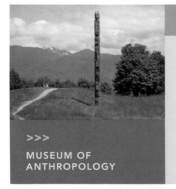

>>> MUSEUM OF ANTHROPOLOGY

15 CHIEF KALIFIX MEMORIAL POLE 1951

> Mungo Martin, the most respected carver of his time, carved this pole in the Kwakwaka'wakw tradition to commemorate the lineage of his ancestors. The crests are Thunderbird, Ancestral Chief, Raven, Killer Whale and Chief Kalifix. Raven is given a very important place in West Coast legends. He was considered a trickster but was also responsible (sometimes through tricks) for giving the Earth light, fire, water, food and people. •

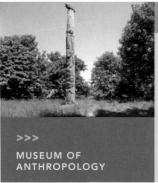

>>> MUSEUM OF ANTHROPOLOGY

16 GITXSAN POLE 1980

> Walter Harris and family members carved this pole for a documentary about traditional skills in a variety of cultures. The figures are Running Wolf, Mosquito, Killer Whale, seated Female Figure, second Human Figure, and Frog with Small Frog in his mouth. Harris helped build the Kitanmaax School of Northwest Coast Indian Art, which opened at 'Ksan in 1970. He was mentored by the artists working there—just as he has since fostered the creativity of many young First Nations artists. •

>>> 1871 WEST MALL

17 STONE GARDEN 1996

> Rocks imported from Shandong Province—the birthplace of Confucius—are scattered around the Asian Plaza. A Confucian virtue is on each rock: *Ren* (humanity, benevolence), *Zhi* (wisdom, knowledge), *Yi* (righteousness), *Xin* (trustworthiness) and *Li* (propriety). The donor was Dr. Cheung-Kok Choi. The Ming Dynasty-style bronze *Peace Bell* was dedicated to Dr. Choi, a "beloved friend, mentor, and benefactor of UBC and the Institute of Asian Research Building." •

>>> 1871 WEST MALL

18 BUST OF RABINDRANATH TAGORE 2002

> Tagore won the Nobel Prize for literature in 1913. He was a versatile Bengali writer of plays, poems, short stories, novels and songs. He wrote the national anthems of both India and Bangladesh and travelled the world supporting educational initiatives. He visited Vancouver in 1929 after his works were published in English. The Consulate General of India and the Indian Council for Cultural Relations commissioned Bengali sculptor Gautam Pal to create this bust. •

19 UNTITLED (TUNING FORK) 1968

> This 7-m-tall Corten steel sculpture was created by Gerhard Class to represent a giant tuning fork, "large enough to have served Pythagoras and his theory of music and harmony of the spheres." Two separate but interlinked forms represent the close relationship of music, fine art, theatre and architecture. Corten steel rusts over time and provides a protective layer to the metal under neath, but in the late 1990s this piece had rusted so much that it had to be removed, reinforced and repaired. •

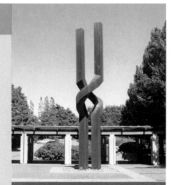

>>>
6361 MEMORIAL RD

20 MILLENNIAL TIME MACHINE 2003

> Within the 19th-century landau is a camera obscura that records the image of a large sequoia tree growing in the distance and projects it as an inverted picture onto a fabric screen in the carriage. Artist Rodney Graham was born in BC and has gained an international reputation for his artistic works. Described by a *New York Times* art critic as "a mercurial conceptualist who remains an enigma," he works in music, video, sculpture, photography and performance art. This piece was the first artwork to be commissioned for UBC since 1976. •

>>>
MAIN MALL
+ MEMORIAL RD

21 MONKEY AND THE BEARDED MAN 1925

> The two stone relief carvings by Charles Marega are a reminder of the role of the university in supporting academic freedom of expression. The bearded man is said to be Charles Darwin holding a tablet that says "*funda.*" The monkey, holding a scroll saying "*evolut,*" represents the "monkey trial" held in 1925 when a Tennessee teacher, John Scopes, defied state law and taught his high school students about Darwin's theory of evolution. •

>>>
1956 MAIN MALL

>>>
I.K. BARBER CENTRE,
1961 EAST MALL

22 MOTHER AND CHILD 1955

> The sculptor of these forms, George Norris, was an early advocate of collaborating with architects to integrate public art into the form and function of a building. This piece was originally to have been sited outside the Education Building, recognizing the early educational influence of mothers on their children. Norris appears to have wanted to acknowledge the role of fathers as caregivers and intended to have a sculpture called *Father and Child* to accompany his *Mother* but it was never completed. •

>>>
6224 AGRICULTURAL RD

23 PHYSICS AND ASTRONOMY SYMBOLS 2002

> A series of paving stones appear in front of the Hennings Building at UBC Physics professor Mark Halpern created the six designs that, from left to right, are symbols for: spontaneous symmetry breaking—a two-state system of condensed matter with electrons in a lattice; low wave states of a quantum mechanical well—a square well potential quantum oscillator; Kepler's law of equal areas and equal times; general relativity—gravitational encounter between a star and an object; electric field lines—an electric dipole with positive and negative charges; and a Feynman diagram illustrating particle physics. For more information on the symbols go to: www.physics.ubc.ca/homepics/Paving_Stones/ •

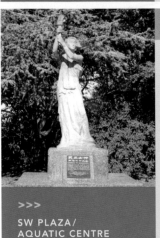

>>>
SW PLAZA/
AQUATIC CENTRE

24 GODDESS OF DEMOCRACY 1991

> In 1989, Chinese tanks rolled across Beijing's Tiananmen Square, crushing hopes of students and protesters gathered to support a democratic government process. Also destroyed was the original student-made 10-m-tall metal, styrofoam and papier-mâché statue that faced the tanks. This epoxy and white marble dust figure by Joseph Caveno and Hung Chung is a replica of a bronze statue by Thomas Marsh in San Francisco. The UBC Alma Mater Society, the Chinese Student and Scholar Association and the Vancouver Society in Support of Democratic Movement sponsored it. •

25 UNTITLED (SCARFE BUILDING) 1965

> Copper, brass and aluminum were used to create these forms, which are organic in shape and inspiration. Sculptor Paul Deggan often used natural forms for his artwork. A self-proclaimed Renaissance man, Deggan taught at the Vancouver School of Art and Capilano College and held residential summer art workshops in the Auvergne region of France. The BC Teachers' Federation presented this sculpture to the university at the opening of the Neville Scarfe Education Building. •

>>>
2125 MAIN MALL

26 WHALER'S POLE 1982

> This tall totem pole was carved by Vancouver Island Nuu-chah-nulth artist Art Thompson with assistance from four other First Nations people from his tribal area. The pole tells a story about the whaling traditions of the West Coast (Nootka) people and Makah—the only Pacific Coast people to hunt whales. It was commissioned by the UBC Museum of Anthropology to recognize the contributions of Dr. Douglas Kenny, Dean of Arts, 1971–75, and president of the university, 1975–83. •

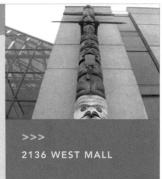

>>>
2136 WEST MALL

27 EOSphere 2004

> Sculptor Tony Bloom created a large sphere with a partial map of the Earth on one side and a cut-out slice exposing the central core on the other. Originally a ceramicist, he now works in media ranging from metal and clay to concrete. Symbols representative of Earth and Ocean Sciences are embedded into the paving stones leading to the *EOSphere* and rocks from different areas of BC are scattered along the paths. Don't forget to look up. •

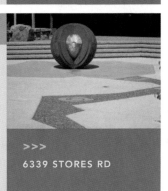

>>>
6339 STORES RD

28 SUSTAINABILITY STREET 2006

> A short street created by Dennis Boyle and Rhonda McNaught of Elio Creative Inc. was launched at the World Urban Forum to emphasize UBC's continuing commitment to the sustainable development policy it adopted in 1997. The project won a silver award for landscape architecture and a National Award of Merit from the Canadian Society of Landscape Architects. The street will soon be part of a new facility: the Centre for Interactive Research in Sustainability. •

>>>
WEST MALL
AT STORES RD

>>>
6350 STORES RD

29 UNTITLED (METALLURGY BUILDING) 1968

> The main entrance of the Frank Forward Metallurgy Building is marked by a wall decorated with terracotta brick sculptures. Sculptor George Norris was commissioned to highlight the wall so that students and visitors could more easily find the front door, which is difficult to locate. He used a hexagonal shape, which is found in the structure of many metals, and industrial shapes, such as cogs, for imprints and attachments. •

>>>
MAIN MALL NEAR
STORES RD

30 ENGINEERS' CAIRN 1988

> Flaming tires, endless coats of paint, forklift assaults directed by students from various faculties—all have been used to try to destroy or alter the Engineers' Cairn since it was originally built in 1966. It was rebuilt in 1988 after Forestry students using a pneumatic drill and a backhoe destroyed it. The new one was christened in 1989 with a bottle of beer. The engineers finally got it right and grounded it with rebar extending into a large base sunk into the soil. •

>>>
6361 AGRONOMY RD

31 UNTITLED (MAN ABOUT TO PLANT ALFALFA) 1967

> This small granite man, usually referred to as the "Man About to Plant or Pick Alfalfa," is waiting for the return of the alfalfa plant that he once held in his hand. Alfalfa is one of the most important high-feed-value legumes grown around the world. George Norris was the sculptor who responded to a request to create a memorial to the parents of Dean Eagles of the Faculty of Agriculture, whose family members were pioneer farmers in British Columbia. •

>>>
2525 WEST MALL

32 MAN MEETS BEAR HOUSE BOARD 1974

> Pictures from 1898 show the original of this house board in the village of Musqueam. It is now in the Museum of Anthropology while a replica, carved in 1974 by Coast Salish artist Simon Charlie, stands outside the Totem Park Residences. The man on the board, identified in the 1930s by Chief Jack of the Musqueam Nation as his grandfather, had unique powers to mesmerize animals by singing a special song before killing them. •

33 MINOTAUR WITH HARE 1996

> This 2.7-m-tall galvanized-wire Minotaur, with a tiny hare cradled in his hands, was created by UK artist Sophie Ryder and was originally part of the 2005–2007 Vancouver Biennale. The labyrinth and sculpture represent a myth that was tragic for all involved. Not only was the birth of the Minotaur the result of his mother's misjudgements due to mental illness, but when he was then consigned to a labyrinth, seven virgin women and seven young men were given to him in tribute each year. •

>>>
UBC BOTANICAL GARDEN

34 THUNDERBIRDS 1967

> The BC First Nations gave permission for UBC to use the Thunderbird, a powerful spirit bird that can be both a protector and an aggressor, as the symbol and name for its varsity teams. Sculptor Zeljko Kujundzic was born in Yugoslavia and worked in Scotland before moving to Cranbrook, BC. Skilled in the use of clay, painting, print-making, metal, stained glass and weaving, he also founded the Kootenay School of Art in Nelson, BC. •

>>>
WEST 16TH AVE
+ MARINE DR

35 JOURNEY 2004

> This mosaic of a leaping salmon was designed by Water-front Studios for the Journeys housing complex, part of a campus development effort to accommodate students and staff and generate a financial endowment for UBC. Although some Vancouverites were horrified that UBC was "selling off the campus," its 1907 agreement with the provincial govern-ment granted the land with the understanding that portions could be used to help finance the university. •

>>>
HAWTHORN PLACE,
2500 MAIN MALL

36 SOPRON GATE 2001

> This gate near the Forest Sciences Building, made of BC yellow cypress, recognizes the acceptance by UBC in 1957 of nearly 200 Forestry students and faculty from the University of Sopron in Hungary, following the 1956 Hungarian Revolution. Transylvanian craftsmen Arpad Gal and Laszlo Jozsa used a traditional Hungarian folk design for the gate. Jozsa also carved the nearby *kopjafa* (2007), a traditional wooden monument. •

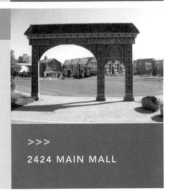

>>>
2424 MAIN MALL

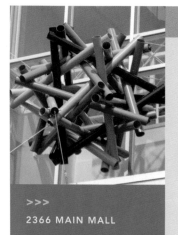

>>>
2366 MAIN MALL

37 UNTITLED (COMPUTING BUILDING) 1993

> This multi-coloured entwined structure hangs above the entrance to the Institute for Computing, Information and Cognitive Systems/Computing Sciences. Dr. Jack Snoeyink designed it while he was a professor researching the topic of the "number of distinct motions needed to assemble collections of simple geometric objects." The 30 coloured metal tubes are grouped to create 5 twisted tetrahedra (figures enclosed by 4 triangles) and have the symmetries of a dodecahedron (a figure with 12 plane faces). •

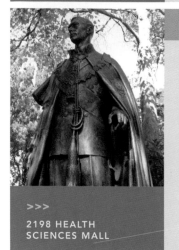

>>>
2198 HEALTH
SCIENCES MALL

38 KING GEORGE VI 1958

> This sculpture was commissioned by the Woodward family and was dedicated by Queen Elizabeth II during her 1958 visit. Her parents were the first reigning monarchs to visit Canada and their 1939 trip included Vancouver. Sculptor Sir Charles Wheeler specialized in monuments, including the fountains at Trafalgar Square. Just before a rededication ceremony by the Queen in 2002, a repentant student returned the sword that had been "removed" from the king's hand 25 years before. Where is it now? •

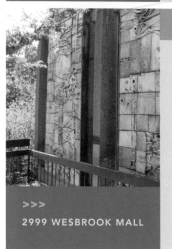

>>>
2999 WESBROOK MALL

39 UNTITLED (DENTISTRY BUILDING) 1971

> Near the south entrance of the MacDonald Dentistry Building is a complex design of ceramic tiles placed in two panels. A closer look will reveal variation in designs, texture and shades of colour that create the whole. A Vancouver holiday lured sculptor Robert Weghsteen from his home in Britain and he immigrated shortly afterwards. He taught at the Vancouver School of Art and created many large ceramic and murals installations. These panels were described by the artist as having "fun with forms." •

> Architects Clive Grout and Walter Francl designed the triangular wind tower (traditionally used for natural ventilation) for the library at the Christian-based Regent College. Oriented to the North Star, it allows daylight into the library below. Toronto's Sarah Hall designed the artistic and spiritual *Lux Nova* within the tower, including dichroic crosses and an Aramaic (the language of Jesus) version of the Lord's Prayer. Photovoltaic glass, using solar cells between panes of glass, collects energy by day to power the blue-oriented LED lighting system at night. •

>>>
REGENT COLLEGE

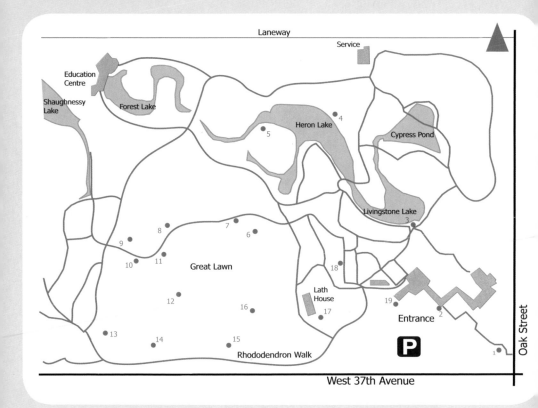

vandusen garden

SOUTHEAST CORNER

1 SWEDISH FOUNTAIN 1975

> Edward Alm, a member of the Swedish community in Vancouver, wanted to recognize the connections between his homeland and Canada, his new home. The Swedish Folk Society commissioned Swedish sculptor Per Nilsson-Ost. The seven panels depict the work of Swedish pioneers in Canada. Other symbols are a Viking ship, the three crowns of Sweden, a dogwood blossom and a totem pole, to indicate the friendly relationship between Canada and Sweden. •

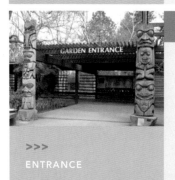

>>>
ENTRANCE

2 AL OF THE GISPUWADA 1976 MOSQUITO 1976

> Arthur Sterritt carved the legend of "Al." A hunter, after being transformed into a Bear Man, returned to his village where no one could recognize him. Luckily, the village shaman was perceptive and changed him back to his human form. Earl Muldoe carved a legend about Baboudina—the chief of the mosquitoes. There are many beginnings to the legend but, in the end, the mosquito's body is always burned and the ashes become a cloud of living mosquitoes. •

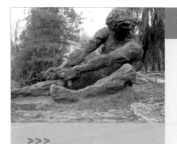

>>>
SOUTH OF
LIVINGSTONE LAKE

3 FISHER HAULING IN THE NET 1976

> Romanian sculptor Gerhard Juchum used bronze and resin in this piece depicting the human struggle to reach goals—an experience he had lived as he moved first to escape communist oppression in Romania and then to pursue his work and art. As a thanks to his adopted city, the early practitioner of guerrilla public art spontaneously placed one of his works on the front lawn of City Hall. After an initial controversy, *The Lovers II* is still there. •

>>>
EAST OF HERON LAKE

4 TRAVERTINE SCULPTURE 75 1975

> David Marshall, a Vancouver sculptor, gave different names to this piece at various times (the other two were *Three Forms* and *Family Life*). He suggested that the upper form is "supported like a child by its parents." However, opening interpretation to the viewer, he also states, "Sculpture is an international languageThe written or spoken description often becomes a substitute, and a poor one, for what is being communicated by form." •

5 DEVELOPING FORM 1975

> American-born French sculptor Michael Prentice used marble to create this rounded voluptuous form. It has gained many irreverent names such as "intestines" and "bouquet of bottoms." Perhaps to encourage (or counter) such interpretations, the retired curator of the garden, Roy Forster, said, "Abstract sculpture is sometimes more successful than representational sculpture as it doesn't evoke images that impinge too much on the quiet flow of ideas that one likes to enjoy in a garden." •

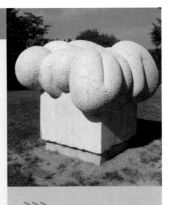

>>>
WEST OF HERON LAKE

6 LANDSCAPE 75 1975

> Iranian travertine was chosen by Japanese sculptor Jiro Sugawara for this form. Similar to marble, travertine is mainly calcium carbonate. Although it is softer and more porous than marble, it hardens as it ages and is exposed to the elements. The designs created by the streaks of colour—a result of minerals in the sediment forming the stone—and the placement of the four parts of this sculpture could represent the origins of travertine, which is formed by deposits in springs and rivers. Travertine is quarried primarily in Turkey, China, the US and Europe. •

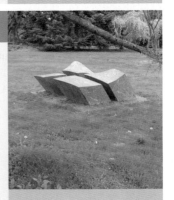

>>>
GREAT LAWN

7 HAIKU STONE 2008

> Started in 2006, the Cherry Blossom Festival is Vancouver's first rite of spring and has a variety of activities: Cherry Jam Downtown, Bike the Blossoms, Sakura Day, Cherry Scouts, Tree Talks and Walks, Cherry Trolley Tours— all inspired by the more than 36,000 Japanese ornamental cherry trees in Vancouver. The 2009 haiku invitational received 1,450 haiku from 29 countries. The 2008 Canadian winner wrote, "A winter blizzard/I turn my calendar/to cherry blossoms." Read them all! Write one! •

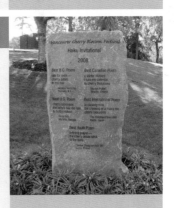

>>>
SOUTH EDGE
GREAT LAWN

>>>
NORTHWEST
GREAT LAWN

8 META MORPHOSIS 1975

> Early in her career, Serbian/Yugoslavian sculptor Olga Janic began to use a stylized form of the human figure. Her sculptures have been displayed at a number of world expos, including Expo 67 in Montreal. She said, "[This] sculpture struck up a friendship with the surrounding countryside and started a quiet life of its own." The sculpture is nestled on a site that was originally logged by the Canadian Pacific Railroad and later was the Shaughnessy Golf Club. •

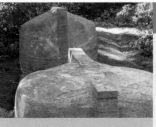

>>>
WEST OF GREAT LAWN

9 BETWEEN 1975

> Adolf Ryszka, a noted Polish sculptor, took part in numerous sculpture symposia around the world, including the *Monument of Immortal Love* project for Fuji Memorial Park in Japan. The truth he wished to search for in his work was "wisdom and suffering, self-sacrifice and love, modesty and kindness." This work, composed of two large, almost equal-sized, blocks of travertine, sits at the edge of a tree grove—between light and shadow. •

>>>
WEST OF GREAT LAWN

10 OBSERVING YOUR SOCIETY 1975

> Many of the sculptures by Inuit carver David Ruben Piqtoukun depict traditional ways and mythology, using materials such as stone, feather, antler and baleen. This marble sculpture, made early in his career when he was just 25, represents "my northern outlook upon the way of life of our southern counterpart. The faces tend to watch the directions of growth and progress of your society. The eyes are constantly observing." •

>>>
WEST OF GREAT LAWN

11 HORIZONTAL COLUMN 1975

> The German husband-and-wife team of Wolfgang Kuback and Anna-Maria Wilmsen-Kuback created this marble form as a lighthearted joke. They are the founders of the Foundation Kubach-Wilmsen Museum and Stone Sculpture Park in Bad Münster am Stein, Germany. They have exhibited worldwide and have installations in many sculpture parks. For over 30 years, they have explored the properties of many different types of stones, such as an exhibition of 20 stone books. •

12 FOR THE BOTANICAL GARDEN 1975

> French-Japanese sculptor Hiromi Akiyama used travertine to shape a flowing form with a step-like silhouette, echoing the North Shore mountains. He welcomed the 1975 Vancouver International Stone Sculpture Symposium as helping to create a wider view of art and decrease the isolation that artists sometimes experience. During the sculpture symposium, artists and their assistants worked and lived in close quarters, and shared ideas and experiences as they produced many of the sculptures now found within the garden. •

>>>
GREAT LAWN

13 KOREAN PAVILION 1986

> This ornate structure was given by Korea to Vancouver after it was displayed at Expo 86. In 2005, a "national living treasure"—Buddhist monk and painter Hy In—led a group of artisans in restoring the pavilion using the ancient traditional decorative colouring called *dancheong*. Five basic colours of red, blue, yellow, black and white are used to stain rather than paint the wood. *Dancheong* was also used to indicate the rank of the structure and express beauty and majesty. •

>>>
SOUTHWEST
GREAT LAWN

14 THRONE OF NEZAHUALCOYOTL 1978

> This brightly painted steel form by Mexican sculptor Sebastian was a gift from the Government of Mexico. It represents the throne of an ancient Aztec ruler, architect and poet who ruled for 40 years in the 13th century. On the Mexican 100-peso banknote, there is one of his poems which, translated, reads, "I love the song of the Mockingbird / Bird of four hundred voices, / I love the color of the jadestone / And the enervating perfume of flowers / But more than all I love my brother: man." •

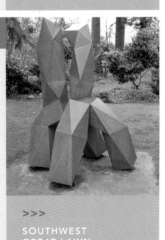

>>>
SOUTHWEST
GREAT LAWN

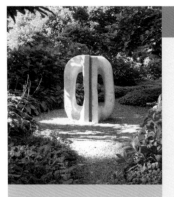

>>>
HYDRANGEA GARDEN

15 WOMAN 1975

> Kiyoshi Takahashi, a Japanese sculptor, used marble to create this form, "in which the character of the medium takes up the environment's spatial energy and then lets it settle into the ground upon which it is placed." This is one of 11 sculptures found throughout the gardens that were created as part of the Vancouver International Stone Sculpture Symposium, organized in 1975 by Gerhard Class. Many of the raw stones used for the sculptures were brought as ballast in ships returning to Vancouver, and were donated by Debro Construction Products when they left their premises during the redevelopment of False Creek. •

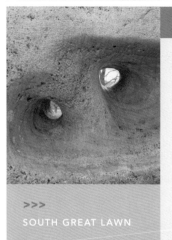

>>>
SOUTH GREAT LAWN

16 EARTH, AIR AND SEA 1975

> Canadian sculptor Joan Gambioli has stated, "Each sculpture is an attempt to express my deep, unwavering affection for the materials and forms found in nature." She used travertine here to incorporate a theme that resonates with all who live on the west coast. Development of this wonderful landscape garden was directed by W.C. Livingstone from 1971 to 1976, and then by the curator of the garden, Roy Forster, who was responsible for much of the planting design from 1977 to 1996. •

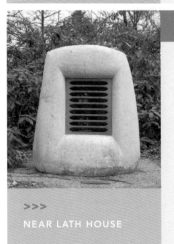

>>>
NEAR LATH HOUSE

17 IN MEMORIAM OF TEILHARD DE CHARDIN 1975

> Teilhard de Chardin was a French Jesuit priest, philosopher, palaeontologist and geologist. His theories on evolution and the origin of the cosmos abandoned traditional Biblical dogma in favour of a less strict interpretation of creation, and were opposed by the Vatican during his lifetime. Austrian sculptor Mathias Heitz created this marble form with bars to represent imprisonment. Two openings stand for philosophy and science, which de Chardin sought to use to shed light on the "eternal mystery" as represented by the black sphere in the middle. •

18 THE THREE BOTANISTS 1987

> Jack Harman sculpted these bronze busts of three famous botanists. Carl Linnaeus developed a taxonomy for naming, ranking and classifying organisms that now includes kingdom, phylum, class, order, family, genus and species. Archibald Menzies travelled with Captain George Vancouver to the west coast of Canada and collected botanical specimens for study in England. David Douglas transformed British gardens and landscapes and the timber industry after introducing over 240 North American plants to Britain. The Douglas fir tree is named after him. •

>>>
ADMINISTRATION BUILDING,
FORMAL ROSE GARDEN

19 PUTTINO (BOY WITH DOLPHIN) 1979

> *Putti* are those plump little naked boys with wings, sometimes as Cupid, that one often sees in Renaissance art. The Pitcher family presented this bronze statue to mark the UN's Year of the Child in 1979. The original statue was created by 15th-century sculptor Andrea del Verrocchio in Florence, Italy, for the courtyard of his patrons, the Medici family. Verrocchio was also a teacher with pupils who became well-known: Michelangelo, da Vinci, Botticelli, Perugino and Ghirlandaio. •

>>>
CHILDREN'S GARDEN

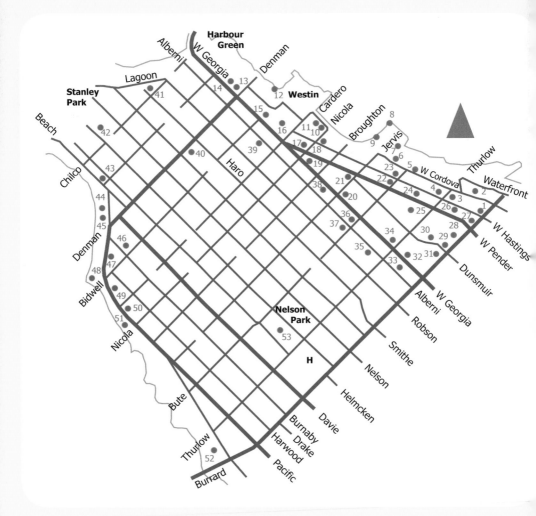

w e s t e n d

355 BURRARD ST

1 MARINE BUILDING 1930

> Many claim this is Vancouver's most significant architectural statement. It was begun in 1929 and its Art Deco ornamentation, by McCarter and Nairne, is worthy of considerable study. Marine and transportation motifs, on both the interior and exterior but especially at the main entrance, are particularly exuberant. When the Depression hit, bankruptcy struck the developer. The city refused an offer of the building for a new City Hall since, politically, it was "going south" with the annexation of south Vancouver. •

1077 WEST CORDOVA ST

2 UNTITLED (LIGHT COLUMN) 2005

> Starting from large green panels at the base of the 42-storey Shaw Tower, this light shaft transforms into a narrow blue LED light that can be seen from the North Shore and both harbour bridges. Some interpret this as the change from earth to sky. Fog is emitted to shroud the base of the light. The art budget was $400,000 but Westbank Projects chose to spend over $1,000,000 to install the unique artwork. The artist is Diana Thater of Los Angeles. While under construction, the building was a film set for the motion picture *I, Robot* starring Will Smith. •

1099 WEST HASTINGS ST

3 VANCOUVER—GATEWAY TO THE PACIFIC 1986

> Vancouver's oceanfront location made it an obvious choice from the beginning as the gateway for Pacific and Asian commerce and immigration. In Portal Park, a tile map of the world shows the countries around the Pacific Rim with which Vancouver has increasing trade and cultural contact. Lea Associates Consulting Engineers donated the archway and map to the Vancouver Board of Parks and Recreation during the city's centennial year. •

4 LYING ON TOP OF A BUILDING ... NEARER 2009

> Westbank Projects' promise to "add some pizzazz" to public art in Vancouver will certainly be realized. Around the sides of the Fairmont Pacific Rim Hotel, large steel upper-case letters spell out a poem by English artist and poet Liam Gillick. Each line is complete in itself—e.g., LYING ON TOP OF A BUILDING THE CLOUDS LOOKED NO NEARER. The effect— as predicted—is an unforgettable reference to an individual's perceptions. •

>>>
299 BURRARD ST

5 ONE IN LIGHT 2006

> Surrounded by metal and glass condominiums, these eight stainless steel towers by Dan Corson duplicate their shape and, when lit at night, their luminosity. The coloured chunks of glass and resin in the towers refer to the site by representing coal or diamonds. In the early years of Vancouver, coal was thought to exist here, resulting in the name Coal Harbour. The use of "raw" coal and "rough" diamonds presents questions of Vancouver's past and present development. •

>>>
1 HARBOUR GREEN PL

6 SEMAPHORES 2003

> Integrated art is on the 34 fused-glass gates to the town-homes in two developments. Colombia-born artist Claudia Cuesta interviewed residents for themes that were relevant to them. With a few exceptions, the gates are based on nautical themes: water, boats and islands. Cuesta has stated she "maintains an open space for lyrical discovery." A large glass artwork by Cuesta can also be seen in the lobby of the Carina development. •

>>>
1233 WEST CORDOVA ST

7 SHIPWRECK 2001

> There are over 500 recorded shipwrecks off the BC coast and about 16 in the Vancouver area, including the SS *Beaver*, which sank off Stanley Park. As a metaphor, a shipwreck could imply ruin and destruction. However, artist Eric Neighbour worked with over 1,400 residents and visitors to Vancouver not only to create these new cedar sculptures but also to foster interests, skills and friendships among the participants. •

>>>
HARBOUR GREEN PARK

COAL HARBOUR SEAWALL

8 LIGHTSHED 2004

> This work by Liz Magor reflects the former marine character of the area and serves as a contrast to the modern marina nearby. It is a half-scale model of an old freight shed, slightly askew on log pilings, typical of those that used to be along this working waterfront. Although made of painted cast aluminum, it shows the details of each cedar plank and mussels and seaweed. The interior of the shed is illuminated at night—acting as a lighthouse for the harbour. •

323 JERVIS ST

9 WEAVE 2002

> Our personal histories and that of the city are woven from many strands—interactions, experiences and the stories left by our ancestors. The four parts of this installation by Douglas Senft are evocative of trees and include circles of stones based on BC tree circumferences, panels on building columns that mimic tree cross-sections and tree grates that reflect the floatplane history of Coal Harbour. The words on the benches tell of the First Nations, Spanish and English. •

COAL HARBOUR BETWEEN
NICOLA ST + CARDERO ST

10 MAKE WEST 1997

> Artists and architects Bill Pechet and Stephanie Robb asked, "What if you threw a vase of history from the 27th floor of a new condominium tower and it shattered into countless pieces?" The answers can be seen as you walk along the Coal Harbour seawall. Symbols, pictures and words on 120 shards of cast bronze explore the early use of technology. They refer to the loss of natural surroundings, methods of teaching natural history and clues to several stories. •

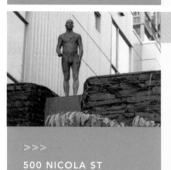

500 NICOLA ST

11 SLIDING EDGE 2003

> Artist and architect Nancy Chew states that this statue and waterfall "alludes to the always moving edge of the waterfront … the tides … the shifting of the earth's edge, the changes over time." The tree surrounds in the shape of a saw blade refer to the natural and industrial history of the site. The poem is by Earle Birney, a prodigious writer of prose and poetry who taught at UBC for years and inspired many young writers in Canada and internationally. •

12 COAL HARBOUR FELLOWSHIP BELL 1979

> This brass bell honours the companies and employees who, between 1891 and 1979, created a dynamic marine industrial community. Over 300 individual names and industries, ranging from Pilkington Blacksmith and Ideal Ironworks to Harbour Ferries and Jibset Sailing School, tell the story of the changing harbour, from essential industries to the addition of luxury services. •

>>>
SEAWALL, WEST OF
BAYSHORE WESTIN HOTEL

13 SEARCH 1975

> Seward Johnson Jr. has created a familiar scene: the search for that elusive "something" at the bottom of a purse. He has succeeded in "using my art to convince you of something that is not real. You laugh at yourself because you were taken in, and in that, change your perception." Since turning from painting to sculpture in 1964, Johnson has created over 250 bronze figures—many with colourful details—and his works are in collections around the world. •

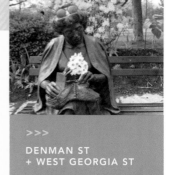

>>>
DENMAN ST
+ WEST GEORGIA ST

14 SOLO 1986

> When this stainless steel and cedar sculpture by Natalie McHaffie was installed, concerns were expressed about its size and about it being "too Modernistic" for the site. Times have changed and now viewers are more willing to look at the meanings embedded in art forms. McHaffie has stated that she was representing "movement" and that "there is very little that is stable in the world." •

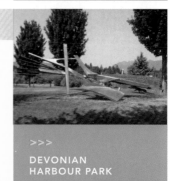

>>>
DEVONIAN
HARBOUR PARK

15 LEAF STREAM 2002

> Douglas Senft incorporated the natural history of the site, where the Bayshore Towers now stand, into his bronze leaf sculpture and fountain. Bigleaf maple trees once grew along the shoreline and some can still be found in Stanley Park. The maple leaves that Senft created appear to float upon the water's surface as they define a river flowing from the circular pond above to the rectangular pond at the bottom. •

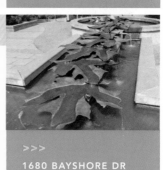

>>>
1680 BAYSHORE DR

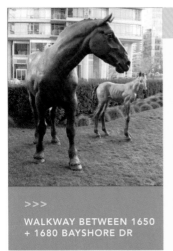

**WALKWAY BETWEEN 1650
+ 1680 BAYSHORE DR**

16 MARE AND COLT N.D.

> For over 40 years, Joe Fafard has recorded the lives of prairie people and animals through his sculptures. Although he is best known for lifelike (and often life-sized) cows, he has also completed portraits and caricatures—getting his ideas, he says, "from myself and my experience." His early works used clay but, in the 1980s, he shifted to bronze as his main medium. Fafard has received numerous awards and was made an Officer of the Order of Canada in recognition of his contribution to Canadian culture by documenting aspects of rural Canada through his art. •

1529 WEST PENDER ST

17 CURTAINED SKIES 2002

> Situated at the entrance to an office building, the layers of multi-coloured polyurethane encased in three wedge-shaped forms appear to be billowing yellow and black curtains. From inside, office workers see blue and white layers—sky and cloud colours—hardly a replacement for the real things, which are obscured by ever taller buildings. The artist, Clay Ellis, lives and works in Edmonton, Alberta, and exhibits in Canada and internationally. •

500 NICOLA ST

18 SCOPES OF SIGHT 2003

> Six stainless-steel-and-concrete periscopes/telescopes were created by artist and architect Jill Anholt. Interpretative plaques among the "scopes" identify local historical events, such as building warplanes in Coal Harbour, shipping trees to China for the Imperial Palace, dynamiting herring and sinking shafts to look for coal. Some scopes have etched glass in the "eyepiece" related to the particular story, whether it's about planes or fish. Looking into the scopes, images of the surrounding trees and buildings are reflected back. •

19 LOVE 1969–1999

> This *LOVE* sculpture by Robert Indiana is permanently in the Georgia Street plaza of the Buschlen Mowatt Gallery; other pieces come and go at the front and the back. It was originally created during the Vietnam War, and although the shapes and materials used for *LOVE*'s letters have changed over the years, the message of hope for universal peace remains. Indiana was an important contributor to the popart movement and internationally known for his realist approach. •

>>>
1445 WEST GEORGIA ST

20 RINGS OF LIFE 2008

> Mosaic artist Liz Calvin included numerous references to life in Vancouver within this mosaic. Encircled by a boat's rope are aspects of the skyline of Vancouver, Stanley Park and the mountains in the background. In the centre are a cross-section of a tree with a bear paw, a salmon and a feather to represent the elements of earth, water and air necessary for life. •

>>>
WEST GEORGIA ST
+ JERVIS ST

21 UNTITLED (STREET MEDALLIONS) 1995

> Coast Salish artist Susan Point used a carved cedar panel as the mould to create bronze medallions that can be seen on a number of streets in the area. One type of medallion features human faces and the second type has the faces on salmon. Salmon are frequently used as symbols in the myths and art of the Coast Salish people. •

>>>
WEST GEORGIA ST
+ JERVIS ST

22 UNTITLED (EAST ASIATIC BUILDING LOBBY AND PLAZA) 1964

> George Norris was a versatile sculptor, working in stone, concrete relief, jade and, for these pieces in the lobby, copper relief. The design on the inside used typical Vancouver symbols—a heron, waves, a cormorant. The outside concrete sculpture brings Zen peacefulness to the small plaza. The East Asiatic Company, founded in 1897 in Copenhagen, was a major carrier of Canadian wheat to China and had timber holdings on Vancouver Island. •

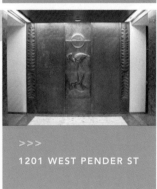

>>>
1201 WEST PENDER ST

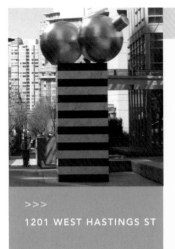

1201 WEST HASTINGS ST

23 UNTITLED (GLOBES) 2007

> This installation—two 24K-gold-leaf-covered globes perched on top of stacked black and white marble slabs—is a car-stopper and a conversation piece. Which is exactly what the Delta Land Development president asked for when he requested proposals from artists who create public art. Vancouver artist Alan McWilliams has taught art and been a curator, as well as creating more conventional works like the Lotus fountain in Yaletown. He did not give a title to this piece but hopes that when viewers look at his public art installations they will "ask questions about the art, themselves, their cultures and belief systems." •

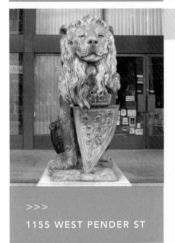

1155 WEST PENDER ST

24 UNTITLED (LIONS) 1920

> It is interesting to look at the facial expressions of the lions in our city. These two gigantic bronze lions outside the mixed-use Stonehill Building look friendly and obliging as they hold a shield with one paw and extend the other. Others look ferocious (the Shanghai lions at Portside), while some appear totally implacable (the Art Gallery lions). These lions were originally cast in 1920, stored in New York until 1962 and placed here in 1969. •

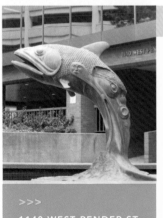

1140 WEST PENDER ST

25 TRANSFORMATION N.D.

> The title of this bronze sculpture by Abraham Archer may refer to the transformation of the salmon during its years from spawning to returning to its birthplace. One First Nations transformation legend is about people (the faces on the sculpture) who were kidnapped by Salmon but returned to their village with special powers and knowledge, and became shamans. Today, the sculpture addresses a more desperate theme: the need for major conservation initiatives for oceanic fish stocks. •

26 THE FATHOMLESS RICHNESS OF THE SEABED 1969

> This ceramic mural, evocative of the ocean and the ocean floor, is in the lobby of the Guinness Building. The artist, Jordi Bonet, was born in Spain and moved to Quebec in 1954. He created over a hundred murals around the world, mostly in ceramic and concrete, including ones in the Montreal Métro and at numerous universities. He was a professor of art in the Université de Montréal's school of architecture. •

>>>
1055 WEST HASTINGS ST

27 PUBLIC SERVICE / PRIVATE STEPS 2003

> Canada Lands, a Crown corporation, is known for re-developing surplus federal property across the country. They've leveraged their responsibility for social legacy into a series of award-winning public art projects. At this office tower, a structure of columns and cubes by Alan Storey replicates the movement and positions of the five elevators inside the building and, on a matrix screen on the underside of each cube, the movements of the passengers in the elevators. •

>>>
401 BURRARD ST

28 FOUNTAIN OF THE PIONEERS 1969

> Bronze was used to form this 4-m-high fountain recognizing early contributors to Vancouver. Although many immigrants were of British origin, the involvement of Chinese and First Nations peoples was essential. Water, Earth and Heaven are the three elements that are involved in every fountain, according to the sculptor, Seattle's George Tsutakawa. He tried to "unify water ... the life force of the universe ... with an immutable metal sculpture." •

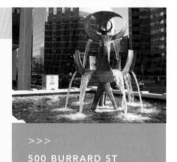

>>>
500 BURRARD ST

29 SEA OF OPPORTUNITY 2008

> Several other pieces of public art contributed to the design of this mosaic by Bruce Walther. The fisherman is a stylized version of the fisherman on the 1903 city coat of arms and in B.C. Binning's mural of BC beginnings. The swirling water design is similar to that of the BC Centennial Fountain. Fishboats and fish support the theme of one of BC's resource economies—the fishing industry. •

>>>
BURRARD ST
+ DUNSMUIR ST

>>>
1025 WEST GEORGIA ST

30 'KSAN MURAL 1972

> The escalator to the Royal Bank of Canada's mezzanine provides a wonderful view of this powerful installation. This is a must-see! Ask staff for the pamphlet that gives an informative interpretation of the various sections of this incredible 40-m-long mural. It tells the story of Weget (the Man-Raven) and the frog, killer whale, owl, wolf, bear and human. Five Gitxsan carvers carved it in western red cedar: Chief Walter Harris, Chief Alfred Joseph, Earl Muldoe, Ken Mowatt and Art Sterrit. 'Ksan is a cultural centre in northern BC dedicated to illustrating the richness of Gitxsan culture and history. •

>>>
BURRARD ST
+ DUNSMUIR ST

31 THE BUILDERS 1986

> Joyce MacDonald created this sculpture during the centennial sculpture symposium. It is located in little Discovery Park, as "a tribute to the immigrants who settled in Canada." The three forms of black Quebec granite create the abstract shape of a person in prayer. Vancouver, increasingly multicultural in nature, continues to rely on immigrants as major contributors to the economy. In the same area, also see the bust by Jack Harman of Charles Bentall, one of BC's pioneering construction leaders. •

>>>
1075 WEST GEORGIA ST

32 PRIMAVERA 1987

> "Two splendid butterflies breaking from the cocoon of spring" are seen in this plywood and paint structure by Jack Shadbolt (working with Greg Bullen and Allan Wood). The abstract and realistic forms represent, according to Shadbolt, "a transformational process and spring as the time of ritual birth of new life." The tension he frequently created in his paintings reflects a search "to articulate the language of form." Shadbolt, one of Canada's most prolific and respected artists, was an important contributor to abstract art. •

33 SPACE RIBBON 1985

> Two bronze ribbons curl upward in the plaza of the Grosvenor Building. Grosvenor is an international real-estate investment, development and asset-management group of companies that has been active in the Vancouver condominium market. They were early and continuing supporters of public art as part of their development strategy. This sculpture was created by Roy Lewis. •

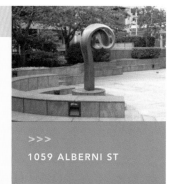

>>>
1059 ALBERNI ST

34 SPIRITS IN A LANDSCAPE 1992

> Abraham Anghik Ruben is an Inuit artist who was born in the Northwest Territories. When he was 20, he was able to apprentice under a professor at the University of Alaska's Native Art Centre. He now creates mainly small projects using both traditional and contemporary styles in soapstone, bronze and mixed media. This large bronze sculpture shows birds and animals found in BC and is "a reflection of our own human pursuits and activities." •

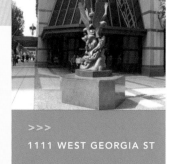

>>>
1111 WEST GEORGIA ST

35 CARL THE DOORMAN N.D.

> Sculptor Mary-Ann Lui created this sculpture as her first commission in bronze. Representing luxury and security, a doorman at any building is an added value for its residents; and with this one, the residents never need to worry about his cost-of-living wage increases. Lui began her career using clay as her main medium but later spent four years working in Jack Harman's foundry to learn about the qualities of bronze, from its molten form to the cast sculpture. •

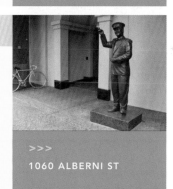

>>>
1060 ALBERNI ST

36 PERSIAN WALL 1998

> Artist Dale Chihuly is recognized worldwide for his spectacular glass creations. He has taken a leading role in the use of glass in large contemporary sculptures. A fascination with the interaction of light, colour and shape is shown in this colourful "Persians" florets sculpture, which was his first public art installation. More recently, he has used the Royal Botanic Gardens, Kew, England, and the New York Botanical Garden for both themes and sites for his works. •

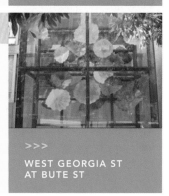

>>>
WEST GEORGIA ST
AT BUTE ST

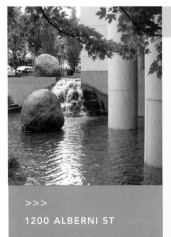

1200 ALBERNI ST

37 NEW CURRENTS, AN ANCIENT STREAM 1994

> Leonardo da Vinci is the author of the words used in this art installation by Gwen Boyle, who wished to convey "a sense of a river's journey." Water often represents purity and cleansing and, as a spiritual symbol, the flow of life and energy and the passage of time. Boyle placed a 10-ton glacial erratic in the upper pool and a bronze duplicate in the lower pool, and connected them by the flowing river. It represents the ancient rivers that once flowed into Burrard Inlet and is similar to "the mythical river Lethe as a repository of memories." •

1300 WEST GEORGIA ST

38 MILKY WAY 1999

> Artist Katherine Kerr transformed the walkway between two West End streets into a celestial experience with 40 swirling mosaics that are abstract images taken from visible galaxies. She set 160 fibre-optic lights into granite, with lines to indicate constellations. The different colours of granite indicate starlight intensities and are set into 40 coloured fields of stone aggregate representing the Milky Way. Bronze outlines of four boats—which have used navigation aids from stars to high-tech instruments—are embedded in the concrete. •

1630 ALBERNI ST

39 MOSAIC (CANADIAN SCENE) N.D.

> One could be justified in feeling confused when approaching the Consulate General of the Republic of Indonesia. The tile mosaic in the doorway is pure Canadiana—a choice made by a previous tenant. This mountain scene with towering coniferous trees and a stag contrasts greatly with the tropical seductions of Indonesia. In 2008, Indonesia opened a trade promotion office in Vancouver and 10 other world cities. •

40 WECCstoration PROJECT 1995

> As part of the West End Community Centre restoration, a colourful mural was painted on the walls close to the front door. The artist was Tiko Kerr, "painter, creator, artist," who integrates bright colours and light with his "strong sense of movement and spatial orientation." This results in pictures that are alive with movement or potential movement—keep an eye on that seagull! •

>>>
870 DENMAN ST

41 UNTITLED (RELIEF) 1972

> A concrete relief design, resembling drifting sand or the reflections on the bottom of the Kitsilano outdoor swimming pool on a sunny day, rises up the side of this tall building. The designer was Jordi Bonet, a Spanish-born artist who lived in Quebec. He gained an international reputation for large murals, using paint, ceramics, concrete, bronze and aluminum as his media. Much of his work was for churches and sacred sites. •

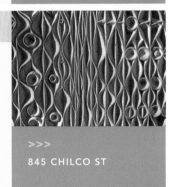

>>>
845 CHILCO ST

42 UNTITLED (WHITE HOUSE MURAL) 1980

> The White House apartment block has on either side of its entrance a subtle single-coloured mural painted by Greta Dale. Her work was mainly murals for schools and commercial buildings. Techniques she used were mosaic, fresco, low relief, encaustic (the application of coloured molten wax to create the images) and sgraffito (the scratching of a surface to reveal a colour or texture underneath), the latter being the technique used in these murals. •

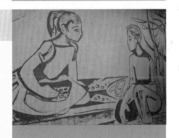

>>>
2033 COMOX ST

43 THE EUGENIA 1989

> Architects Henriquez Partners, placed a tree on the top communal balcony to indicate the height of the old-growth forests that once grew in the area. They also created concrete planters moulded to look like old tree stumps. The stumps are placed about the property to show the footprint of the previous building. The back fence duplicates the pattern on the garage doors and the original floor plan can be seen in the car park. •

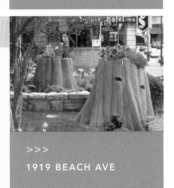

>>>
1919 BEACH AVE

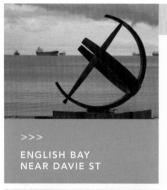

44 GEORGE CUNNINGHAM MEMORIAL SUNDIAL 1967

> ENGLISH BAY
NEAR DAVIE ST

> This bronze sundial is atop a granite base inscribed with carved bold geometric shapes. It includes the words: "I mark my hours by shadow, mayest thou mark thine by sunshine." It is dedicated to the English "Three Greenhorns" who first claimed land in this heavily wooded area in 1867. The piece, by Gerhard Class, was donated by Cunningham's drugstore chain, whose first store was nearby. A later edition of the sundial was made for VanDusen Garden. •

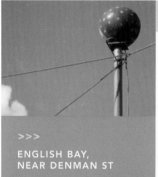

45 SEAL'S BALL N.D.

> ENGLISH BAY,
NEAR DENMAN ST

> There is often strong polarization of views in BC, including views about animal welfare and the keeping of animals in captivity. In Stanley Park, when the zoo's polar bears had lived out their lives, they were not replaced. There was also once a statue of a seal with a ball balanced on its nose. Animal rights groups objected to this demeaning pose so the ball was relocated atop this pole at the English Bay concession stand. But where is the seal? •

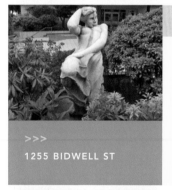

46 UNTITLED (FEMALE STATUE) N.D.

> 1255 BIDWELL ST

> Curious, the positions in which some sculptors place people! This woman, who appears to be rising from the waves, has tremendous balance; perhaps she is trying to avoid the encroaching bushes! The form was sculpted by Egon Milinkovich in limestone using a classical style. •

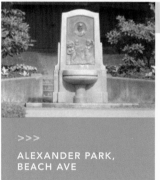

47 JOE FORTES DRINKING FOUNTAIN 1926

> ALEXANDER PARK,
BEACH AVE

> This bronze and granite fountain was created by Charles Marega as a memorial to Vancouver's first paid lifeguard, Seraphim "Joe" Fortes. After arriving from Barbados, he gave swimming lessons to children and adults at English Bay for 30 years. The fountain is child height because "Little children loved him." He was named Vancouver's Citizen of the Century in 1986 and a West End library branch and a popular Thurlow Street restaurant are named after him. •

48 INUKSHUK 1986

> Inukshuks, northern native rock sculptures, are ancient symbols serving as landmarks and navigational aids or noting productive hunting and fishing sites. This inukshuk was commissioned by the Northwest Territories government for its Expo 86 pavilion, then donated to the city and moved here in 1987. The artist, Alvin Kanak, lives in Rankin Inlet, Nunavut. A similar inukshuk was installed in Brisbane, Australia. A stylized inukshuk has been chosen as the logo for Vancouver's 2010 Olympic Games. •

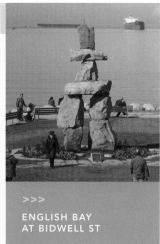

>>>
ENGLISH BAY
AT BIDWELL ST

49 FOUNTAINS, STEEL AND COPPER c. 1965

> The two steel and copper fountains designed by Lionel Thomas in the plaza above the swimming pool for Beach Towers appear to be ships misplaced by a wild storm in English Bay. The Beach Towers buildings were among the first apartment blocks built in the 1960s after the height restriction of six storeys was removed. They continue to provide rental apartments, rather than condominiums, in the West End. •

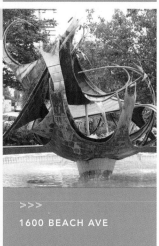

>>>
1600 BEACH AVE

50 CINQUE TERRE 2003

> Nine different architectural details were cast on-site in Agilia concrete and installed on promontories around the top of this condominium building. The modern Italian architectural style refers to the Italianate architecture of the older building to its left. Ken Clarke, using his typical sense of humour and place, created the faces of the weather gods of Zeus, Pluvius, Lorimus and Tempeste, and of children with various expressions. Even the underground garage has artwork: statues of Italian opera stars! •

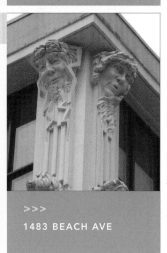

>>>
1483 BEACH AVE

>>>
SUNSET BEACH

51 AIDS MEMORIAL 2004

> Nestled into the slope below Beach Avenue, this curving wall of rusting Corten steel by Bruce Wilson has the names of almost a thousand BC AIDS victims cut through the steel. The random placement of the names indicates the nature of the impact of HIV/AIDS. Originally controversial, it is both a memorial and an educational opportunity. It includes words from a poem *To W.P.* by Spaniard George Santayana to indicate "the presence of absence felt by those who have lost loved ones."A virtual Web-based memorial exists to honour those who have died since the memorial was placed here. •

>>>
1050 BEACH AVE

52 THE SWIMMER 1997

> The motions of a swimmer depicted in this abstract bronze sculpture represent real people in the Aquatic Centre. The centre—not one of Vancouver's better architectural structures with its dark, monolithic roof—has a 50-m pool and a 4.8-m diving tank. George Norris created *The Swimmer* and another water-oriented sculpture in Vancouver (perhaps his most famous): *The Crab* at the planetarium. •

>>>
NELSON PARK,
MOLE HILL

53 LOOK 2004

> Artist Nicole May enjoys both colourful artistic results and including the residents of an area in producing her artwork. Inside the Plexiglas panels of this tall rectangular lamp are colours and shapes that can be found in the surrounding neighbourhood. Vancouver only had one official lamplighter to light all the coal-oil lamps, who worked from March to August until 1887; after that, electricity was introduced. Mole Hill is the last intact area of the city with original Edwardian and Victorian architecture. •

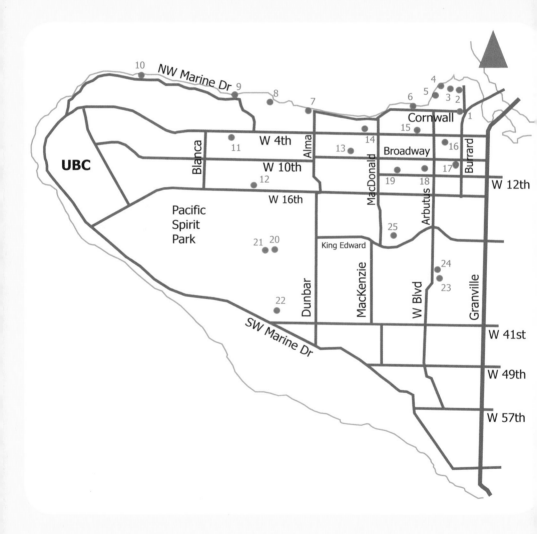

>>>
BURRARD ST
+ CORNWALL AVE

1 WELCOME TO KITSILANO 1997–98

> The Kitsilano Chamber of Commerce initiated the installation of this cedar-log welcome sign. The area was named after Khatsahlanough, a Squamish Nation Chief. The logs are covered with images representative of Kitsilano past and present. The choice of material and style of the art refers to the extensive logging that occurred in Kitsilano in the late 1800s. In the 1960s and early '70s, Kitsilano was the home of Vancouver's hippie counterculture. Carver Pete Ryan depicted the trees, ocean, market, planetarium and quaint houses that continue to make Kitsilano a desirable place to live. •

>>>
OGDEN AVE
+ CYPRESS ST

2 CENTENNIAL TOTEM POLE 1958

> This totem pole is a replica of one carved for British Columbia's centenary by Chief Mungo Martin and his relatives from a 600-year-old red cedar from the Haida Gwaii. The original was given to Queen Elizabeth II and stands in Windsor Great Park. Each figure on the pole (Chief wearing hat and robe, Beaver, Old Man, Thunderbird, Sea Otter, Raven, Whale Woman on Sisiutl, Halibut and Cedar Man) represents a mythical ancestral figure of the 10 clans of the Kwakwaka'wakw people. •

>>>
1905 OGDEN AVE

3 RAND AND EDGAR MURAL 1986

> This mural, at the Vancouver Maritime Museum, illustrates maritime events in the history of English Bay and the Vancouver harbour from when First Nations paddled on the waters to their present use for industry, tourism and recreation. Historic people (such as Joe Fortes, Vancouver's most famous lifeguard) and maritime icons (the St. Roch) are depicted. Artist Frank Lewis, working with other artists, has done many large murals including two in the "mural town" of Chemainus on Vancouver Island. •

4 VANCOUVER IN THE RAIN 2000

> One of the *Millennium Story Stone* series, this rock on a walkway north of Kits Beach on English Bay is about the impact of rain on Vancouver. Regan D'Andrade tells the tale of how an encounter with an exotic duck made her smile and appreciate the annual 1,219 mm of rain we get here in "Raincouver"—which makes our landscape both grey in winter and green in summer. •

>>>
KITSILANO POINT

5 LOST STREAMS 1994

> Before the arrival of Europeans in 1791, the area of present-day Vancouver was a dense forest with at least 18 fish-bearing streams emptying into False Creek. Artist Marion Penner Bancroft made 16 in-ground markers, each of which gives the reason for the disappearance of the particular stream and also names the plants and animals that have also disappeared. One of four above-ground markers is located by the swings at Kitsilano Beach and provides a map of the lost streams. •

>>>
KITSILANO BEACH
TO JERICHO BEACH

6 WIND SWIMMER 1996

> The *Wind Swimmer* at Kits Pool met with very positive public response, perhaps because "[Doug] Taylor combines folk art and high-tech mechanisms to thematically explore the relationship between society, technology, and the environment." It was reported that this piece was intended as a "mate" for an older man who swam regularly off Stanley Park. Kits Pool, Vancouver's largest, has heated salt water and possibly the best views of any public pool in the world. •

>>>
2305 CORNWALL AVE

7 CONTINUITY 1978

> Two small, naked children carefully balance their way along a cedar log, duplicating the activity of countless children at nearby Locarno Beach. These bronze sculptures by Letha Keate are set in the woods on the grounds of Brock House, a facility that hosts many weddings and houses a seniors' centre. The children should make us think about the continuity and balance we all need in life: keeping things in perspective, being active and enjoying life. •

>>>
3975 POINT GREY RD

>>>
EAST OF
JERICHO SAILING CLUB

8 HABITAT 1976

> The first United Nations Conference on Human Settlements was held in Vancouver in 1976 at Jericho Park. Bernard Thor created this sculpture from trees, which, in various forms, and in most cultures, provide shelter, fuel and often transportation. Since that "moment in time when people came together to think of their neighbour," a World Habitat Day is held each October and the renamed World Urban Forum meets every two years. The forum addresses rapid urbanization, the urbanization of poverty and the hazards posed by climate change and natural disasters. •

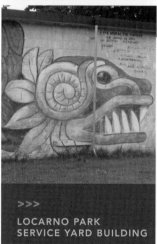

>>>
LOCARNO PARK
SERVICE YARD BUILDING

9 MURAL FUE PINTADO 1992

> Mexican artists collaborated with artists in the Art in Action Program on this Spanish-themed mural. It shows Quetzalcoatl (the feathered serpent) and the destruction of Tamoanchas (the mythical place where life began), commenting on the need to recapture the desire to live. British Columbia has numerous trade initiatives with Mexico, enough that there is a Mexican consulate in Vancouver as well as a Mexican Business Association. An additional benefit is a vibrant Latin American dance, music and restaurant presence in the city. •

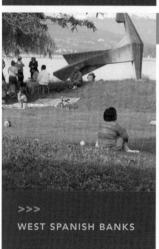

>>>
WEST SPANISH BANKS

10 ANCHOR 1986

> Except for the theory that Sir Francis Drake was here secretly 200 years earlier on military reconnaissance, the first Europeans to arrive at the site of Vancouver were the Spanish. In 1791, a year before Captain Vancouver arrived, Spaniard Don Maria Narvaez anchored the *Santa Saturnina* near Point Grey. This reinforced concrete anchor, donated by the Docksteader family, was created by Christel Fuoss-Moore as part of the centennial sculpture symposium. Like other Vancouver cultures, the Spanish are now "anchored" here. •

11 BEARS, DOG + OTHER SCULPTURES c. 2000

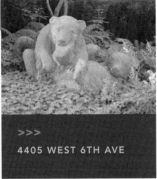

> To the delight of passersby, a sculpture garden has grown over the years on the lawn and boulevard of a private Point Grey home. In the front yard of the Bolton house is the oldest and largest dogwood tree in Vancouver. The family wanted to create a park-like setting for the enjoyment of those who passed by. Victoria's Nathan Scott sculpted the grandmother sitting on a bench and the little boy, modelling them on his own family members. •

>>>
4405 WEST 6TH AVE

12 STEPPING STONES TO THE FUTURE 1999

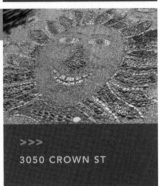

> Children from the Jules Quesnel French immersion school helped artists Glen Anderson and Marina Szijarto make these stepping-stone mosaics. The stones lead to the school's front door, with other stones hidden in the grass along the boulevard. The artists expressed hope that involvement would give the students a model for collaboration and contribution. *Community Stepping Stones* (Anderson, 1997) are also placed around the West Point Grey Community Centre and along the beach. •

>>>
3050 CROWN ST

13 MEDALLIONS (BROADWAY) 2008

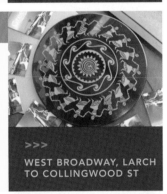

> The Hellenic Canadian Congress of BC, the West Broadway Business Committee and the Kitsilano Chamber of Commerce wanted to recognize both the Greek community and the Coast Salish who have inhabited the area. Presenting some powerful philosophical thoughts, 36 granite medallions, with designs by either Coast Salish artists Susan Point and Kelly Cannell or Greek artists Evie Katevatis and Alexandra Dikeakos, are embedded into the corner curbs along West Broadway. •

>>>
WEST BROADWAY, LARCH
TO COLLINGWOOD ST

14 DELANO APARTMENTS 1997

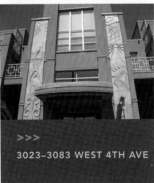

> Vancouver sculptors Charles Marega and his student Beatrice Lennie, and others working through the 1950s and '60s, such as George Norris, created friezes or panels to enhance otherwise ordinary buildings. Today, integrating art with a development project is part of the marketing. The designs on this Art Deco-style building are Vancouver-related, with frolicking dolphins, sailboats and bicyclists. A curious anomaly is the seahorse, which is not native. •

>>>
3023–3083 WEST 4TH AVE

15 HUBCAPS 1993

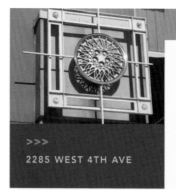

>>>
2285 WEST 4TH AVE

> Thomas Plimley's family ran a Dodge Chrysler dealership on this site for 40 years. Consequently, Chrysler Voyager hubcaps act as light covers approximately every 25 feet. The 25 feet represents the width of lots in Kitsilano. The building, by Hotson Bakker Architects, was a leader in "green" architecture. Developer Salt Lick Projects won an Ethics in Action award. Note also the carved head by M.A. Graham (1994) on the second storey wall in the courtyard. •

16 CITY FARMER GATE 1999

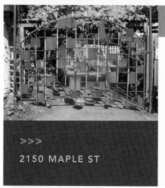

>>>
2150 MAPLE ST

> The metal gate that leads into the City Farmer compost demonstration garden is a lesson in recycling with its use of old metal gardening tools and metal scraps. It can be raised and lowered like an ancient portcullis. City Farmer has similar principles of sustainability and recycling: members teach composting methods, water recycling and high-intensity gardening to the general public. The gate was created by internationally recognized sculptor Davide Pan. •

17 ASCLEPIUS 1951

>>>
1807 WEST 10TH AVE

> A sculpture of Asclepius by Beatrice Lennie is inset on the former building of the College of Physicians and Surgeons of BC. In Greek mythology, Asclepius is the god of healing and medicine. His sword, with a snake entwined on the blade, is the universal symbol for physicians. The centaur who raised him taught him his medical and surgery skills as well as the use of drugs, incantations and love potions. •

18 CARLING-O'KEEFE BREW TOP N.D.

>>> ARBUTUS WALK
GREENWAY AT
WEST 11TH AVE

> The steel top of a beer-brewing vat rests in the Brewmaster's Garden as a tribute to the Reifel brothers who started Vancouver Breweries in 1919 on this site. The Carling-O'Keefe group, and later Molsons, continued to produce popular ales here until the area was redeveloped. The brick tower and archway on the housing complex replicates one from the original brewery and now includes a plaque describing the history of the breweries and the area. •

PEACE MURAL + PATH TO PEACE MOSAIC 2002

> In the halcyon days of the 1960s, Kitsilano was the centre of love, peace and hippies. This mural, painted over 40 years after the "give peace a chance" era, addresses issues of war, losses and hope for global peace. Artists Ruth Jones and Dan Will's work shows the challenges and consequences of war. The peace-walk mosaics and the mosaics at the main entrance reinforce the theme as does the *Family Mural* (2005) by AC & Kits Crew on the east wall. •

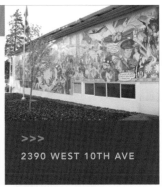

>>>
2390 WEST 10TH AVE

20 MURAL (QUEEN ELIZABETH SCHOOL) 2005

> At Queen Elizabeth Elementary School Annex, Ann Thorsteinsson and schoolchildren painted a colourful mural. It's a panoramic landscape: flowers, mountains, river and sun, with a full range of animals real and imagined, from skunks and bunnies to fire-breathing dragons. With a lion and lots of angels, it's one of the three pieces of public art in Vancouver that combine these two images. The others are the graffiti wall on Central Avenue and *Antiquity* in Victory Square. •

>>>
4375 CROWN ST

21 WOODLAND CIRCLES 1997

> To the south of the front door and along the edge of the east lawn of Queen Elizabeth Elementary School Annex are circles of stone with copper inlays created by students and artist Elizabeth Roy. Finding the circles can be a challenge, but one can study their designs reflecting natural history elements such as snails, ferns and leaves. Perhaps they are a Canadian version of the European fairy circles—gateways into the elfin kingdoms of nearby Pacific Spirit Park. •

>>>
4375 CROWN ST

22 SOUTHLANDS SALMON WALL 1995

> Southlands Elementary School is attended by many of the children who live on the Musqueam Reserve. Historically, their families fished in the Fraser River for salmon as a staple food. However, this is changing. It is estimated that, with a moratorium on fishing, it will take until 2020 to increase the numbers of salmon to the point where they will accommodate human consumption. Artist Alison Diesvelt, with Debra Sparrow from the Musqueam Reserve, completed the mural with the children. •

>>>
5351 CAMOSUN ST

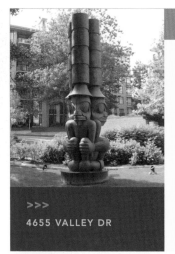

>>>
4655 VALLEY DR

23 THREE WATCHMEN 2003

> James Hart, the carver of this piece, is a hereditary Haida chief and the great-great-grandson of Charles Edenshaw (Haida chief, artist and consultant to anthro-pologists). Hart worked with both Bill Reid and Robert Davidson. This 4-m-tall bronze, commissioned by developer Polygon, has three figures in tall hats—once common on totem poles in Haida Gwaii—who watch out for danger not only in the real world along the city streets but also in the larger super-natural world. •

>>>
4500 ARBUTUS ST

24 GREEK CENOTAPH N.D.

> The Broadway–Arbutus area has long been home to a large number of people of Greek origin. On the grounds of St. George's Greek Orthodox Church is a memorial with an inscription in Greek, the interpretation of which indicates it commemorates all soldiers who have fought for some just cause—anywhere in the world at any time. They are brave regardless of their nationality and deserve recognition. A cenotaph is a sepulchral monument erected in memory of a deceased person whose body is buried elsewhere. •

>>>
4170 TRAFALGAR ST

25 TRAFALGAR TILE WALL 1998

> Art on exterior school walls has taken several forms in Vancouver, including murals and mosaics. In the case of this elementary school, memories of students who attended the school from 1948 to 1998 were drawn on ceramic tiles by the children from kindergarten to Grade Seven. Artist Alison Diesvelt, who led this project, is now an elementary school teacher—what fun her students must have in art class! •

the vancouver biennale

ECHOES Goulet, Michel

217.5 ARCS x 13 Venet, Bernar

KING AND QUEEN Etrog, Sorel

WALKING FIGURES
Abakanowiscz, Magdelena

JASPER Clement, John

ENGAGEMENT RINGS Oppenheim, Dennis

> In 1998, several sculptures by internationally recognized artists were displayed along English Bay with little fanfare. By 2002, the number of sculptures had grown to 17, and public awareness and enjoyment increased as the works were placed throughout the city. A driving force behind the idea for the original Vancouver Sculpture Biennale was Barrie Mowatt, a long-time supporter of the arts and sculpture in Vancouver who, through the Buschlen Mowatt Gallery, sponsored sculptures from 1998 to 2004. In 2005, a 10-year agreement was finalized between the newly formed non-profit Biennale organization and the Vancouver Parks Board, allowing placement of the sculptures in the city parks for a specific period of time. Modelled on the biennales held in other "world-class" cities around the world (e.g. Vienna, Paris, Frankfurt), the Vancouver Biennale is intended "to engage Vancouver citizens and visitors in a citywide festival that celebrates the social value of public spaces and provides interactive cultural programming" and "to promote Vancouver and Canada as a dynamic cultural destination highlighting the unique outdoor lifestyle of the Pacific Northwest."

The inaugural Vancouver Sculpture Biennale, a collaboration of the federal government, the Vancouver Parks Board, local business sponsors and the Biennale non-profit organization, was held from 2005 through 2007. Twenty-eight sculptures or installations from 11 countries, were placed in the first Biennale. They ranged from German Sebastian Fleiter's installation, *Swans*, which could be seen through a sewer grate, to American John Henry's soaring, 25-m brilliant red steel *Jaguar*, near the entrance to Stanley Park. For 18 months, the sculptures in Vancouver showed the city the range and potential of both small- and large-scale public art. Throughout the coming years, the renamed Vancouver Biennale will continue to provide new topics for discussion and an opportunity to explore international art, which will now include both sculptures and new media art.

The following six sculptures were purchased by the Biennale organization in 2007 as a legacy. They are on permanent loan to the city but they can also be loaned to other cities and reinstalled later in Vancouver.

ECHOES 2003

> A series of eight steel chairs with words cut out of the seats was constructed by Michel Goulet, a Canadian artist living and working in Montreal. In 2008, he received the Governor General's Award for visual and media arts. His whimsical chairs encourage viewers to discover the multiple meanings of everyday objects. The poetry on them, UNE QUESTION DE TEMPS JAMAIS POSEE A TEMPS in English and French, stimulates thought about communication and language. •

>>>
SUNSET BEACH

217.5 ARCS x 13 2005

> Sculptor Bernar Venet, considered one of the most important French conceptual artists, had his first art show at the age of 11 and works in a variety of media. For forms such as *217.5 Arcs*, he uses mathematical theories to create the shape of the structures. He believes that his work is suitable for public art because it often presents a powerful, thought-provoking surprise to the viewer who comes upon his gigantic structures (*217.5 Arcs*, made of Corten steel, weighs 5,500 kg). •

>>>
MORTEN AVE
+ DENMAN ST

KING AND QUEEN 1998

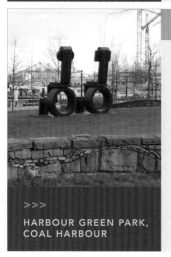

> The two stylized monarchs created by Sorel Etrog are masters of all they survey. Etrog used 1,814 kg of bronze to create each form. The intersection of the bolts, hinges and thick metal that make up these human forms, and their placement against the backdrop of a busy urban centre, poses questions about industrialization and individualization. Etrog is an acclaimed Canadian sculptor, with works in the Tate and Guggenheim museums and the Musee d'Art Moderne, among others. •

>>>
HARBOUR GREEN PARK,
COAL HARBOUR

WALKING FIGURES 2005

> Sixteen 2.7-m-tall headless figures in cast iron walk forward relentlessly—towards what? Polish artist Magdelena Abakanowiscz had the figures cast individually (so each is unique in stance and markings) for the Biennale. The figures refer to both the social and political disruption that Abakanowiscz has experienced, as well as the "mindless" nature of group behaviours. She has had over 120 installations placed around the world and is considered one of the foremost sculptors of the 21st century. •

>>>
ON LOAN

JASPER 2006

> The twisting forms of brightly painted tubular steel that American sculptor John Clement uses for many of his sculptures delight adults and children alike and invite everyone to climb over, on and through them. His forms are often in a series, each sculpture having its own unique shape and presentation, and are given appealing names such as *Chewy*, *Juicy Fruit*, *Kini's Playground* or *Kit Kat*. A young man, Clement was mentored by two world-famous constructivist artists, John Henry and Mark di Suvero. •

>>>
1300 ROBSON ST

ENGAGEMENT RINGS 2005

> Dennis Oppenheim is one of the world's most significant conceptual artists in the areas of sculpture, photography, film and video. He was recognized as part of the avant-garde in the 1970s. The Plexiglas and aluminum *Engagement Rings* were created specifically for the Vancouver Biennale. The idea for them developed when Canada was passing its same-sex marriage law. Placed in the West End of Vancouver during the 2005–2007 Biennale, they provided multiple meanings for the viewer. •

>>>
ON LOAN

website resources

> City of Vancouver, Office of Cultural Affairs, Public Art Program: www.city.vancouver.bc.ca/publicart

> Discover Vancouver: www.discovervancouver.com

> Downtown Vancouver Business Improvement Association: www.downtownvancouver.net

> The History of Metropolitan Vancouver: www.vancouverhistory.ca

> Morris and Helen Belkin Art Gallery at the University of British Columbia: www.belkin.ubc.ca

> Museum of Anthropology at the University of British Columbia: www.moa.ubc.ca

> Spirit Wrestler Gallery: www.spiritwrestler.com

> University of British Columbia Library list of sculptures: www.library.ubc.ca/archives/sculptures

> Vancouver Parks Board, Arts and Culture: www.vancouver.ca/parks/arts

> Virtual Museum, Government of Canada: www.virtualmuseum.ca

bibliography

> Archival records, VanDusen Botanical Garden.

> Archival records, Morris and Helen Belkin Art Gallery.

> Archival records, Museum of Anthropology.

> Bevan, J. *UBC Outdoor Art Tour*. Vancouver: University of British Columbia, n.d.

> *City Shapes*. Vancouver: City of Vancouver, 1986.

> Cartiere, C. and Willis, S., eds. *The Practice of Public Art*. New York: Routledge, 2008.

> Charity, R., ed. *Re Views Artists and Public Spaces*. London: Blackdog Publishing, 2005.

> Clark-Langager, S. *Sculpture in Place: A Campus as Site*. Bellingham: University of Western Washington, 2002.

> d'Acres, L. and D. Luxton. *Lions Gate*. Vancouver: Talon Books, 1999.

> Davis, C. *The Greater Vancouver Book*. Vancouver: J.J. Douglas Ltd./Linkman Press, 1976/1997.

> Davis, C. and S. Morey. *Vancouver: An Illustrated Chronology*. Burlington: Windsor Publications, 1986.

> *The Vancouver International Stone Sculpture Symposium Sculpture Collection*. Vancouver: VanDusen Botanical Garden, 1975.

> Doss, E. *Spirit Poles and Flying Pigs: Public Art and Cultural Democracy in American communities*. Washington: Smithsonian Institute Press, 1995.

> Fleming, R.L. *The Art of Placemaking Interpreting Community Through Public Art and Design*. New York: Merrill Publishers Ltd., 2007.

> Grant, P. and L. Dickson. *The Stanley Park Companion*. Vancouver: Bluefield Books, 2003.

> Harris, G.and S.J. Proctor, eds. *Vancouver's Old Streams*. Vancouver: Vancouver Public Aquarium Association, 1989.

> Hayes, D. *Historical Atlas of Vancouver and the Lower Fraser Valley*. Vancouver: Douglas & McIntyre, 2005.

> Jacob, M.J., et al. *Culture in Action: A public art program of Sculpture Chicago*. Seattle: Washington Bay Press, 1995.

> Kalman, H. and R.W. Phillips. *Exploring Vancouver*. Vancouver: UBC Press, 1993.

> Kermacks, C. "Art in the Garden," VanDusen Guide Newsletter. Vancouver: VanDusen Botanical Garden, 2004.

> Kluckner, M. *Vancouver The Way It Was*. Vancouver: Whitecap Books, 1984.

> Lacy, S., ed. *Mapping the Terrain: New Genre Public Art*. Seattle: Washington Bay Press, 1995.

> Mastai, J., ed. *Art in Public Places A Vancouver Casebook*. Vancouver: Vancouver Art Gallery, 1993.

> Mitchell, W.J.T., ed. *Art and the Public Sphere*. Chicago: University of Chicago Press, 1992.

> Moss, R. *Footprints Community Art Project*. Vancouver: Ultratech Printing, 2003.

> Project for Public Spaces. *How to Turn a Place Around*. New York: Project for Public Spaces, 2000.

> Snyders ,T. *Namely Vancouver: A Hidden History of Vancouver Place Names*. Vancouver: Arsenal Pulp Press, 2001.

> Raven, A., ed. *Art in the Public Interest*. Ann Arbor, Michigan: UMI Research Press, 1989.

> Rich, C., ed. *Collected Memories A Guide to the Community Markers of Southeast Vancouver*. Vancouver: The Discovery Project, 1997.

> Roots, G. *Designing the World's Best Public Art*. Victoria, Australia: The Images Publishing Group, 2002.

> Roy, P. *Vancouver: An Illustrated History*. Toronto: Lorimer, 1980.

> *Sculpture Collection*. Vancouver: VanDusen Botanical Garden, 2008.

> Senie, H.F. and S. Webster, eds. *Critical Issues in Public Art Content, Context, and Controversy*. Washington and London: Smithsonian Institute Press, 1992.

> Shearar, C. *Understanding Northwest Coast Art*. Vancouver: Douglas & McIntyre, 2000.

> Steele, R.M. *The First 100 Years: An Illustrated Celebration*. Vancouver: Vancouver Board of Parks and Recreation, 1988.

> Stewart, H. *Looking at Indian Art of the Northwest Coast*. Vancouver: Douglas & McIntyre, 1979.

> Stewart, H. *Looking at Totem Poles*. Vancouver: Douglas & McIntyre, 1993.

> Walker, E. *Street Names of Vancouver*. Vancouver: Vancouver Historical Society, 1999.

ARTIST INDEX

ARTWORK INDEX

acknowledgments

> We wish to thank our families—Carrie, Andrew, Stephanie and Patrick—for their support and encouragement. Also, all the friends and extended family who tolerated our obsession with public art during the year that it took to write this book.

A thanks to Marlyn Horsdal who did an excellent job of editing an amazing amount of detail, and Ruth Linka, Publisher, and the graphics staff at TouchWood, who took the written words and pictures and created an attractive, accessible guidebook. Thanks also to Holland Gidney for her work as proofreader.

The public art registries of both the City of Vancouver and the Vancouver Parks Board were invaluable first-line sources for information and artist statements. As well, the archivists and librarians who helped with locating elusive information. The individuals at the end of the phone lines, who directed inquiries about specific art installations in the public or private sphere, all deserve detective badges as well.

A grateful thanks to the artists, art educators, administrators of public art programs, public art consultants, architects, developers and gallery owners who gave of their time and ideas to discuss their perspectives on public art. Their thoughtful input has been embedded in the introduction. Their expertise and passion about the creativity and skill of Vancouver's artists, their excitement about their own work in the field and their dedication to the future of public art provides energy and direction that will continue to support dynamic growth of public art in Vancouver.

Interview subjects: Daina Augaitus, Chief Curator and Associate Director, Vancouver Art Gallery; Lorna Brown, educator, curator and artist; Barbara Cole, artist, public art consultant and project manager; Norm Couttie, developer; Alison Diesvelt, artist and educator; Barry Mowatt, gallery owner and Biennale Executive Director; Eric Neighbour, artist; Bryan Newson, Manager Public Art Program, City of Vancouver; John O'Brien, professor of art history, visual art and theory, and member of Provost's Committee on University Art, UBC; Gary Sim, architectural technologist and art historian; Marko Simcic, artist and architect; Maureen Smith, artist, public art consultant and project manager; Debra Sparrow, artist; Alan Storey, artist; Richard Tetrault, artist; Jil Weaving, Manager, Arts and Culture Program, Vancouver Board of Parks and Recreation; and Paul Whitney, City Librarian, Vancouver Public Library. •